WATERCOLOR: PAINTING SMART

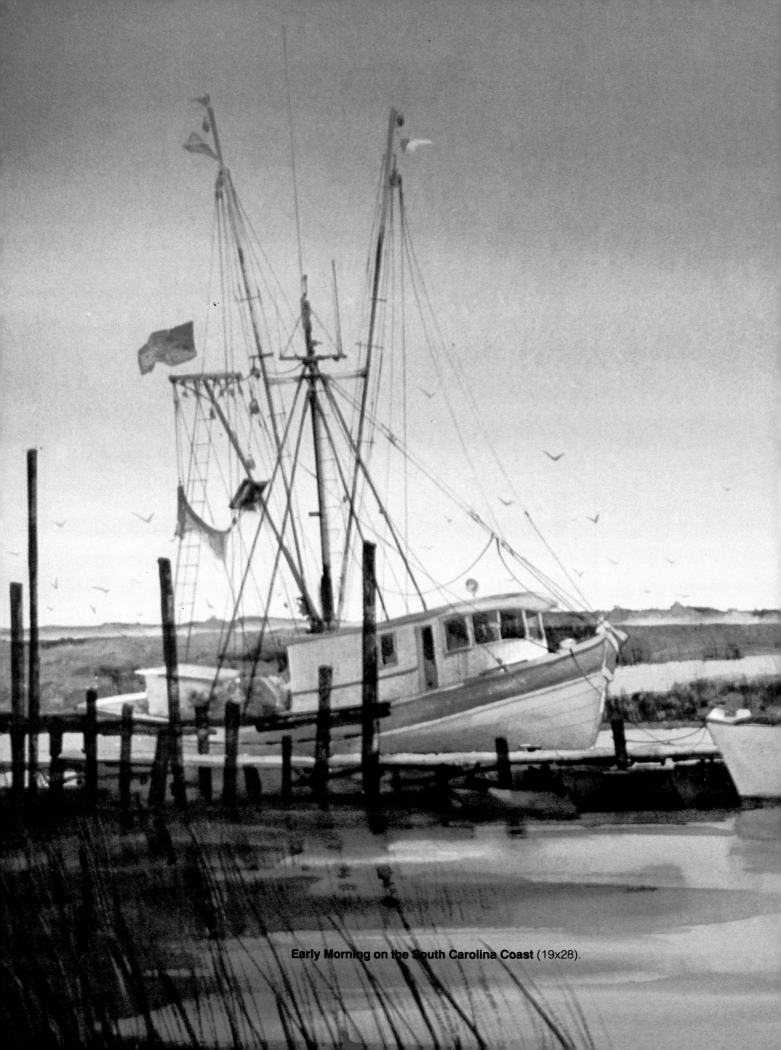

Early Morning on the South Carolina Coast (19x28).

WATERCOLOR
PAINTING SMART

AL STINE

NORTH
LIGHT
BOOKS

CINCINNATI, OHIO

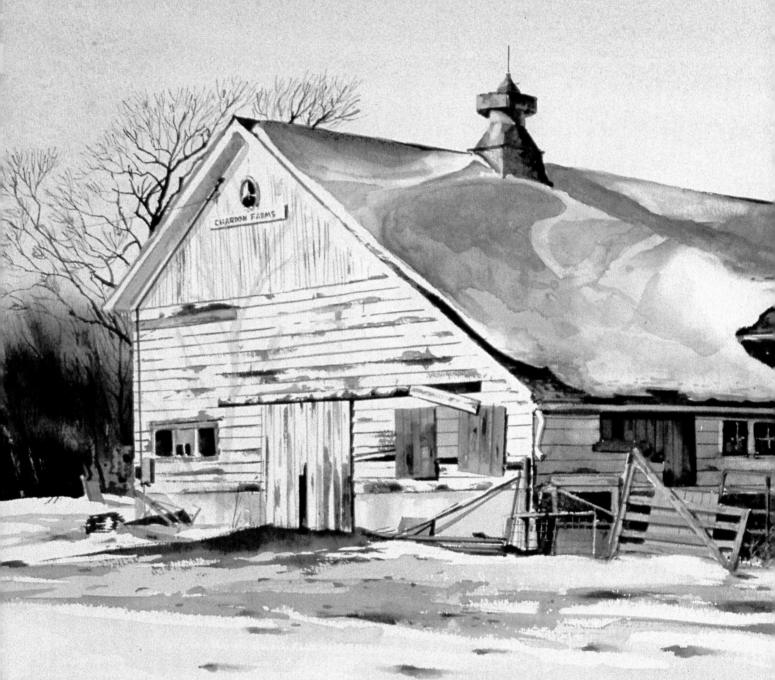

**Library of Congress Cataloging-in-
Publication Data**
Stine, Al, 1920-
 Watercolor: painting smart/Al Stine.
 p. cm.
 ISBN 0-89134-328-8
 1. Watercolor painting—Technique.
 I. Title
ND2420.S75 1989
751.42'2—dc20 89-23146

94 93 92 91 90 5 4 3 2 1

Edited by Greg Albert and Mary Cropper

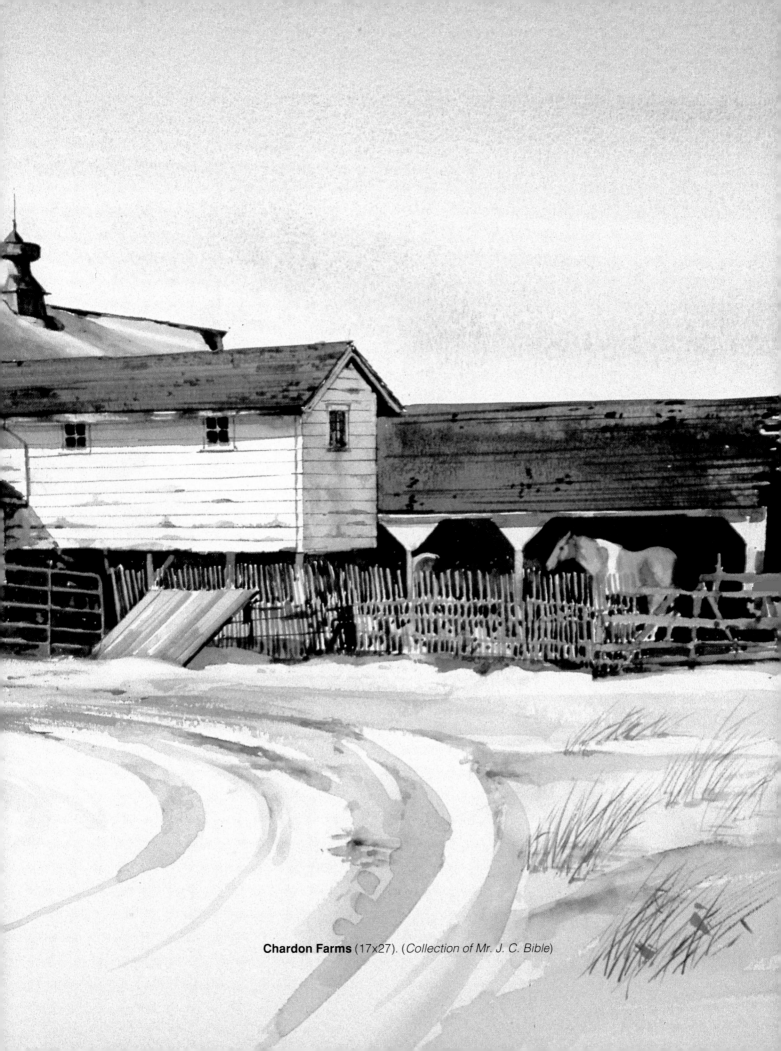

Chardon Farms (17x27). (*Collection of Mr. J. C. Bible*)

When I was first approached to do this book, I had no idea of the amount of time and effort that would be expended. My editor, Greg Albert, assured me that he would hold my hand and walk me through it—he did, and for this I thank him. Thanks also to my friend, Dolly Martin, who encouraged me to submit an article to *North Light Magazine*, and to Libby Fellerhoff for liking the article and painting enough to take it to the publisher. To Mary Cropper and Lynn LaRue for their superb editing, and to the production staff for their design efforts. Lastly, to my friends, colleagues, and students who encouraged me along the way.

This book is dedicated to my best friend, my wife Liz. Without her constant encouragement to paint and her unselfish neglect of her own talent as an artist, this book would not have been possible.

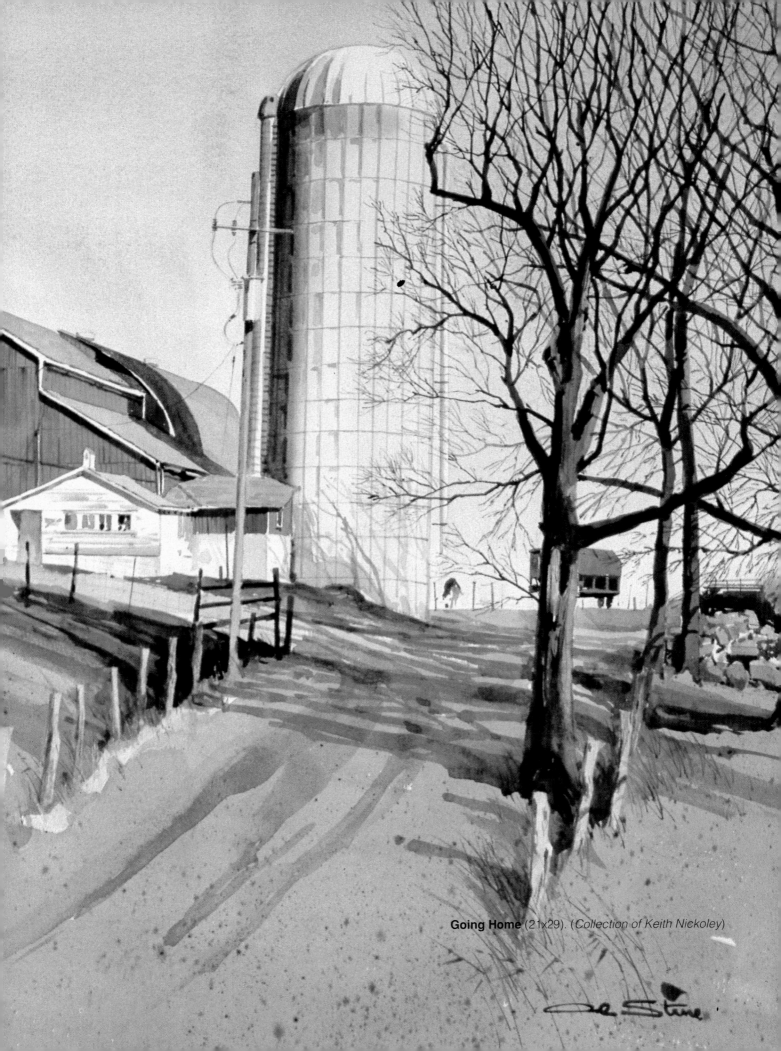

Going Home (21x29). (*Collection of Keith Nickoley*)

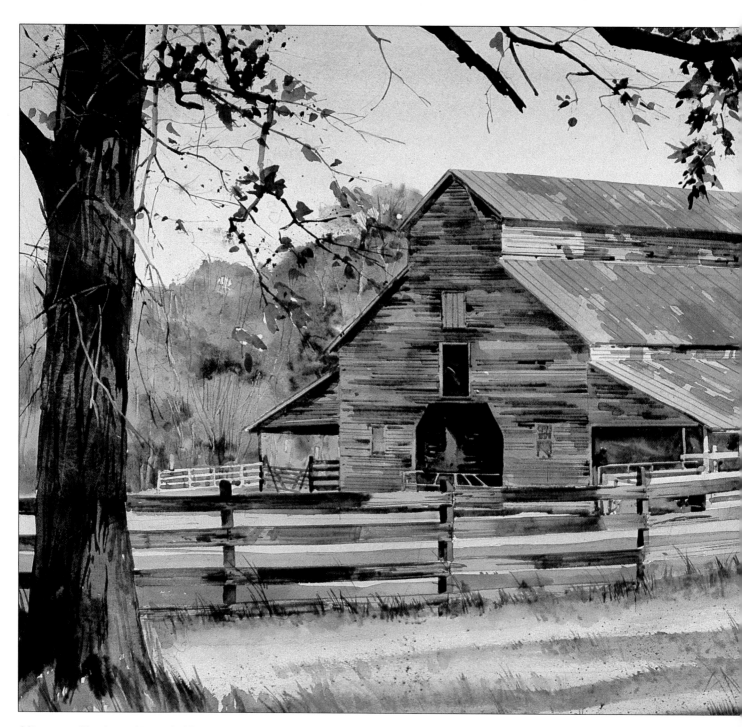

Afternoon Shadows (21x28). (*Collection of Mr. & Mrs. Moyne Noah*)

C O N T E N T S

Introduction1

1. *Starting Smart*2

2. *Choosing Equipment*14

3. *Exploring Techniques*24

4. *Using a Limited Palette*46

5. *Practice Makes Perfect*58

6. *Design Smart*70

7. *Plan for Success*82

8. *A Good Beginning*90

9. *A Great Ending*98

10. *Playing Around*112

11. *Painting Smart:
 Demonstrations*128

Index ..148

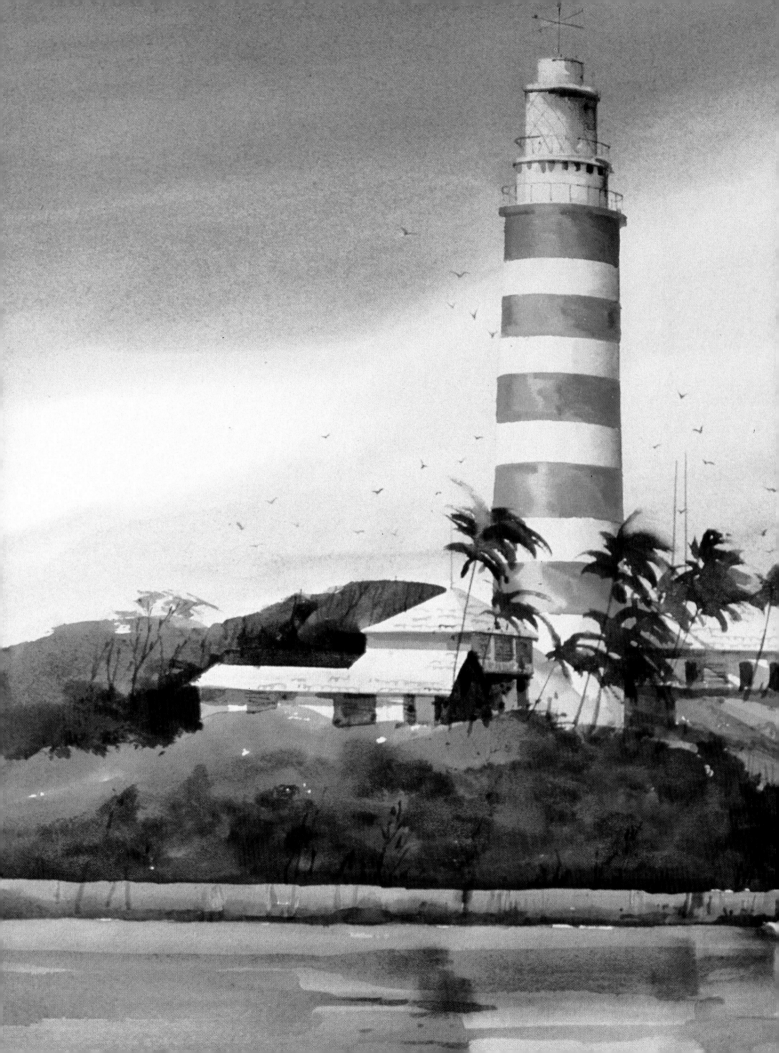

INTRODUCTION

I know no other group of painters as devoted to their medium as watercolorists. They take pleasure in their painting, are always eager to learn something new, and above all, are willing to share their knowledge with each other. Watercolorists are a hard-working group, but they always take the time to enjoy life along the way.

That's why I've attempted to share what I've learned over many years as an illustrator and painter. If you find one bit of information that's helpful then the effort of illustrating and writing this book will have been well worth the effort. If I inspire you to see a subject in a new and creative way or prod you into thinking smart about what and how you paint, then I'll consider this work a success. My reward as a teacher has been to see students' faces light up when they reach a new level in their painting.

I hope that when you come away from reading this book, you'll have a new way of looking at a subject you want to paint, that you'll begin to analyze what you're seeing and to ask yourself meaningful questions about it. You'll ask, for instance, "What would be the best way to design this subject for a painting?" "What palette would best express the mood so that others viewing the painting will share my feelings?" "How am I going to apply the colors and what combination of methods will I use?" or "How can I simplify the scene to make it better?" Knowing the answer to all these questions will help you become a more thoughtful, creative watercolorist.

A watercolorist should never reach the point where he or she feels there is nothing more to know about the subject; I know I learn something new with every painting I do. Even if a painting does not turn out as I had envisioned it, I still gain new insight. When a painting works, I try to figure out what made it successful. When one doesn't, I ask myself whether the values were correct, if I used the right palette to express my feelings, whether the design was good, and so on. Before you start over, you must know why your painting did or didn't work.

Once you've grasped the fundamentals of watercolor, you may use them your own way. Since there is no one correct way to paint a watercolor, I've simply tried to show you in the pages of this book how I go about it. Whether you're a beginner, an advanced painter, or somewhere in between, I hope you will find something in these pages to stimulate your growth as an artist. Feel free to take what will help your painting and discard the rest.

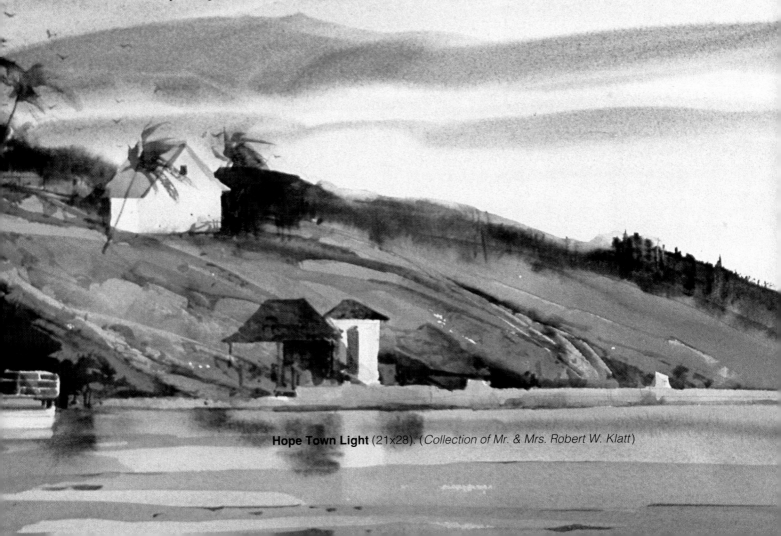

Hope Town Light (21x28). (*Collection of Mr. & Mrs. Robert W. Klatt*)

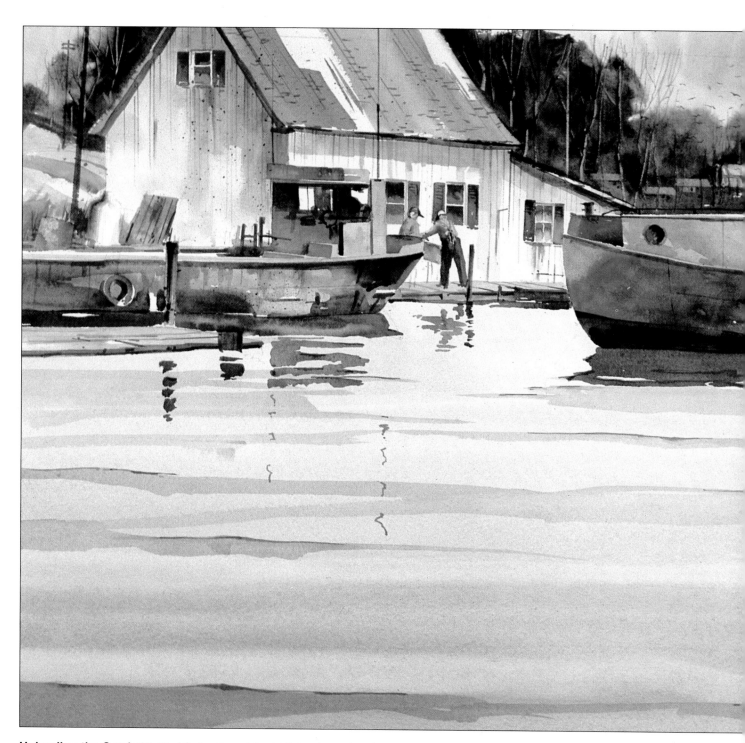

Unloading the Catch 20x28. (*Collection of David Price Associates*)

CHAPTER ONE

Starting Smart

Perhaps the first step in getting started is learning how to see. I don't mean where to look or what to look at, but how to look at it. We're all looking at the same world, but artists see it very differently. Ordinary people look at a scene or subject and think, "Isn't that pretty?" Artists look at the same scene or subject and think, "How can I make that into a painting?" They paint a picture in their minds, analyzing it in terms of composition, color, value, and texture.

I would like to help you develop your ability to see like an artist, so that every time you find something interesting— on the coast, on the farm, or even in your own backyard—you'll be able to translate it into a painting.

In order to paint smart, you need to train your eye to see the world in terms of making a painting. When you're looking for your next painting opportunity, ask yourself:

1. What do I feel about this scene? How can I convey feeling?
2. What is my center of interest?
3. What colors will best convey the mood of the scene?
4. What is the value range?
5. What should I put in?
6. What should I leave out?
7. What colors should I mix to suggest the ones I see?

There really aren't any right or wrong answers. The most important thing is that you consciously ask yourself these questions and then answer them based on smart painting practices. Too few beginning painters stop to think about these questions. Instead, they are in such a hurry to put paint on the paper that they forget how important it is to make certain decisions before painting. They may be so eager to paint an exact replica of what they see that they forget an artist must often improve on nature. In other words, rather than make conscious decisions, they let luck answer the questions for them.

Smart painting isn't a matter of luck. It's the result of asking the right questions and answering them based on the principles of design, color theory, and sound technique. For example, a good painting will have one center of interest that will act as a magnet for the viewer's eye. As we'll see in Chapter 6, the eye is naturally attracted to the part of the painting with the greatest contrast. When the artist is planning a painting—before beginning to mix colors—he or she thinks about the center of interest and plans to place the darkest and lightest values there. Making a value sketch before drawing on the watercolor paper helps the smart artist check out ideas while it is still easy to experiment. In the middle of painting —when the paper is wet and the colors are being applied—is no time to make a decision about where the center of interest ought to be.

Remember, painting smart means: Think before you paint.

The First Step

The first question a smart painter asks is, "What do I paint?" Beginning painters often feel that they have to seek out the quaint or picturesque to find suitable subject matter. But you don't have to go to some exotic locale to paint great watercolors.

Good subject matter is everywhere; however, nature rarely offers us a perfect arrangement that is ready to paint "as is." Instead, the smart artist has to apply the principles of design and do a little creative rearranging to make a good painting. Once you begin to understand how this works, you soon realize that almost any subject can be transformed into a great painting by applying the right rules. In fact, the true mark of a master is his or her ability to make exciting paintings from the most ordinary subjects.

I'm always on the lookout for things to paint. On weekends, my wife Liz and I frequently hop into the car and go for a drive in the country. While we travel, I keep my sketchbook and camera ready to record anything I think might be a good subject. Barns are especially fascinating to me—I never tire of their endless variety throughout this country.

I plan my vacations around painting. I take plenty of film and frequently come back with enough material for months of work. Not only does this often answer my question about what to paint, it seems to prolong the enjoyment I had while on vacation.

Very few artists paint subjects that are completely imaginary. Instead, they work from a variety of sources: sketches, photographs, and slides are probably the most common and useful. They then put these materials together in many ways to create paintings.

I suggest that you carry a sketch pad with you wherever you go and use it. Not only will this improve your drawing skills, but it will train your eye

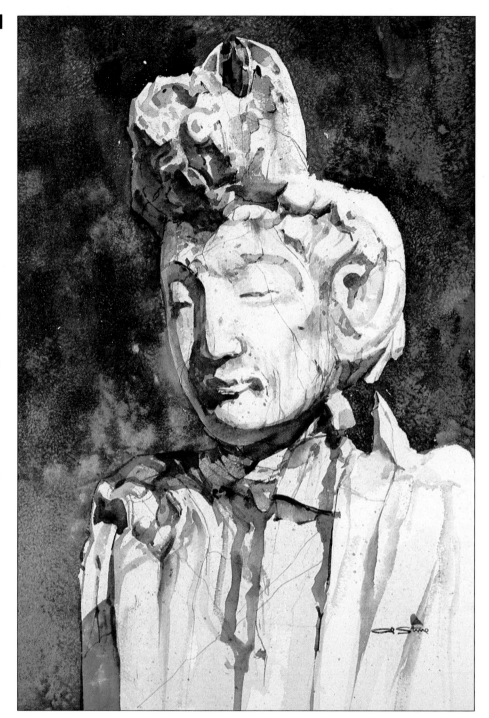

Old Friend (17x13). Here's an example of something I found in my own backyard. I've had this statue for many years. It originally sat on the hearth in my living room in Illinois and now holds a prominent spot in our garden in South Carolina. It's been broken and glued together more than a few times. I used salt in the background to achieve a texture that would contrast with that of the statue. (*Collection of Mr. & Mrs. Robert S.D. Browne*)

to see like an artist. I carry a 9x12 spiral-bound pad of white bond and a black Prismacolor pencil. The pad is big enough to let me hold it steady while I draw from the shoulder. I think a small pad encourages you to "noodle," drawing lots of small, insignificant details instead of the big pattern of light and shadow.

If you won't have time to sketch, carry a camera with you. You don't need a lot of fancy equipment or photographic experience to take good photographs for painting. You can use a small pocket 35mm camera that is easy to carry, so you never have to pass up subject matter that would make a great painting.

I use a zoom lens when I can't get as close to my subject as I would like. I can also use the zoom to fill the frame with the subject matter and get better detail from which to work.

Using print film (either color or black and white) or slide film is a matter of personal choice. It is easier and more convenient to draw from a print: It can be held in your hand and doesn't require a slide projector. I can make a panorama by taking two or more shots of my subject, moving the camera just enough so the image I see in the viewfinder barely overlaps the previous shot. Then I tape the prints together to make a larger image from which to work. Often I make a composite image with several photographs.

On the other hand, there are good reasons to use slide film. You can enlarge the image as much as you like to give you the feeling of drawing and painting on location. There's also the advantage of not having to worry about how to keep the image in front of you; unlike a print, you don't have to hold a slide or clamp it on your drawing board.

Don't use photos from magazines or other people's material. It is important to remember the "feel" of your subject as well as the smell, the colors, and the general atmosphere of the place. You can't do that with someone else's photographs.

Here are several snapshots I took of the peculiar fishing boats that sail out of Gills Rock, Wisconsin. I taped two pairs of photos together to get a composite image from which to paint. (See the finished painting I did from the second pair on page 11.) Snapshots like these are the handiest way to record detail for later use in the studio.

A collection of source materials that I use for paintings, including snapshots, slides, and sketches. You can choose to work from any or all of these on each painting What's important is that you decide what you want and plan how to combine them.

Think Before You Paint

Before I actually begin painting—whether I'm working from slides or photographs in my studio or working on location—I go through a thinking process that is the key to painting smart. The old adage about spending 80 percent of your time thinking and 20 percent painting is a good one to remember. As John Pike says, "Think like a turtle, paint like a rabbit."

I ask myself, "What am I trying to get across in this painting?" and "What do I want the viewer to feel when it is shown?" Then I draw a series of "thumbnail" sketches, experimenting with ways in which the principles of design can be used to create the best answers to those questions.

After I've tried out various ideas in a series of thumbnails, I do a larger value sketch of the one I feel works best. I use a small 8x10 sketchbook and either a General's sketching pencil or some other graphite pencil with a large soft lead. Use whatever you are comfortable with. Sketch with large, loose strokes. You only want to determine the best pattern for the darks and lights.

The value sketch is a very important step in my procedure. In fact, getting the value pattern right is more important to the success of a painting than getting the colors right. By determining before I actually paint where my darks are going to be, I can confidently paint my darks with rich, strong colors when the time comes. It pays off to paint boldly with watercolor, but you've got to get it right the first time. Watercolor isn't as flexible as other media, which can be corrected more easily.

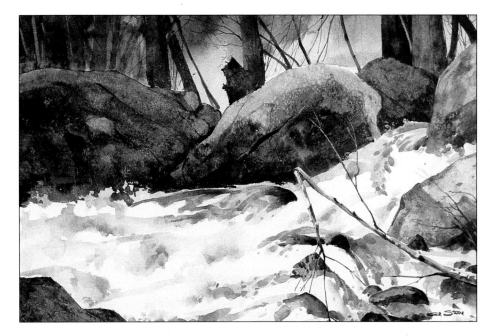

When I'm satisfied with my value sketch, I transfer my drawing to watercolor paper using a simple grid pattern to help me keep the proportions right. This grid pattern can be as simple as a horizontal and vertical line dividing the rectangle into equal quarters. If my sketch is more complicated, I'll divide it equally again. I rarely need to make a smaller grid, but I could if I wanted to. I find it easier to work in sections rather than trying to reproduce the drawing in one big chunk.

Generally, I try to use only the lines I need and to draw them as lightly as possible, so there aren't too many pencil lines visible in the finished painting. This also keeps the paper from getting greasy and soiled from my fingers or damaged by erasures.

After I have done a value sketch, I occasionally also paint a small color rendering to decide which palette will best establish the mood. These little color renderings are only about 6x9, and some turn out to be lovely paintings. I have matted and either sold or given some as gifts.

Mists of the Hidden Falls (13x19). A painting is the result of a long thinking process that begins well before I put paint on paper, just as this rushing water has its source in the mountains high above. (*Collection of Mr. H. A. Royster*)

Starting Is Easy

Most watercolorists would agree that watercolor is more than a hobby. It's such a fascinating pursuit—there is always something new, something more to learn, something new to try. So don't be surprised if you find yourself hooked. I know many watercolorists who have been painting happily for years and report that there are still new adventures to be had.

Getting started in what may well be a lifetime involvement with a wonderful art form is easy. First, of course, you need the basic equipment, which is discussed in the next chapter. It's not unusual for the beginner to buy more equipment than necessary, but using a variety of different tools will help you select what really works for you. Many watercolor veterans work with just a few brushes and seven or eight colors.

Once you've decided to try watercolor and bought the equipment you want, the best thing to do is join a local club or a statewide watercolor society. Learning any new skill is a lot easier and more fun if you do it with other enthusiasts. Joining a club lets you rub elbows with fellow artists. The experience is stimulating, and I guarantee you will learn a lot. These groups are found all over the United States. (A list is published each year in *The Artist's Magazine*.) Most clubs and societies sponsor demonstrations and workshops that offer great opportunities to learn.

If you are unable to attend demonstrations or workshops, you can buy or rent cassette tapes and slides or video instruction tapes to see how to paint better watercolors. Finally, read, read, read. You can learn a lot from good books on watercolor. I have a few favorite books I read and reread continually that have taught me things I couldn't learn anywhere else.

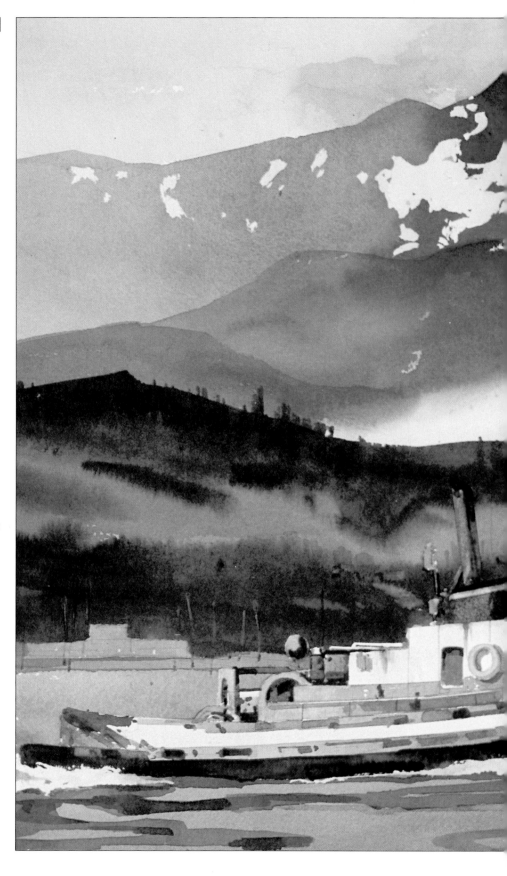

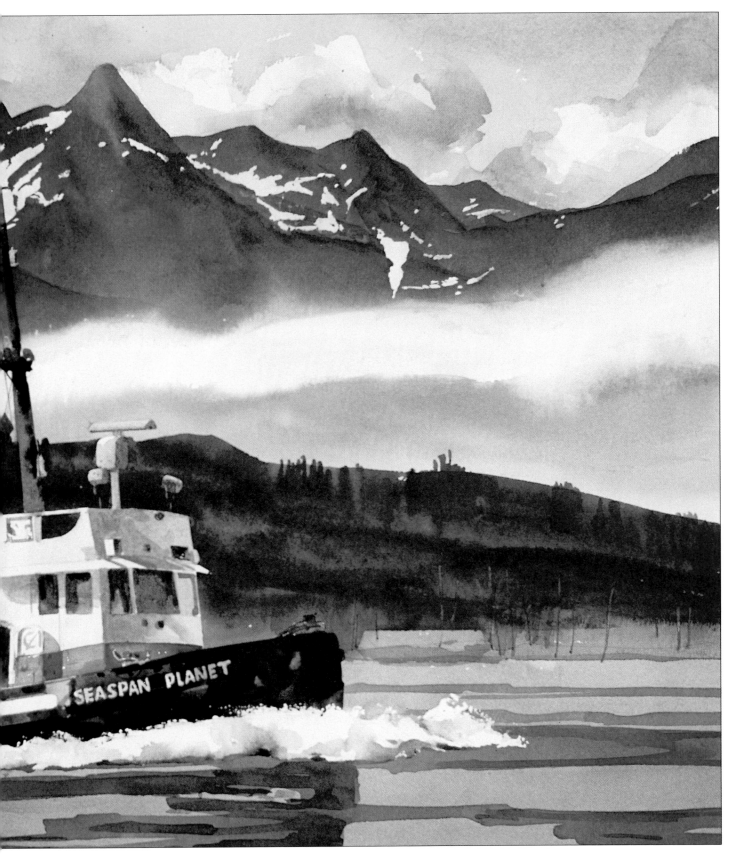

Harbor at Vancouver (13x20). Here is a painting inspired by one of my favorite spots in the Northwest. Of course, my first efforts at watercolor weren't this satisfying, but you have to start somewhere. Luckily, starting is easy. (*Collection of Alistair Campbell*)

Practice Smart

Before trying to do a complete paint-
ing, practice the various components
on quarter sheets (15x11). Paint skies
and clouds, trees, rocks, and so forth
separately before putting them all
together in a complete landscape.
Experiment with different techniques.
Study your results and keep the exer-
cises handy so you can refer to them
occasionally in your studio to refresh
your memory about discoveries you
have made. Time spent practicing the
components will pay off when you
begin to put all the pieces together.
Remember that even the most compli-
cated painting is nothing more than a
collection of relatively simple elements
that you can practice beforehand. In
chapters three, four, and five of this
book we'll work on these components
one at a time. First we'll look at
techniques for applying color, then
working with a limited palette, and
finally handling elements of your
paintings like sky, water, and so on.

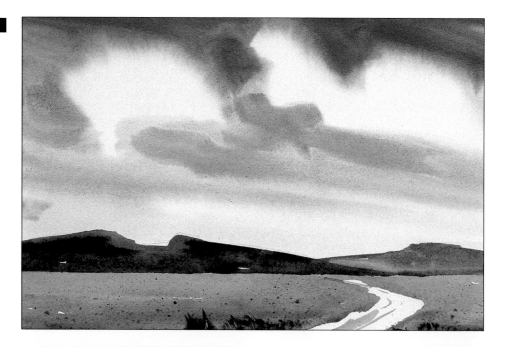

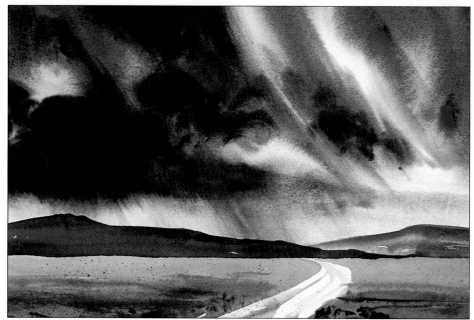

The subject matter is the same in these two paintings, but the sky has been treated
differently in each. This is an example of practicing one component of the painting.
Notice how the different skies dramatically change the mood of each picture. Simply
by altering one component of a painting, you can express many different emotions.

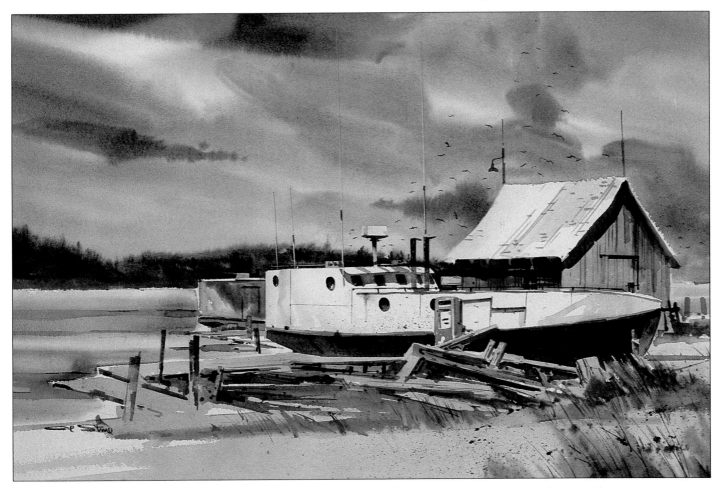

Learn from Your Failures

Learning anything new can be frustrating. I believe there are two ways to learn: the hard way and the smart way. The hard way is to try to make a masterpiece each time you paint, to try too hard to be perfect right away. You become very critical of your every mistake and take your failures personally—it's as if your worth as a person was somehow linked with how good your paintings are. Then you get very frustrated and contemplate quitting—to take up golf.

The smart way is to do your best all of the time but realize that your work won't be perfect. The smart way is to see each "failure" as an opportunity to learn what doesn't work so you can do it better the next time. The smart way is to strive to make bold statements, using strong dark values and big confident brush strokes when you need them. If you find that you produce a painting that doesn't come up to your expectations, stop and analyze it. Ask smart questions. Did you follow your value sketch? Did you overwork it with small brushes and too many details? Did you mix all your colors on the palette and let them get muddy?

Finally, the smartest thing to do is to practice, practice, and practice some more!

The Day Is Done (14x21). This painting is one of many I have done of the peculiar fishing boats called "seiners" that sail Lake Michigan out of Gills Rock in Door County, Wisconsin. I have painted these boats on location, from sketches and photographs made on the spot and from memory. This one was done from a composite photograph. Though I've never done the same painting twice, I've learned a lot from painting the same subject in different ways.

Painting on Location

Most watercolorists sketch and paint outdoors, even if they do their best work in the studio. Some artists only paint in the controlled environment of their studios, but I think there are tremendous benefits to be derived from painting on location. Working on the spot encourages you to "think on your feet," to simplify your subject and work economically, with just enough colors and brushes to do the job. Paintings done on the spot may be less refined than those done in the studio, but they are usually more spontaneous and energetic.

When you paint outdoors, you don't have the time to worry about tricks. You're so occupied with observing your subject that you forget all about good or bad technique and focus on getting it down on paper. It also encourages you to work boldly because you don't have the time to mull over every possible choice. As a result, this way of painting elicits the real you and your natural style.

When painting on location, I follow a procedure slightly different from my studio work. Because the light outdoors changes constantly, I try to establish the lights and darks right off the bat. I do the thumbnail sketches while thinking about where my darks will go. Then I skip the enlarged value sketch and transfer my drawing onto the watercolor paper.

Occasionally you will be unable to finish a painting on location due to lack of time or to changing light or weather conditions. Don't despair! Simply take your painting and finish it indoors. Once, while in Ixtapa, Mexico, I wanted to paint a scene of the sun's first rays coming up over some large rock formations at the end of a beach. I arose very early one morning to capture it, but the air was so heavy with moisture at that time of day that my washes just wouldn't dry. I tried fanning the paper and waving it around, but nothing worked. I had to wait for the sun to rise and dry the paper before I could finish the details on the painting. It turned out quite nicely in the end but took much longer than I had anticipated.

Here I am painting on location. All of my equipment is light and portable.

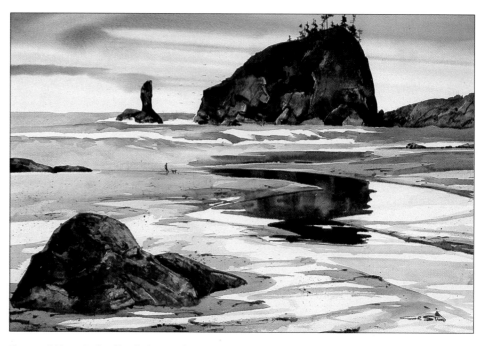

Second Beach, La Push (18x26). I've done a number of paintings of this isolated beach near La Push Indian Village in Washington. Some places offer unlimited opportunities for good subjects to paint, and this is one of them.

Typically, I set off to paint on location with my knapsack on my back, my French easel in one hand, and my tackle box in the other. I keep my John Pike palette and my brushes—a 3-inch Robert Simmons Skyflow for wetting the paper and doing large washes, a 1-inch flat, a 3/4-inch flat, number 6 and 8 rounds, and a number 4 rigger—in the easel drawer. I carry all my colors, sketching pens, pencils, an old toothbrush, salt, and other miscellaneous materials in the tackle box. My old army knapsack holds my 8-1/2x11 sketchbook, an old army canteen with its own cup to carry water, some rags, and a box of tissues. I generally carry a half-sheet of stretched watercolor paper or an 140-pound Arches cold-pressed watercolor block (16x20).

No matter where you live, there are probably groups of artists who go out on weekends to paint together. Join them. They will love the company, and you'll enjoy their support and encouragement. A few years ago, I joined seven other watercolorists at an inn in Door County, Wisconsin, and painted outdoors for five days. I did at least two paintings a day, one in the morning and one in the afternoon. The camaraderie was not only stimulating but also instructive. As a thank-you to the owners of the inn, the eight of us worked on a group painting. It turned out to be very nice, and we all signed across the bottom.

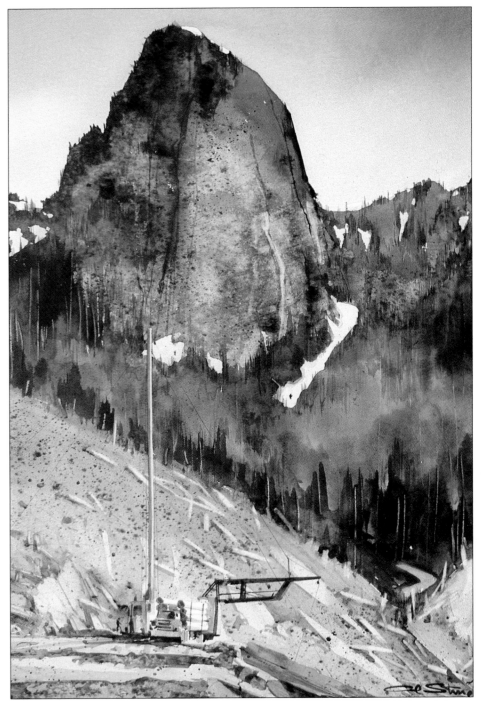

High Country Logging (19x13). While in Campbell River on Vancouver Island, a friend in the logging business took me on a run in his truck. Logs were being loaded above the snowline, and we zigzagged back and forth up the mountain. On the way down, the truck frame snapped at the first switchback, and the load had to be dumped over the side of the mountain. Although it was an unprofitable day for my friend, this was an exciting one for me. The scenery was majestic, and several paintings came out of the trip. (Collection of Mr. & Mrs. Earl Graham)

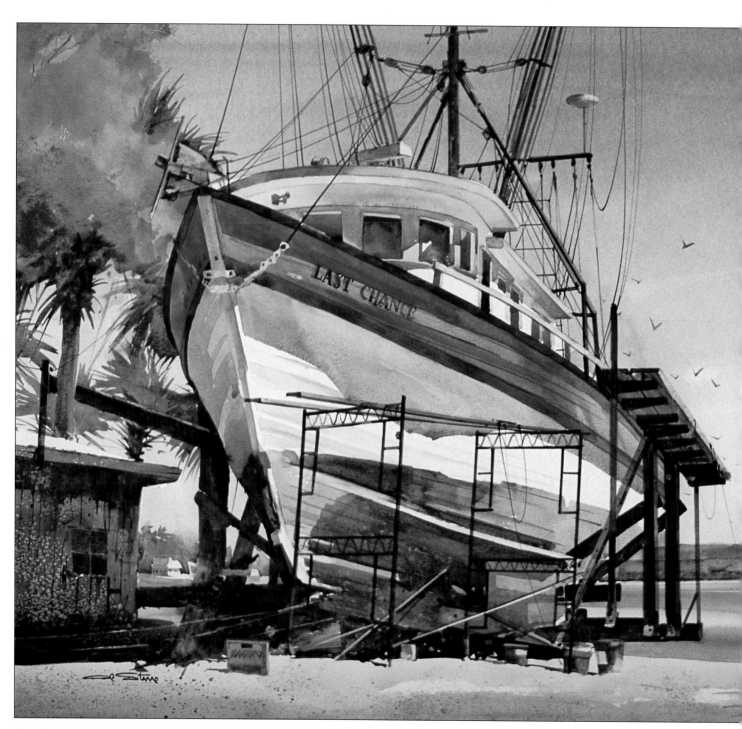

Sprucing Up (21x28).

CHAPTER TWO

Choosing Equipment

Most watercolorists I know are fascinated by all the equipment that we use to paint with. For most of us, this fascination began with our introduction to watercolor, when we were mystified and confused by all the materials needed for painting. We were impressed with the array of brushes, paints, and other paraphernalia that more experienced watercolorists had accumulated. Most of us have since become gadgeteers and collectors, with a lifelong habit of picking up anything that might be useful.

Despite all the gizmos that I keep in my paint box or on my studio table, I rarely use more than one or two of them on any one painting. Instead, I usually stick to the basics. Although it is fun to collect odds and ends for special tricks and effects, there is no magic in them. They won't do your painting for you.

Painting smart begins with knowing what the basic tools and equipment will do. Eventually you'll find it easy to choose a special tool for a particular texture or effect. But let's start with a good look at the essentials, the things we just can't do without: brushes, colors, paper, a palette, boards on which to stretch the paper, water containers,

sponges, tissue, a pocket knife, HB pencils, erasers, a spray bottle, and a sketchbook. I'll also discuss some of the nonessential but handy items I keep around for special purposes.

It is important to set aside a permanent place in your home to work, preferably one where you can retreat to paint undisturbed. Many artists have started their watercolor careers on the kitchen table, but having a space dedicated to your art can be a real asset. I find that I can focus my energies best in familiar surroundings with all my equipment close by. I have associated my studio with creative activity, and it's easier to get into the mood to paint when I am there. I also know where everything is and can reach for a tool or brush without thinking about it.

Having the right light to paint by is also important. The ideal lighting is overhead, color-balanced fluorescent lighting. You don't want to be painting in your own shadow. Ordinary fluorescent bulbs are too cool and incandescent lights too warm to make good color choices. It can be a real shock to see a painting done in cool fluorescent light under warm incandescent light.

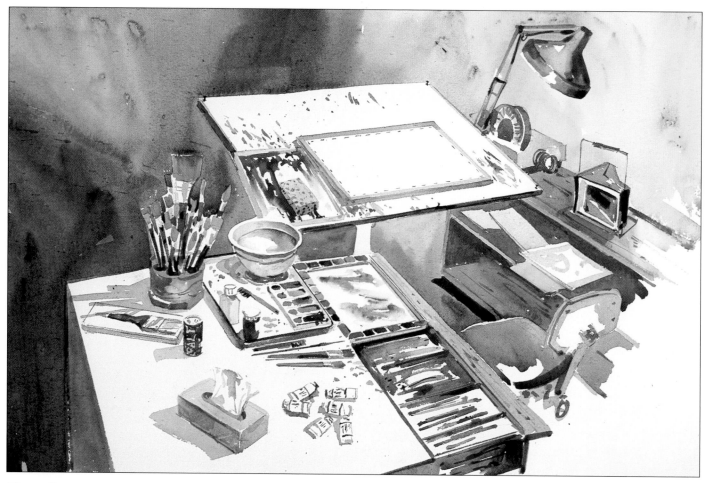

This is a watercolor of my studio setup.

Brushes

There are many excellent brushes on the market, and a few that are not so good. I strongly urge you to buy smart when purchasing brushes, and that almost always means buying the best brushes you can afford. If you must stint, do it on something other than brushes. This is one instance where it is certainly true that you get what you pay for.

Red sable-hair brushes are the most expensive, but they are also undoubtedly the best. With proper care, they will last for a very, very long time and will prove to be a wise investment. If you can't afford red sable, ox-hair brushes are a good second choice. They are not as expensive as the red sable, but there is a noticeable decrease in the springiness of the bristles and the amount of paint they hold. Synthetic brushes are even less expensive and not a bad value for your money, particularly the white nylon bristle brushes. The synthetic fiber flats generally don't hold enough paint and water for my tastes, and I think they are too mechanically shaped. I prefer red sable or ox-hair for my flats. Synthetic fiber brushes with some natural fibers, such as the Winsor Newton series 101 Sceptre, are very good choices, especially the rounds.

I normally use the following brushes and recommend this selection for the beginner. There are enough brushes to get the job done, but not so many that choosing the right one becomes troublesome when painting.

I use a 2-inch Robert Simmons Skyflow for wetting the paper, for painting backgrounds, and for painting skies. This brush does have synthetic fibers, but still holds a good charge of water. I use three red-sable flats—a 1 1/2-inch, a 1-inch, and a 3/4-inch, and four red-sable rounds—numbers 12, 8, 6, and 4. The larger the number, the larger the brush. I encourage you to use the largest brush you can when painting; small brushes invite fussiness. I keep an oil painter's 1/2-inch bristle brush for applying heavy pigment into wet areas and a small, 1/8-inch oil bristle brush for scrubbing and lifting out small areas of a painting for rocks and stones. I use a number 4 rigger, a long, thin brush to paint fine lines such as the rigging of ships, lacy tree branches, and grasses.

Brushes are a major investment, so it pays to take good care of them. First, you should only use them for watercolor. Never use your sable or ox-hair brushes for acrylics, which tend to dry near the ferrule (the metal sleeve that holds the hairs on the wooden handle) and eventually ruin the springiness of the hairs. If you do use acrylics, use synthetic brushes.

Second, you should clean your brushes thoroughly after every painting session. Make it a habit to rinse them out in clear water after each use. Many artists also use a mild soap to remove any residue that may linger in the bristles. Always make sure you rinse out all the soap.

Third, store the brushes in a way that protects the fibers. I store mine vertically in a brush holder as shown in the photograph. When I transport them, I carry them taped to a piece of stiff cardboard. Finally, if you do store your brushes for a long time, put a few moth crystals in their container. I've been told moths love sable hair. Of course, the best way to combat this problem is to use your watercolor brushes every day!

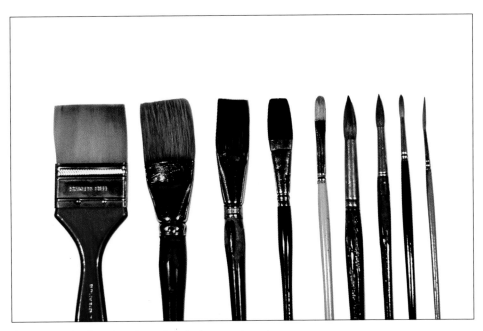

These are the brushes I use in all of my watercolors.

This is a good way to transport your brushes. For added protection, place a second piece of cardboard on top and tape the pieces together.

Paper and Board

Watercolor paper comes in various weights and textures. When we speak of the "weight" of the paper, we mean how much 500 sheets of a particular paper weighs. For example, if 500 sheets of a paper weigh 140 pounds, it's called 140-pound paper.

The less a paper weighs, the more it wrinkles and buckles when it is wet. I would not recommend painting on anything lighter than 140-pound paper, and paper that light will need to be stretched. The heavier papers can be held down on the drawing board with large clips, and the very heaviest can be used unmounted.

The standard size watercolor sheet is 22x30. You can purchase full sheets from your local art supply store or by mail order. A half sheet (22x15) is the size most commonly used by watercolorists. Paper can also be purchased in blocks. Watercolor blocks are pads of paper glued together on all four edges; you work on the top sheet, then slide a knife around the edges to separate it from the block when it is dry. Blocks come in sizes from 7x10 to 18x24, and in a variety of weights and textures.

Watercolor papers come in several different textures. Very smooth paper is called hot pressed because it is made by passing the paper between large, hot rollers. Cold-pressed paper has a more textured surface because it has not been subjected to heat in its manufacture. Rough paper has a very distinctly textured surface.

Paper texture and technique are closely related. Some techniques will work on rough or cold-pressed paper but not on hot pressed, and vice versa. For instance, dry brush techniques are not very effective on the smooth surface of hot-pressed paper, because the dry brush is supposed to deposit color on the ridges of the paper's surface. On the other hand, the smooth surface of the hot-pressed paper allows for easier lifts and wipe outs. Choosing the most appropriate technique for your paper texture is part of painting smart.

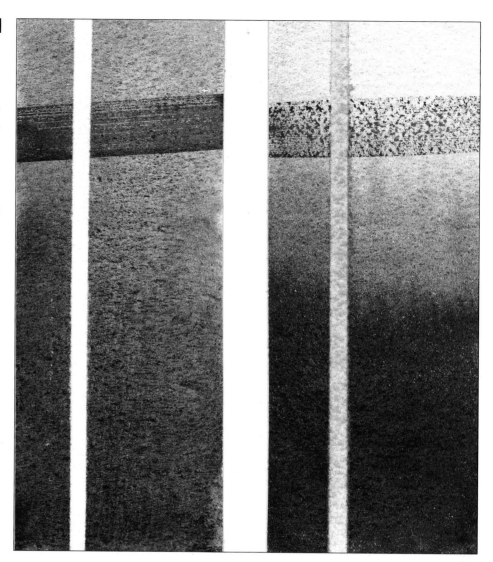

These are graded washes of French ultramarine blue on 140-pound Arches cold-pressed paper (left) and 112-pound Crescent Rough Watercolor board (right). I have added a strip of dry brush to show the difference in texture. I've also lifted out color with a sponge after masking out an area with tape. As you can see, the color lifts off the board more easily than the paper, giving you much cleaner whites.

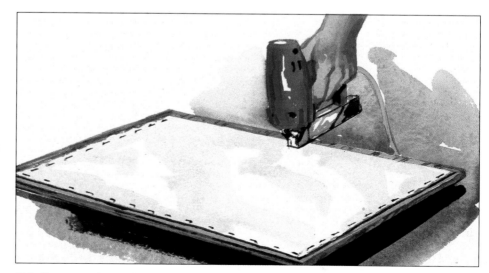

This illustrates the method I use to stretch paper over board. I'm using an electric staple gun to make it faster and easier. Stapling is the most effective method I've found; the paper has never come loose when a painting has dried.

I suggest that you stick with one brand and weight of paper until you attain some degree of competency. The experience will familiarize you with exactly how your paper reacts to your colors time after time. I use Arches 140-pound cold-pressed paper for the majority of my paintings, and I recommend it for beginners.

Since I use 140-pound paper, I need to stretch it before use. There are several methods for stretching paper; I find using staples the most satisfactory for me. Stapling is quick, and the paper never comes loose, as it can with some of the other methods. No matter what method you use to stretch the paper, you will need a hard board slightly larger than your paper; boards of 16x24 for a half sheet and 24x32 for a full sheet would be about right. Many different materials can be used for boards, including plywood, masonite, and plexiglass.

The first step in stretching your paper is to soak it in a tub in cool or room temperature water for about five minutes. Never use warm or hot water; it will soften the paper and turn it into a pulpy gruel. Remove the paper, drain the excess water, and hold it up to the light so you can read the watermark (if there is one). Lay the wet paper down on the board so that the watermark can still be read correctly. Wipe off the excess water with a damp sponge and begin stapling the paper to the board. I find an electric staple gun the fastest and easiest to use. Begin in the middle of the longest edge and work toward the corners. Then staple the opposite side and the two shorter sides. Lay the board flat to dry.

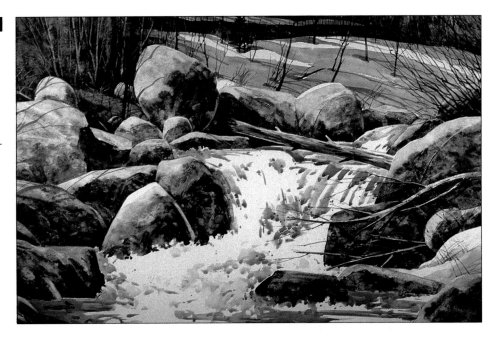

The paper will dry taut and flat. When it is rewet for painting, the paper will expand and return to the state it was in when it was first stapled, but it will not expand so much that it buckles and wrinkles. And when the colors dry, the paper will again dry very flat.

An alternative to paper is watercolor board, which is watercolor paper glued to a cardboard backing. I use 112-pound Crescent Rough Watercolor board. Although it is designated as rough, the surface is smoother than Arches cold-pressed paper. The nicest thing about using board is that you don't have to stretch it. Here's a little tip to help keep your board from buckling before your painting has dried: Dampen the back of the board with a wet sponge before you begin to paint on the face of it. The paint rides on the surface, and you can get some wonderful texturing as shown in the painting above. You can also lift colors on this board quite easily because the colors stay more on the surface.

Thaw in Motion (24x34). This rock and river scene was painted on 112-pound Crescent Rough Watercolor board. By laying pigment on quite heavily, using water in a spray bottle, and lightly blotting with a tissue, you can achieve beautiful texturing on the rocks. (*Collection of Mr. & Mrs. Jack Hollenbeck*)

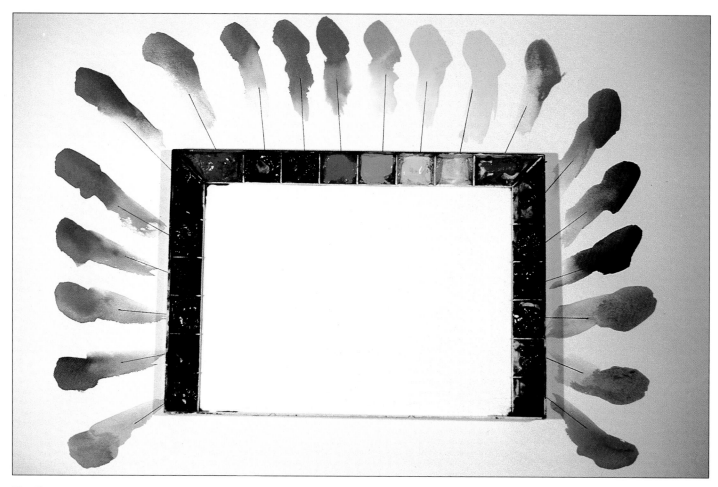

Palettes

You can use anything from a dinner plate to a butcher tray for your palette, but there are a number of excellent plastic palettes made just for watercolor. I use a John Pike palette, a plastic palette with a tight-fitting lid and twenty wells for colors. The wells surround a large central mixing area and are separated from it by a small dam that keeps the mixtures from creeping into the colors. The top can also be used for mixing colors. An important feature of this palette is that it's airtight. At the end of the painting session you can place a small damp sponge in the center of the tray and replace the lid. The colors will stay moist and ready for use for several days. If you aren't able to paint for a while, open the palette, spray the paint lightly with clean water from a sprayer, and replace the lid. If the colors do dry out, spray them with water several hours before you paint so they can regain their softness.

My palette of colors, as shown above, contains (left to right):
olive green
Payne's gray
cobalt blue
Winsor blue
Hooker's green dark
French ultramarine blue
cerulean blue
Winsor green
alizarin crimson
cadmium red
cadmium orange
cadmium yellow pale
lemon yellow
cobalt violet
burnt sienna
burnt umber
Van Dyke brown
raw umber
raw sienna
brown madder alizarin

I follow the standard arrangement of putting the cool colors on one side and the warm colors on the other. You can arrange your colors any way you like— this is what works well for me.

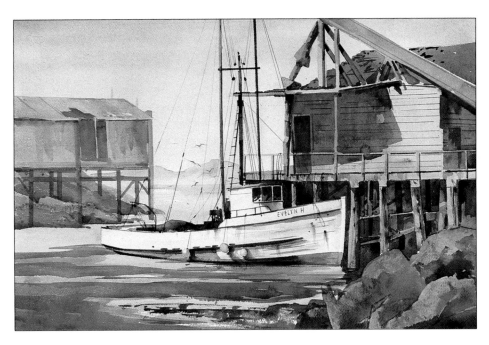

Every artist develops his or her own palette of colors as a matter of personal preference. As you paint, you will make your own discoveries about mixing color, and soon you'll have developed your own favorite palette. I keep all these colors in my paint box, but I rarely use more than six or seven in any one painting.

Each of the colors is included in my palette for a reason—that's what makes it a smart palette for me. Although I have four blues, French ultramarine blue is the real workhorse. Besides being nice for skies, it makes quite a variety of greens when mixed with yellows, lovely grays when mixed with earthtones, and a lovely purple when mixed with alizarin crimson. I use three reds: cadmium red, which has a little orange in it; alizarin crimson, which has a little purple in it; and brown madder alizarin, an earthy, slightly rusty red. I have lemon yellow, a yellow that tends toward green, and cadmium yellow pale, which has a touch of orange in it.

Notice that I've included a warm and a cool of each primary (for example, I keep both Winsor blue—cool, tending toward green—and French ultramarine blue—warm, tending toward purple). This allows me to create color temperature contrast even when I'm using one basic primary. Having a cool and warm version of each primary helps you mix complements without getting mud.

I also have an assortment of secondary colors (colors composed of two primary colors) including cadmium orange, an intense orange difficult to mix using other colors, and cobalt violet, a hard color to get by mixing.

There are many good brands of watercolors on the market, but I prefer to use Winsor Newton watercolors because of their excellent handling qualities and their tinting strength. The only color I use that is not W-N is the cobalt violet by Liquitex. It has a nice working quality, a lovely color, and is less expensive.

Most artists arrange their colors with the cool colors on one side and the warm on the other, as I do and recommend you do, too. It's most important to put your colors in the same place every time so that you won't have to hunt for your colors; your hand will go to it automatically. You want to be thinking about what colors you want to mix not what colors you can find to mix.

Be generous when putting your colors on your palette—you need plenty of pigment to paint a watercolor, and digging and scrubbing for color while painting will only disrupt your thinking process.

In my classes, I insist that students squeeze enough color onto their palettes right from the beginning. Paint left over at the end of a painting session is not wasted if it's kept moist.

Pacific Mist (13x19). In this scene from La Push, an Indian village on the Olympic Peninsula, I have attempted to capture a foggy, misty feeling with the sun just breaking through the mist on the building and fishing boat.

Special Tools

Now I want to give you a quick look at some of the special tools I use to achieve various effects and textures. Here I'll just show you a few examples of the way I use them; we'll discuss the actual techniques in more depth in the next chapter.

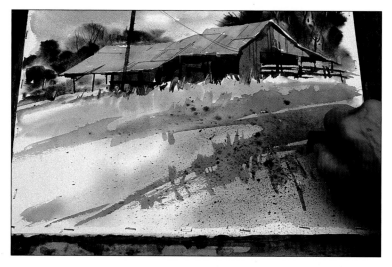

Spattering with a toothbrush is an effective method of texturing. To get larger spatters, load a round brush with color and rap it sharply on the handle of another brush or across your fingers.

Untitled (9x14). A razor blade or a credit card is a very good way to indicate rocks. While the paint is still moist, scratch out the lighter forms of the rocks. (*Collection of Mr. & Mrs. Robert W. Klatt*)

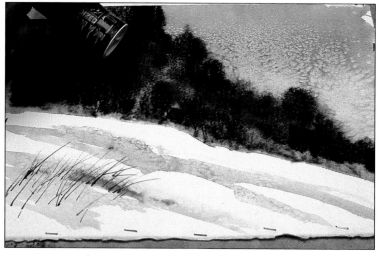

Applying salt to the colors while they are still wet on the paper creates interesting textures. This method is especially suitable for winter scenes. Table salt was used in this painting.

One of the best methods for painting clouds and fog banks is to first wet most of the area with a brush and clear water and then spray some of the edges of the same area with a spray bottle. When the color is put down, you will get some very interesting edges that can only be produced using a spray bottle.

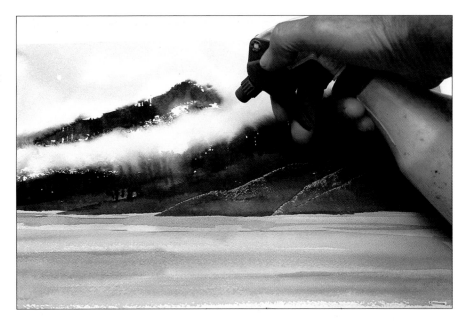

After all my basic washes had dried, I stamped the indications of boards on the barn and the larger posts in the foreground using various sizes of mat board scraps. This is done by mixing a puddle of color on the palette, picking it up with the edge of the board, and applying it to the painting.

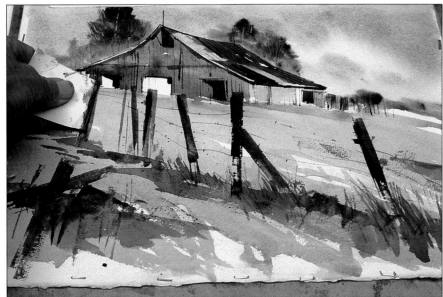

Untitled (9x14). One way to indicate brush or leaves on trees is to pick up the color on a sponge—a natural cosmetic sponge is best—and apply it to the painting. (Be judicious in using this technique, because the painting can get dry and scratchy-looking if you overdo it.) Stamping with a sponge is also a good way to indicate sage brush and grasses. (*Collection of Dr. & Mrs. Clifton Straughn*)

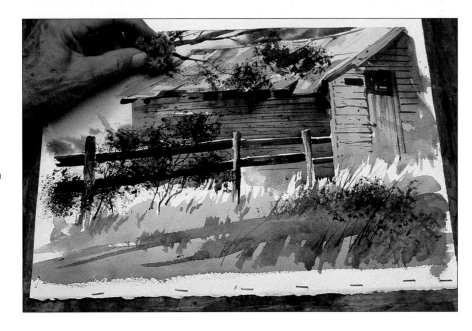

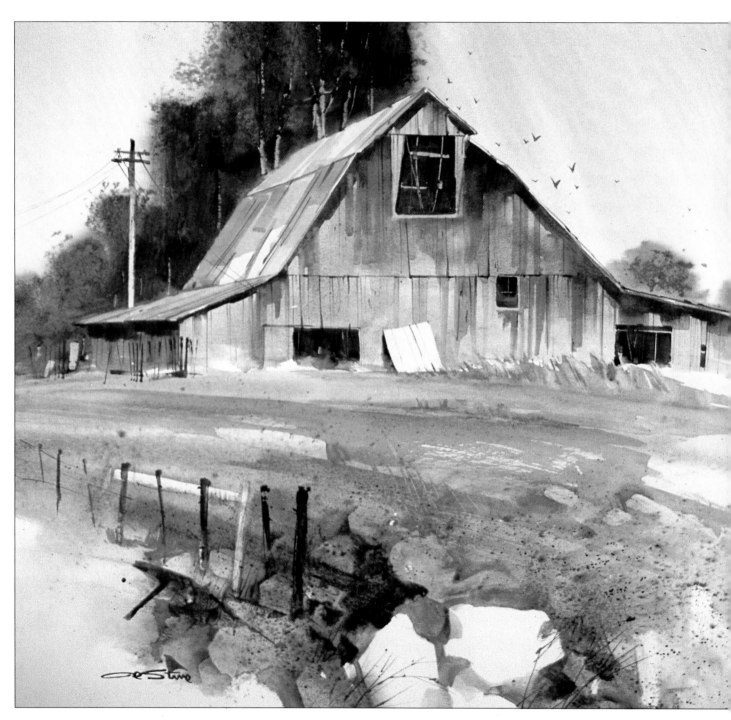

I Remember You (20x28). This painting was done to illustrate the many techniques
for texturing paint. I painted this to demonstrate what can be done to vary texture, so
I probably used more methods of texturing in this painting than I would normally use
in a single painting. How many textures to include is a matter of personal preference;
as you grow as a painter, you'll develop your own idea of what is enough.

Exploring Techniques

There is no one correct way to do a watercolor. In fact, there are as many ways to paint as there are watercolorists. However, all good painters must practice and master certain fundamentals that are the basis for good technique. I am reminded of a professional golfer who was interviewed after a winning game; when a reporter commented, "You were pretty lucky today, Jack," the golfer replied, "Yes, and it seems that the more I practice, the luckier I get!" Well, the same is true for watercolorists. The more we practice, the luckier we get.

In this chapter we will be looking at the different methods of applying color—wet in wet, dry on wet, wet on dry, and dry brush—and the basic wash techniques of watercolor—the flat wash, the gradated wash, and the variegated wash. We will also look at ways to texture watercolors and at lifting colors. These techniques are the foundation of watercolor painting, but knowing HOW to use them is just the beginning. Knowing WHEN and WHY is what painting smart is all about. Let's look at these techniques with this in mind.

A. I used a sponge dabbed into the same color I used for the trees to get a rougher leaf texture here.

B. These lines were scraped out with the squared-off end of a brush handle.

C. The sky was worked wet in wet. I also worked in an oblique direction.

D. I painted these two areas of background trees dry on wet.

E. This ground texture was put in with toothbrush spatter. You can see that I put some of it in while the paper was still damp to produce a softer diffusion.

F. The underpainting of the barn face was laid in with a variegated wash of several colors.

G. All of the rocks in this section of the painting were developed with negative painting (that is, painting with a color around the rock and washing the outer edge away with clear water).

H. I created these two lights by masking off the area with white artist's tape and scrubbing with a small natural sponge.

I. All of the fence posts were stamped in with a piece of mat board.

Four Ways to Apply Color

There are four different methods of applying color to the paper: wet on dry, dry brush (dry on dry), wet in wet, and dry on wet. The last two techniques in particular make watercolor really shine. Oil painters will look with envy at the marvelous diffusion that these methods produce and wonder how it was done. The magic of watercolor is that a few transparent washes, some strokes of color, and a little texture can conjure up a complete landscape.

No matter which technique you use, always remember to paint smart: Have plenty of color squeezed out on your palette so you don't defeat yourself and your painting by scratching around for color that isn't there.

Wet in Wet

This is the most fluid way to apply color. It gives you the most transparent color and the greatest diffusion of color. Wet in wet means the brush is well charged with paint, and the paper is wet with water. In this technique, the paint flows off the brush and intermingles with the water on the paper in an uncontrolled manner. Wet in wet is perfect for skies or wherever you need large expanses of soft color. It is also ideal for producing an initial under-painting. Once it's laid down, you can paint into it dry on wet or, when the underpainting is dry, use direct painting (wet on dry) to define the subject. You can also glaze over a wet in wet wash that has dried.

Wet on Dry

Wet on dry is often referred to as the direct method and is just what it sounds like: You are applying a wet brush full of color onto dry paper. The color stays exactly where you put it, unless you soften the edge with clear water. Wet on dry is probably the safest of all ways to paint, because little is left to chance. However, it is also boring.

Wet in Wet. Here I completely saturated the paper with clear water. Then I brushed in a combination of cerulean blue and French ultramarine blue and let it run. By tilting the board, you can direct the flow of the colors somewhat to create interesting patterns of diffusion and control the run.

Wet on Dry. With this direct method, brush wet with color is applied to the dry paper. Here I have used a variegated wash of several colors—cerulean blue, cobalt violet, and burnt sienna. This would make an excellent underpainting for a barn wall, which I would then paint over to bring out the details.

You miss all the glorious excitement of wet diffusions that is the hallmark of the luminous character of watercolor. You will be using a wet on dry technique primarily for the three basic washes (flat, gradated, variegated) described later in this chapter.

Dry Brush

This technique is sometimes called dry on dry, as the brush has very little paint in it, and the paper is dry. You usually hold the brush perpendicular to the paper and lightly draw across it. The brush leaves a small deposit of color only on the "grain" of the paper, letting the white of the paper sparkle through. As in wet on dry, the color stays exactly where it is placed. This technique is typically used for texturing things like wood and for areas of the foreground where extra detail is needed. It is also good for depicting sunlight sparkling on water. Dry brush works best on paper with some texture, such as cold pressed or rough.

Dry on Wet

Dry on wet is the most useful method for the watercolorist, because it can be controlled without losing the freshness that makes watercolor so exciting. The name is a bit misleading, though; the brush is really damp, not dry, with a strong charge of color on the tip. The excess moisture has been taken out of the brush by touching the brush to a sponge or piece of tissue. The brush deposits color on the paper and soaks up some of the wetness from the paper, so that the color diffuses only a bit along the edges. With this method you can control the placement of the color while getting very lovely soft edges.

Dry Brush. Here the damp brush was lightly charged with color and lightly drawn across the dry paper. The technique can be used for texturing wood or for texturing areas of the foreground.

Dry on Wet. I laid a wash of cerulean blue on the paper. While it was still wet, I picked up a fairly heavy amount of pigment on one side of the brush. I touched the other side of the brush to a damp sponge to remove most of the excess water. Only then did I apply the color side of the brush to the paper. You can see that the color stayed pretty much where I placed it but still gave me soft edges.

Let's talk a little bit about edges here. Getting the edges right is one of the most important things to do in a painting, but it is often neglected. Edges can be either hard—sharp and distinct—or soft—fuzzy and indistinct, or rough. Each type of edge does a different job, depending on how it is used in the painting. A few general guidelines will help you know which edge is best for a particular purpose.

Generally, hard edges attract attention and will usually look closer to the foreground than soft edges. Hard edges suggest angular and mechanical objects and describe smooth textures or flat surfaces. For instance, hard edges would be right for a sunlit rock in the foreground. Soft edges, on the other hand, look more distant and don't attract attention. Soft edges suggest rounded, natural forms and rough edges describe more roughly textured or irregular surfaces such as old tree trunks. Soft edges would be right for background trees.

Hard edges are usually produced by putting a brush wet with paint against something dry. A brush wet with color will make a hard edge when it touches dry paper. It will also make a hard edge if it is painted against masking fluid that has dried on the paper, or masking tape, or anything else that protects the paper from the brush. Soft edges are usually produced by putting a brush wet with paint on wet paper—we saw this in the wet in wet and dry on wet techniques. The wetter the paper, the softer the edge. You can also soften a hard edge by applying the paint and then, using clear water, brush the edge away. To get a rough edge, the brush is dragged lightly across dry paper with less water in the brush. Remember: You need to paint against something dry for a hard edge and something wet for a soft edge.

Now that we've looked at the four basic ways to apply color, let's see how

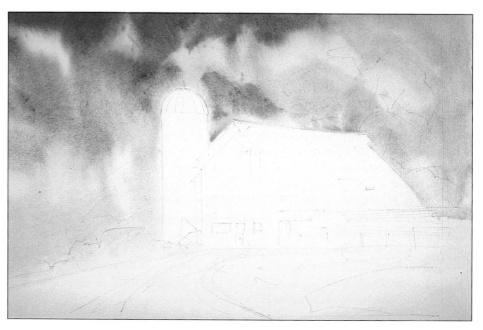

I wanted to work wet in wet, so I wet the sky area with clear water, working around the barn structures down to the horizon. I then washed in the three colors of the sky—French ultramarine blue, cerulean blue, and raw sienna.

While the sky area was still wet, I used the dry on wet technique to indicate the background trees and foliage. Indications of the trunks and limbs were scraped in with the brush handle while the color was still damp. You can see that the color stayed pretty much where it was placed but with diffused edges. The foreground was handled in the same manner.

they can be combined when you're working on a painting. Here I painted the sky using the wet in wet method and letting the colors run and diffuse the way they wanted to. I did the background trees and foliage with the dry on wet technique. First I loaded the wet brush with pigment on one side, then turned it over and laid the other side on a damp sponge to remove most of the moisture. I placed the color side on the paper and painted in the trees and background foliage. The barn was painted using wet into dry, and I finished up the details using dry brush. Please look carefully at how all these different techniques work together and think how you can apply the same methods to your own work.

After the painting had completely dried, I painted the barn structures wet on dry. Using a brush loaded with color and water, I started at the top of the barn, varying colors to get a nice color bounce—the effect of color reflected from the ground—but trying not to vary the values.

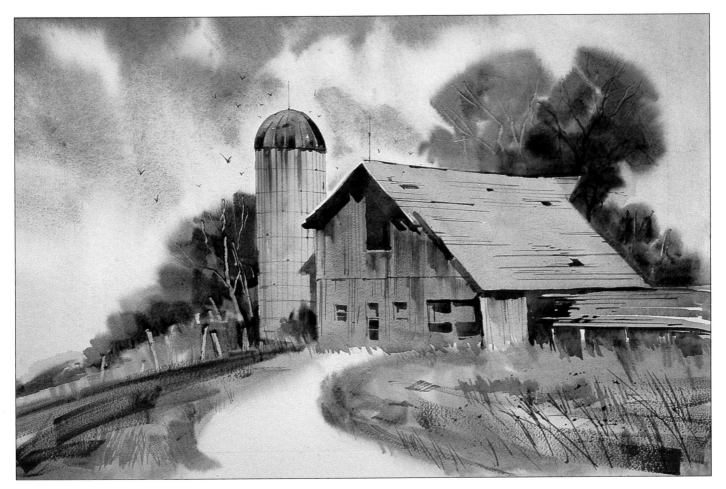

Untitled (13x19). After the foreground area was dry, the dry brush was used to indicate texture. To finish the painting, details were added to the barn and silo, and some weeds were added to the foreground. This painting was done using all four methods discussed on the preceding pages. (*Collection of Mr. & Mrs. John F. Clark*)

Washes

There are three basic washes, all variations on the wet on dry technique: the flat wash, the gradated wash, and the variegated wash. They are illustrated here, along with a painting incorporating all three. A painting all done with the same type of wash would be very boring. Consistency is great, but it's not everything. I just returned from a national show where the quality and diversity of paintings were just outstanding. There were, however, three or four works that were so bad I couldn't figure out why they'd been included. I asked a judge who had critiqued the show about one painting that I thought was just plain bad. He replied, "Yes, but it's consistent." I agreed; it was consistently bad all over.

Flat Wash

For practice, rule off three rectangles of about 5x8. Let's try a flat wash, the simplest of the three. First, mix a large puddle of a dark color. Don't be stingy; mix enough color so you won't run out. Dip a 1-inch flat brush into the puddle until it is fully loaded but not dripping. Very lightly draw the brush across the top of the rectangle. Your board should be tipped at a slight angle so the color will run down. A bead of color will form at the bottom of your stroke. This bead is important—the secret is to move this bead down and across the paper in an even value. Add more paint with each stroke so there is an even deposit of color on the paper. When you reach the bottom of the rectangle, soak up the excess color with a thirsty, damp brush.

Gradated Wash

Now try the gradated wash. It starts the same way as a flat wash with this difference: as you paint, you add more clear water with each succeeding stroke, until there is only a bead of clear water at the bottom. The color should blend gradually from full intensity at the top

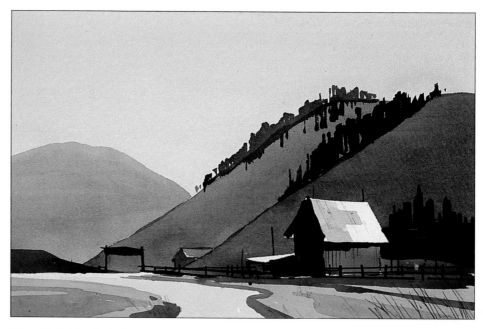

The Flat Wash. This demonstration was done entirely with flat washes. I attempted to keep the washes as flat as I could, trying to avoid any gradation at all. I would like to see you do similar paintings to practice these three basic washes. Practice will really help you understand these methods of applying color.

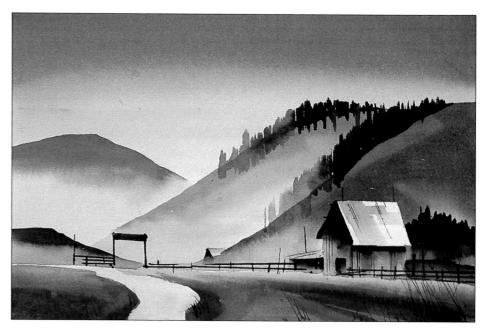

The Gradated Wash. This demonstration was done entirely with gradated washes starting with the sky darker at the top and gradually getting lighter working toward the bottom. The hills were done the same way, darker at the top and lighter at the bottom. The foreground is just the opposite—lighter in the distance and darker as it comes towards you. You can use gradated washes to create a feeling of mystery and depth, as I've done here.

to clear at the bottom. There is one thing to remember about all washes— you take what you get after the first pass. You can't go back and correct it without disturbing the even deposit of color already on the paper. Luckily, there are few instances when you would want a perfectly even flat wash or gradated wash.

Variegated Wash

The variegated wash is probably the most important to learn because it's the most useful wash. Mastering it will take you well on your way to banishing muddy colors and always having colors that really sing. The use of variegated washes keeps a painting from being boring. In fact, a good rule to follow is to vary your colors every two inches or so. Applying color with no variation isn't the smart way to paint.

Start with two colors and then try it with three or more. First, mix separate puddles of color on your palette, and starting at the top of your rectangle, pick up one color and lay it on the paper. Rinse the brush and pick up another color, laying it where you left off with the first color. Keep doing this all the way down the rectangle and you will get a beautiful interplay of colors diffusing into each other. It's important to mix the colors on the paper, not on the palette.

A large variegated wash makes a great underpainting. Once the wash is down, you can paint dry on wet for soft but controllable edges, or you can wait until it dries and paint over it using other techniques.

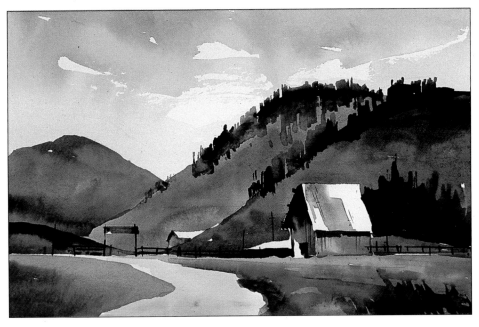

The Variegated Wash. In this demonstration I have tried to keep one value in an area but have also attempted to vary the colors in that same area. The sky was painted first using two colors—indigo blue and raw sienna. I painted directly on the dry paper, starting with the blue, working in some raw sienna, then softening some edges with clear water. To paint the hills, I mixed three puddles of color on the palette—indigo blue, burnt umber, and raw sienna—attempting not to vary the value while allowing the colors to mix on the paper. Remember, you get mud if you mix on the palette. You can see the play of warm colors against cool and cool colors against warm, as well as the exciting intermingling of colors on the paper.

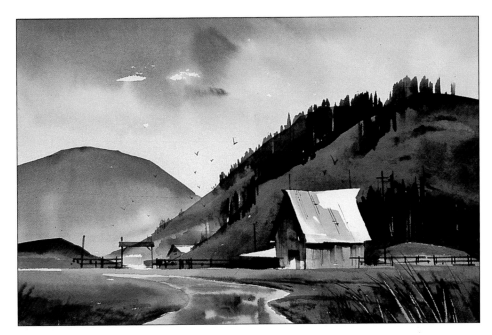

As you may have noticed, using only one of the three basic washes for an entire painting gets very boring—for both the painter and the viewer. So I've tried to combine all three washes to get a more exciting painting. I matched the different types of washes to what I wanted to achieve in this painting. I used a gradated wash for the sky that moved from being darker at the top left to lighter at the bottom right. I also used a variation of color in the sky, combining the gradated wash with the variegated wash. I used a gradated wash darker at the top and lighter at the bottom for the distant hills to add a sense of distance and mystery. I think this little painting has more interest because of the variety achieved by using a combination of the washes. Remember, variety is the spice of life.

Using Glazes

Glazing produces luminous optical effects that you can't achieve any other way. You create a glaze by placing one transparent layer of color over another. This will only work, however, if the first color is completely dry. Otherwise the glaze will disturb the underlying color, and the second color won't be transparent. Watercolors vary in their transparency or opacity; some, especially the staining colors, are ideal for glazes, while others are too opaque and will tend to obscure the underlying color.

 You apply a glaze much like the washes we examined earlier. Tilt your board about 15 degrees so that the wash runs down at the right speed. If you tilt it too much, it will run too fast; tilt it too little and it won't run at all. Experiment with the angle to see what works best for you. All the washes in the demonstration below are gradated washes, so you can see how important it is to learn how to do them.

 Glazing is one of my favorite ways to paint. I like to paint an underpainting using the wet in wet technique and then let it dry completely. Next, I use glazes to build up my subject matter. I do this either by painting the subject itself or by painting around it (negative painting). I often use a glaze that is opposite in color temperature to the underpainting for variety and contrast. For instance, if your underpainting is warm, lay a cool glaze around the subject and then soften the outer edge of the glaze to create a vignette effect. You can keep building these glazes up, until you have established your subject matter and at the

In this demonstration of a desert sky, I have used four colors in this order: alizarin crimson, Winsor blue, raw sienna, and French ultramarine blue. At the left of the painting, the arrows show the direction the glazes were laid, and the numbers indicate the order in which they were put on. Keeping my board at about a 15 degree angle, I completely rotated the painting for each glaze, beginning my first wash with painting upside down. I was careful to let each wash dry before starting the next to keep all my glazes fresh and transparent. See how I did each as a gradated wash, starting with the darkest color and working to clear water at the bottom.

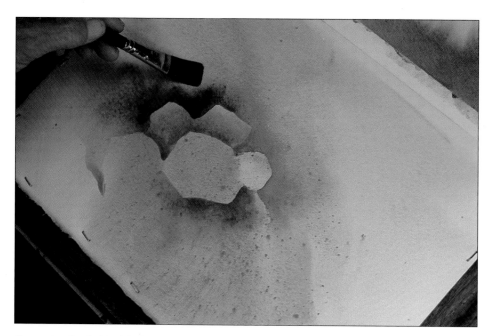

Once that had dried, I decided to use negative painting to build up my subject. Using a little darker version of the same colors, I brushed around areas I thought would make good rocks. While the color was still wet, I brushed away the outer edges with clear water. I repeated the process several times, applying a color and washing away its outer edges until I had built up several rocks and got the dark value I wanted.

same time built to the value you wanted. Remember, you must wait until the previous glaze is dry before adding another. To avoid muddying the color, use strong colors for the glazes. Applying too many weak glazes produces dull colors (like waxy build up!).

Another way to use glazes is to lay a very pale tint of color over one area of your painting or over the entire painting. A pale wash can change the color harmony of a painting and also change the mood and atmosphere dramatically. Sometimes, if I feel a painting isn't "hanging together" right because of a lack of color harmony, I will place a glaze over the entire painting—the colors are pulled together because they now share a common element. Other times only a small area of the painting will need to be glazed.

Using a pale glaze over large portions of a painting or over the entire painting can be a useful technique for producing some very creative effects or for rescuing a painting that has gone astray. Glazing is another option that the smart painter keeps in mind. Since it can be difficult to predict what a painting will look like when it is glazed, it is a good idea to practice this technique on your "disasters" and keep the results as a reference.

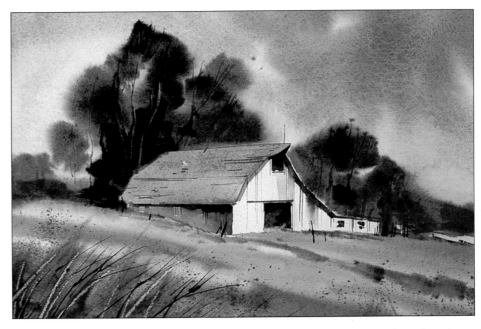

I did this painting for the express purpose of laying various glazes over it to show how they can change the color and mood of a painting. The painting itself was done with French ultramarine blue, cerulean blue, raw sienna, burnt umber, and burnt sienna.

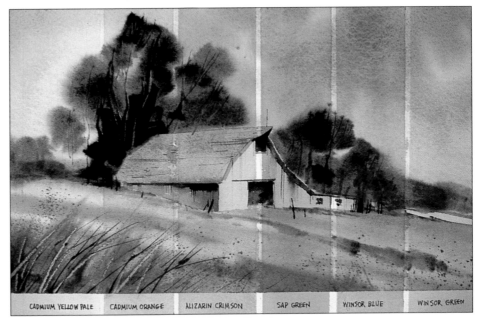

| CADMIUM YELLOW PALE | CADMIUM ORANGE | ALIZARIN CRIMSON | SAP GREEN | WINSOR BLUE | WINSOR GREEN |

Now let's see how glazes can change this painting. Looking at the sample glazes from left to right, you see one done with cadmium yellow pale, one with cadmium orange, one with alizarin crimson, one with sap green, one with Winsor blue, and one with Winsor green. You'll notice that the first three glazes do not change the color balance too much, but the two greens and the blue make a very definite difference.

Fancy Stuff

Many students are afraid to make bold statements when they paint because they're too afraid of making a mistake. So they end up with pale, textureless, rather bland-looking paintings. Part of painting smart is being willing to take risks when you paint once you've achieved some mastery of the fundamentals of applying color first.

I find it great fun to play around with different methods of texturing watercolors. There are no rules on the subject, so you can let your imagination run wild and experiment with anything you can get your hands on. Who knows? You may be the one to come up with something unique.

The following pages will show you just some of the many ways to spice up a painting by adding texture or by lifting out areas. It's impossible to cover all of the creative methods for texturing and lifting in one book, so I've tried to choose ones that cover a lot of bases. Most of the methods of texturing and lifting were developed by the "California School" of watercolor. Two of the best artists of that school—in my estimation, anyway—are Rex Brandt and Robert Wood. Study their paintings if you want to learn more about these techniques.

Using these methods of texturing and lifting judiciously can take a painting out of the ordinary. Using too many methods in one painting can make it look "tricky." Painting smart is knowing when to say when.

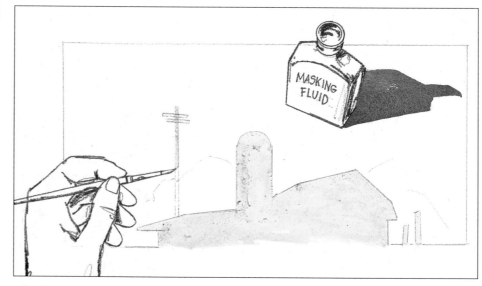

Liquid Frisket. If you want to paint a nice, juicy sky in back of a complicated subject, block out the subject area with liquid frisket. Here's a tip to make it easier to clean the frisket out of the brush when you're finished. Wet your brush and put some soap on it before you pick up the frisket. I only use liquid frisket when absolutely necessary because it leaves hard edges on the painting.

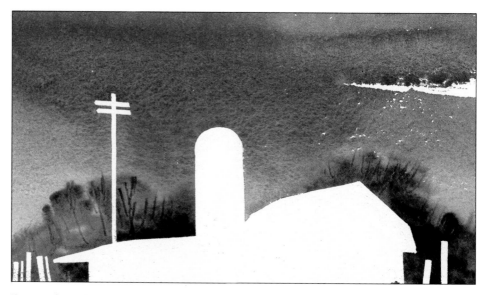

Removing the Frisket. Be certain the painting is completely dry before using a pickup to remove the frisket. You can buy a rubber cement pickup in an art supply store or make one yourself by pouring about a tablespoon of rubber cement on a clean, flat, nonporous table top. Let it dry and ball it up with your finger. If you don't use one, chances are you will smear the colors.

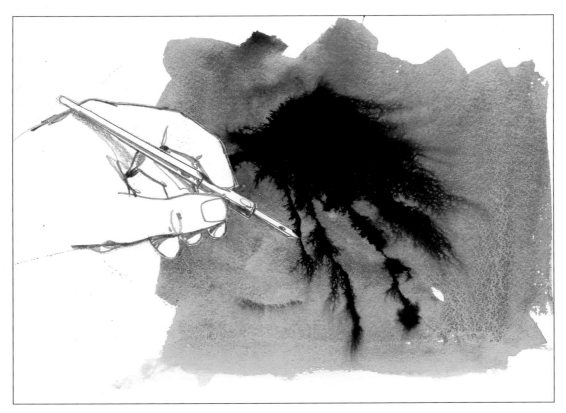

India Ink. Some very interesting effects can be achieved by dropping India ink into wet color. You can also use a crow quill pen with ink and draw lines into the wet color. You can control the dispersion of the ink by controlling the wetness of the paper. The drier the paper, the less the ink will diffuse.

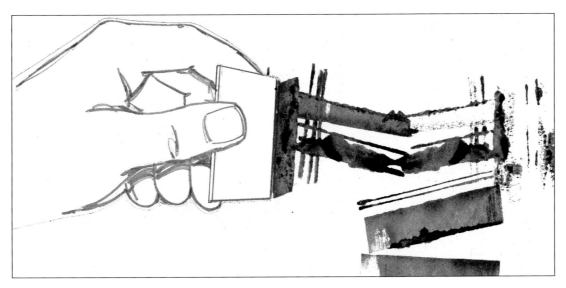

Stamping. This sketch shows stamping with a piece of mat board. There are many things you can stamp with a razor blade, an old plastic credit card, or something with a similar edge. Stamping gives you a different feeling than you'll get with a brush—it seems to have more character and texture. You can use stamping to indicate the boards on a barn, fence posts, telephone poles, and other similar subjects.

Wipe Outs. In this example, I have masked out the area that I want to lift with white artists' masking tape. After the area is masked off, I use a small natural sponge that I've cleaned and squeezed out to rub the area vigorously. Then I blot it with a tissue.

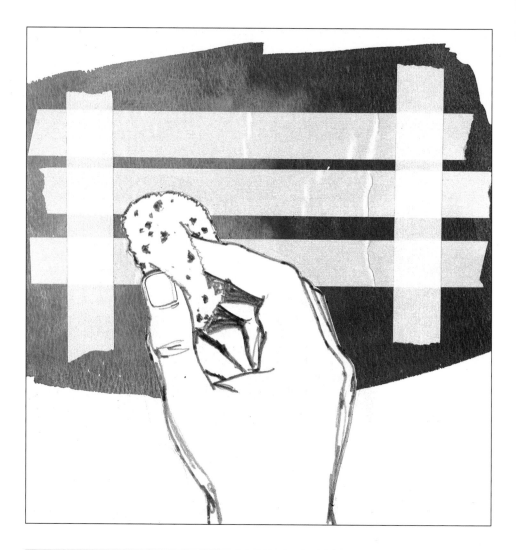

Remove the tape after your wipe out has dried, and you should have a nice, clean lift. This lift was done on 140-pound Arches cold pressed. Paper lifts done on Crescent Watercolor board will lift much easier and will be much whiter. The paint rides on the surface of the board and doesn't soak in as it does on the paper.

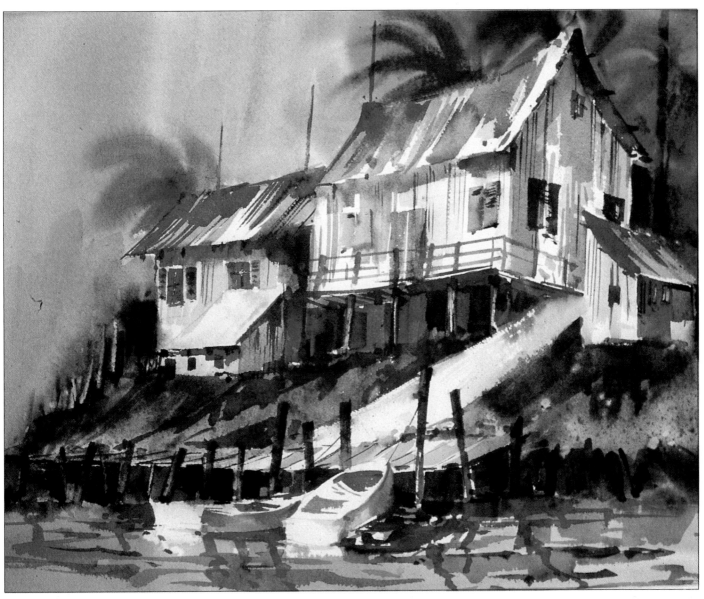

A Day in Hope Town (20x24). This painting illustrates some of the techniques we've just discussed. The path is a good example of wiping out, and the pilings on the pier were done by stamping. I chose these techniques because they were right for my subject matter. You won't use every special trick you know in each painting; it's more important to know when to use which trick to get a particular effect.

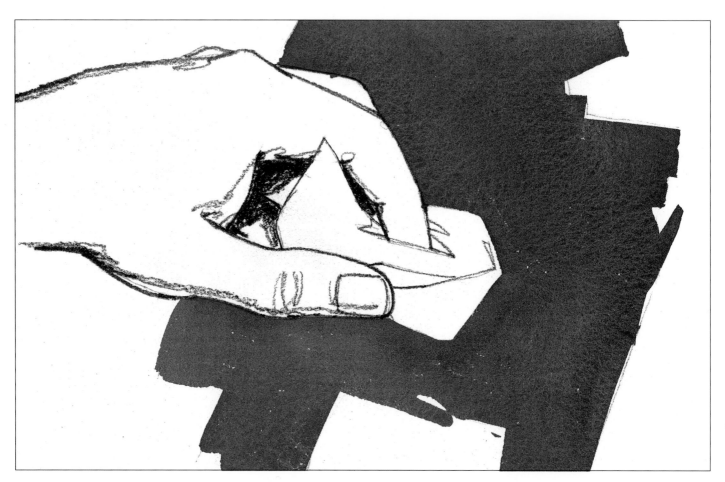

Lifting with a Tissue. Lifting is an excellent way to texture or modify the value of a passage you have already painted. I find it so useful, in fact, that I usually paint with the brush in one hand and a tissue in the other.

Now you can see the result of lifting. Experiment with lifting to see what effects you can create. Although I prefer to use a dry tissue, you should try a damp tissue as well to see the different results. (Damp tissues are nice for clouds, for example.)

Sponge. Here I am using a small natural sponge, which comes in handy for indicating leaves on trees, especially the outer leaves. It's also good for doing ground scrub and especially nice for sage brush.

Blotters. The kind of blotter you buy at a stationery store is good for lifting areas that are wet or even just damp enough to be absorbed by the blotter. I have used blotters for lifting roof areas and other similarly shaped areas to reclaim my whites.

Plastic Wrap. The area where I'm going to put the trees has been painted with fairly heavy pigment. Then I place a piece of plastic wrap over the area while it's still wet.

If you wait until the colors are completely dry to lift the plastic, you will get sharp and crisply defined results. If you move the plastic before the colors have dried, the effects will be more diffused. Try it both ways. I think you'll like the results.

Scraping Out. After doing an underpainting, I used a credit card to scrape away areas. You can also use razor blades, cardboard, and many other items. Scraping out is especially good for texturing rocks, fence posts, mountains, and buildings.

Spattering. One of the most effective ways to spatter is with a toothbrush. Load the brush with color and, holding the brush upside down over the painting, pull your thumb across it. The spatter will fall on the painting. Be careful not to get too much liquid in the brush, or you'll get large droplets. Spattering is good for texturing foregrounds and old wood. It's also excellent for pulling colors together in an area. Make sure you spatter color in while the paper is still wet or damp; the spatters will diffuse in the wet areas and bring the whole into harmony.

Morning's First Light (13x20). I've attempted to use as many of the techniques demonstrated in this chapter as possible. Although I normally wouldn't do this, I feel the painting holds together fairly well. You can see a little use of the sponge at the outer edges of the trees at the upper right. The masts were stamped on with a piece of mat board, as were some of the posts in the foreground. I did some scraping with a razor blade in the foreground and did some more with the squared-off end of a brush handle to get the two posts to the left of the stern.

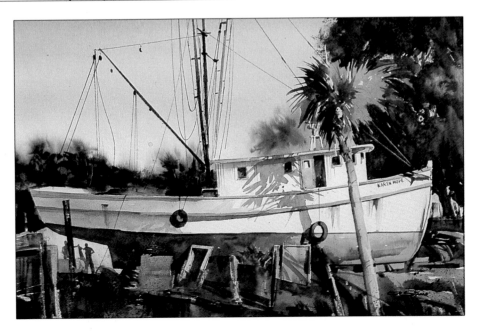

Brush Spattering. Another method of spattering is to load a brush with color, then tap the brush sharply across your finger, as you see here, or across another brush. The spatters will be much larger than those made with the toothbrush. These are good for ground clutter in the foreground.

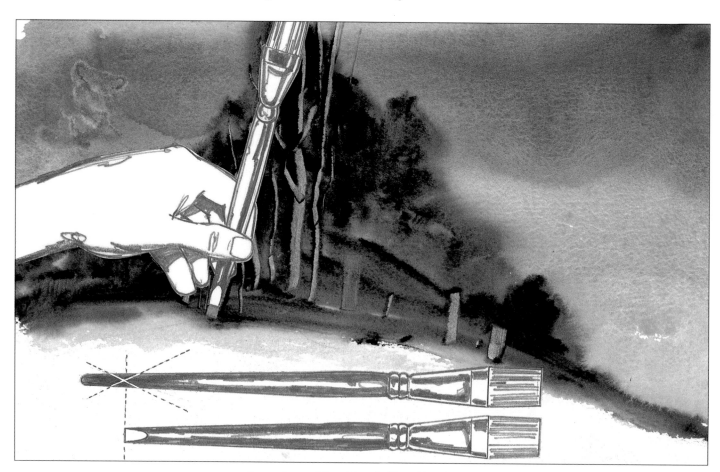

Scraping with a Brush Handle. Scraping with the squared-off end of a brush handle is one of my favorite techniques. I find it very useful for indicating tree trunks, branches, fence posts, boards on barns, and many other objects. Some brushes come with prepared ends, but if you don't have one of these, simply take a knife and square off the end of a brush as you see here. You will find many uses for this technique.

Salt. While the underpainting was still wet, I dropped salt into the area. Here I have used regular table salt, which works fine for me. Some people prefer to use a larger grain salt such as sea salt or kosher salt. The salt can be sprinkled on, as you see here, or thrown on at an angle for different effects.

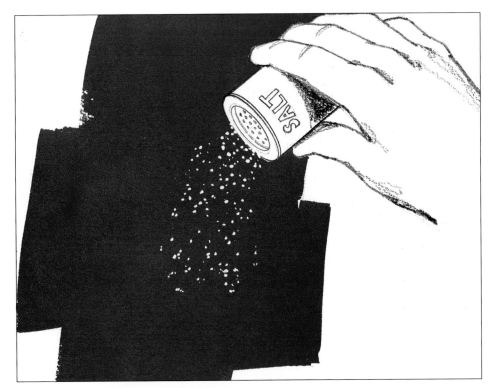

Here you can see the results of texturing with table salt. Don't get carried away; I have seen some paintings that look like exercises in salt painting. Used sparingly and with care in the right places in the right amounts, salt can be very effective. If the grains are too close together, you get ugly, irregular spots instead of the almost starry pattern you want. Remember, painting smart is knowing when to quit.

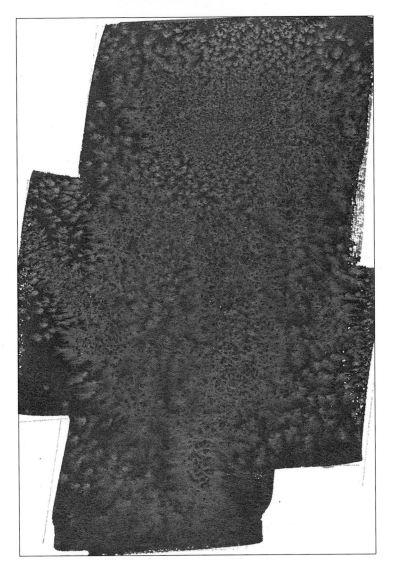

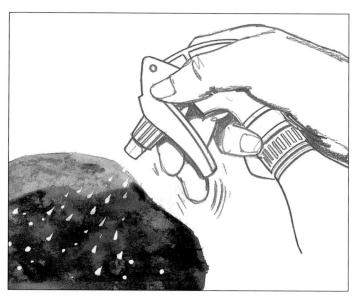

Spraying and Lifting. In this demonstration I'll show you how to spray water back into your painting and lift the rewet areas with a tissue. Although we're creating rocks in the picture, you can also use this method to make trees, grass, or even to alter your skies. Here I have painted an area that would be a rock with quite heavy color, using burnt umber, burnt sienna, Winsor blue, and a touch of olive green.

After letting the colors set for a minute or so, I hold the spray bottle above the area and spray droplets into the color. Only practice will help you determine the proper time interval before using the spray.

After you spray, lightly lay a tissue over the area. Sometimes I use a fingernail to score a mark on the tissue or will press a little harder with the backs of my fingers in places. Although I wish I could tell you exactly how to do this to get the results you want, that feeling for what and how much to do will only come with practice.

Lift the tissue straight up from the painted area and, behold, you can get the most beautiful colors for rocks. You can work back into these areas after they're dry to indicate cracks and some shadow planes. I also use this method for doing background forests.

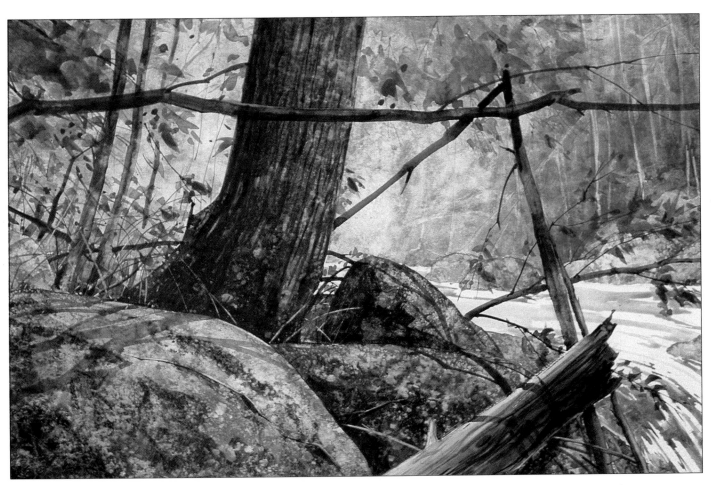

Mountain Mood (20x28). Here's a finished painting in which you can see the beautiful effects you get from the spray and lift method. This is the Cranberry River in West Virginia, where I used to dry fly trout fish. (*Collection of Mrs. Alyse Hallengren*)

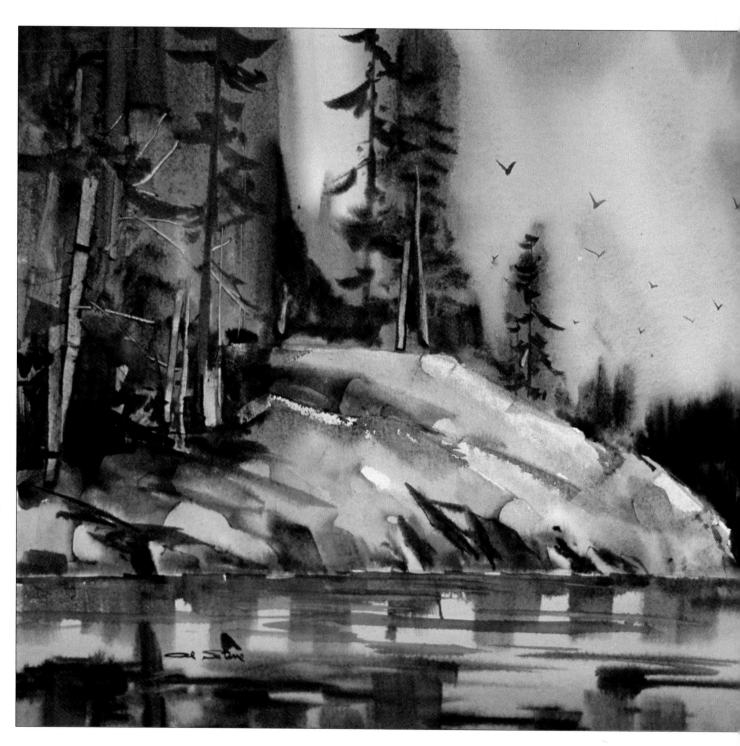

Lake Reflections (13x19). This painting was done with just three colors—indigo blue, raw sienna, and burnt umber—but I'll bet you couldn't tell that just by looking at it. This is a good example of the wide range of colors you can get from a limited palette. It really is easier to paint with three colors than with six or seven, and you'll find it much simpler to maintain color harmony throughout the painting.

CHAPTER FOUR

Using a Limited Palette

Many students load up their palettes with all the pretty colors they can and then attempt to use all of them in their first painting. Soon they feel overwhelmed and confused by color. Their paintings become muddy, they have difficulty matching the colors they see, and they waste paint. Although my palette holds twenty colors, I use only a limited number of colors for most of my paintings. Limiting your palette actually opens up unlimited opportunities for color harmony and control.

Limiting your palette offers several advantages. First, using only a few colors in the beginning gives you the chance to learn what those colors can do. Limiting your palette certainly won't limit how much you can learn about color. Second, a limited palette makes achieving color harmony easier. You will be using colors that have a strong familial resemblance, because they will share the same "parent" colors. Color balance is easier to

attain when you are using a few related colors than when you are using many different colors. Third, a limited palette encourages you to make the most of value pattern and contrast, playing light against dark. You can't rely on lots of pretty colors to save a painting that has weak values. Finally, working with a few colors enables you to concentrate on playing warm against cool colors, saving your whites, and using strong colors against grays.

In this chapter, you are going to see the amazing results that can be obtained with a limited palette. We will start with just two colors, and I think you will be impressed with what can be done. I suggest you do several different paintings with just two colors.

Then, when you are comfortable with two, add another color and do several more studies. And when you're comfortable with three, try four, and so on, adding one color at a time.

Making Your Colors Sing

Color is the first thing that attracts viewers' attention, and the first thing that viewers respond to when they see your painting. I want to show you how you can make your colors really sing. It might sound odd at first to describe color this way, but brilliant color is to the eye what a clear and resonant singing voice is to the ear.

Color harmony is an important concept when you're planning the colors for a painting. It is achieved by balancing a dominant hue with its opposite (or complementary) color and adding accents of discordant colors. Color harmony begins with the selection of one hue that will be the dominant, or most used, color in the painting. If I'm painting a landscape, green may be the dominant hue, but I can mix many different greens from the pigments on my palette. Colors closely related to green, such as blue green or yellow green, add variety but don't conflict with the green.

However, a painting with only greens and colors closely related to green would get boring very quickly. So the painting needs to be relieved by a color that is the dominant color's opposite—in this case, red—but the red must be carefully balanced with the green. You want just enough to keep the green from getting dull, but not so much that it fights for the viewer's attention. Perhaps in a landscape with lots of greens, a small red flower would break the monotony.

Finally, to achieve very pleasing color balance or harmony, we need to add a bit of some colors. In our example, we have the dominant color, green, and the colors closely related to it balanced by the complement, red. A

little orange and purple would add slightly discordant but entertaining notes to the painting—a little spice, in other words. So you can see, color harmony is the balance of a dominant color that unifies the painting with its opposite, which adds excitement, enhanced by touches of the other hues.

The play of contrasts is one of the most important keys to successful watercolor, but it doesn't happen automatically. You have to think about it! It is important to develop the habit of looking at your painting in terms of light and dark, cool and warm. In fact, learning to do this is one of the smartest skills you can have. One of the biggest payoffs of working with a limited palette is the opportunity to really concentrate on making your colors work in this way. When you start to think about whether a color is light or dark or whether it's warm or cool, you are really on the road to painting smart.

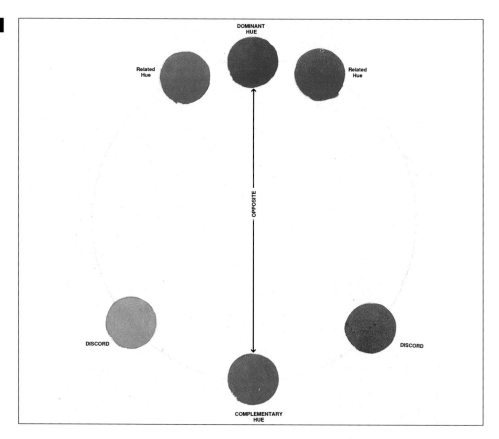

This color wheel shows the relationships of the dominant color and close neighbors with its opposite color and two discordant colors. Using colors in the right amounts will help you achieve color harmony in your painting. Try making some of these color wheels with different dominant colors to help build your feel for color harmony.

Beautiful Grays

I don't think of gray as being merely the mixture of white with various amounts of black. Such a gray is very dull. Instead, I think of grays as all the rich and subtle neutrals that I can mix from the bright and intense colors on my palette. The basic formula for gray is to mix a pure color with varying amounts of a color opposite in hue or color temperature. How much or how little of the opposite color you use determines the special character of the resulting gray. I can mix warm or cool grays or green, brown, or purple grays just by varying the basic formula. Some of my mixtures include French ultramarine blue, which makes appealing grays when blended with earthtones such as burnt sienna and burnt umber. Van Dyke brown, a brown even deeper and darker than burnt umber, makes lovely grays—some warm and some cool, depending on how the brown is mixed with French ultramarine blue; I especially like this combination for creating a background forest in snow scenes. Winsor green mixed with cobalt violet will give you grays that sparkle (and lovely mauves, too). And if you need a dark, almost black, color that still has a lot of life, mix Winsor green with alizarin crimson.

Of course, you should read about color and work with color charts, but the best way to learn about color is to actually experiment with many different combinations. Working with a limited palette, as you'll see, is an excellent way to learn color through experimentation and practice. In the rest of this chapter, we'll look at what you can do with just two, three, four, or five colors.

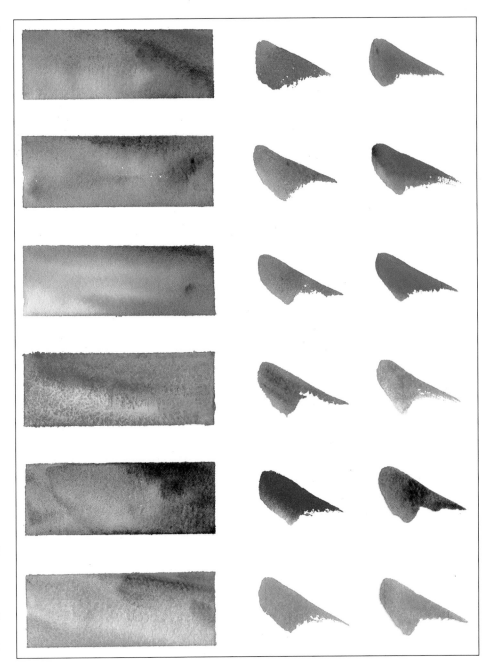

Greys:
1) Winsor blue and burnt sienna
2) Winsor green and burnt sienna
3) Winsor green and alizarin crimson
4) Winsor green and cobalt violet
5) French ultramarine blue and burnt umber
6) Cerulean blue and raw sienna

Using Color Guides

I make up color guides to test the color schemes I plan to use in my paintings. These color guides consist of swashes of the various colors I think I want to use, layered and grouped so I can see how they actually work together.

What's a color scheme? It's the colors you choose to establish an overall mood for your painting. When I choose my colors to create mood, I consider the time of year and the amount of available light, from bright sunlight to heavy overcast. For example, I might use lighter, warmer colors (such as yellows or oranges, green with a tint of yellow, or gray with a hint of red) for a sunny scene or to create a happy mood. But it would be foolish to paint a stormy sky with warm, happy colors. Instead, I'd choose cooler, darker, more somber colors (such as green, blue, purple, or gray) for stormy scenes. I can remember getting caught in a storm with waves running up to seventeen feet while sailing across Lake Michigan with friends. It was wet, gray, and somber, but one of the most beautiful sights I had ever seen although I never want to repeat the experience.

You will occasionally need to vary the color scheme in a painting. If you were painting a forest scene, for

FRENCH ULTRAMARINE BLUE,
ALIZARIN CRIMSON, RAW SIENNA,
BROWN MADDER ALIZARIN

FRENCH ULTRAMARINE BLUE,
RAW UMBER, BROWN MADDER
ALIZARIN

FRENCH ULTRAMARINE BLUE,
CADMIUM RED, BURNT UMBER

FRENCH ULTRAMARINE BLUE,
RAW SIENNA, BROWN MADDER
ALIZARIN

FRENCH ULTRAMARINE BLUE,
BURNT SIENNA, WINSOR GREEN

FRENCH ULTRAMARINE BLUE,
WINSOR GREEN, RAW SIENNA,
COBALT VIOLET, ALIZARIN
CRIMSON

This is a series of color guides showing the exciting colors you can get with just three to five colors. This panel used French ultramarine blue as a base—the first color I put down into which I mixed all the others.

example, and wanted to communicate a sense of moodiness or brooding, it would be a mistake to use warm colors in the background. Warm colors would destroy the depth and mystery required to convey such a near mystical feeling.

I also use aerial perspective to establish distance, making distant objects bluer and foreground objects warmer and darker.

I save the color guides that I do and refer to them constantly. After you have developed many color schemes of your own in this way, you too will have a storehouse of information ready to solve your color problems. For instance, you could look at one of your color guides, select a beautiful, lively gray, and determine if it should be placed next to a stronger warm or cool color.

As I have illustrated in the sample color guides you see here—using from three to five colors in each—great color variation is possible even with a limited palette. Again, having only a few colors to choose from simplifies the process of achieving color harmony. Experiment with your own selections of color, but remember that you should have at least one warm and one cool color playing against each other. By contrasting warm with cool, dark with light, and grays with stronger colors, you can make your watercolors truly "sing"!

CERULEAN BLUE, CADMIUM YELLOW PALE, BURNT SIENNA, FRENCH ULTRAMARINE BLUE, CADMIUM RED

CERULEAN BLUE, COBALT VIOLET, WINSOR GREEN, BURNT SIENNA, ALIZARIN CRIMSON

CERULEAN BLUE, RAW SIENNA, BURNT SIENNA, FRENCH ULTRAMARINE BLUE, ALIZARIN CRIMSON

CERULEAN BLUE, WINSOR GREEN, BURNT SIENNA, CADMIUM RED

CERULEAN BLUE, RAW UMBER, BURNT SIENNA, FRENCH ULTRAMARINE BLUE, CADMIUM ORANGE

CERULEAN BLUE, ALIZARIN CRIMSON, BURNT SIENNA, FRENCH ULTRAMARINE BLUE, WINSOR GREEN

This time I used cerulean blue as the base for a series of color guides. I added some French ultramarine blue only to achieve darker color.

Two Colors

Let's start with two colors. Working with just two colors frees you to think about saving your whites, getting good value patterns, and creating color harmony. Not all two-color combinations will work this way; one color should be cool and the other warm. The cool color will be useful for painting atmospheric conditions and skies, particularly the cool tones in the distance. The warm color will evoke the warmth of the earth in the foreground. French ultramarine blue and burnt umber, for example, can give you a range from blue to gray to brown in both warm and cool tones.

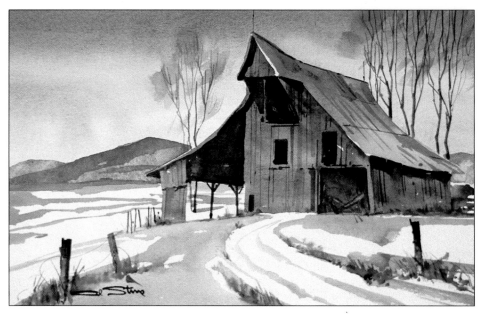

January Surprise (9x14). In this painting I used only French ultramarine blue and burnt umber, mixing cool color mixtures for the sky and the distant mountains and reserving the warmer colors for the barn, posts, and grasses in the foreground. I think you will agree that this painting stands on its own without another color.

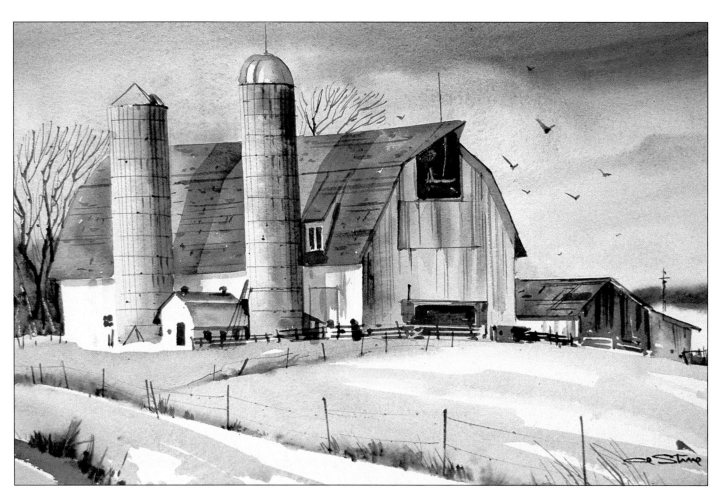

Winter White (9x14). This painting was also done with French ultramarine blue and burnt umber. Again I used the blue for the sky but added a little burnt umber at the top. The warmer tones I saved for the barn and the strip of grass along the fence.

Using Three or Four Colors

After you have done a number of paintings with the two-color palette, add one more color to ultramarine blue and burnt umber. Since we could not mix a green with those two colors, we'll add Hooker's green dark to the palette. This green will provide green for leaves and shrubbery, expanding the range of landscape subjects we can paint with just a few colors. Adding green to the other two colors will make them more interesting as well, and add more excitement to the painting.

To avoid the muddy look that mixing colors on the palette can create, I make separate puddles of the three colors on my palette and do the mixing on the paper. Often, I let the colors intermingle but not blend. By the way, I never use Hooker's green dark directly from the tube; I modify the color by adding other colors, as in this palette, to get more pleasing greens.

Since I began this book, I've been using a three-color palette of indigo blue, raw sienna, and burnt umber, which gives a wide range of warm and cool grays, beautiful greens (without using a green, unlike my demonstration palette), and good, punchy darks. Indigo blue looks almost black when pressed from the tube; remember that it makes a lovely color when diluted with water.

As you can see, you can paint almost anything you want with the three colors in our palette. However, if you wanted to paint a red barn or capture the colors of an autumn afternoon, you would be out of luck! So now it is time to add cadmium red. While you can do a lot with the colors we've worked with so far, different combinations can give you better results.

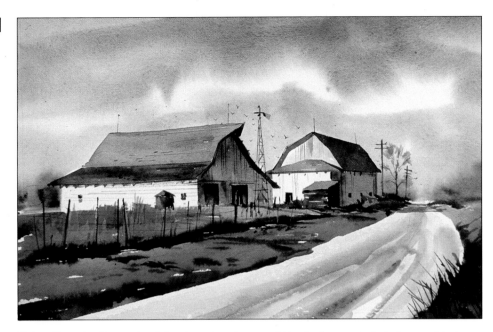

Using French ultramarine blue, burnt umber, and Hooker's green dark, I was able to capture the green of the field. Adding a contrast color, like the green here, puts some spice in your painting. Look at the impact I've gotten by adding green to the sky colors on the buildings.

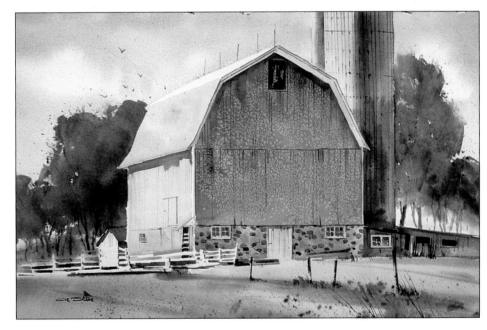

Sunlit (13x20). In this demonstration, I used the same three colors as in the previous demonstrations adding cadmium red because I wanted to have a red barn. I painted the light side of the barn using a very light wash of cadmium red, warming the color up at the bottom with a hint of burnt umber to show the reflections of the earth. On the shadowed face of the barn, I used cadmium red with French ultramarine blue and while still wet, I sprinkled salt into it to get some added texture. I brushed in a mixture of cadmium red and burnt umber on the foreground area.

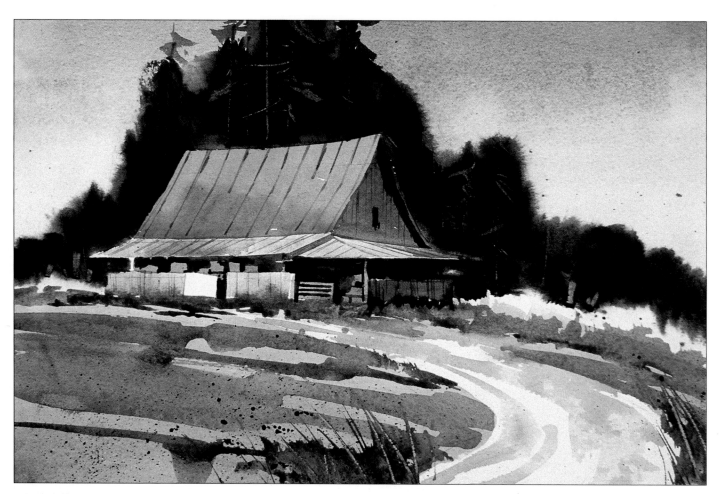

Five Colors

Once you understand the advantages of working with only a few colors and learn how to make the most of them, you will begin to view a palette crowded with colors as a burden, not an opportunity! Now that you have worked with four colors, it's time to add one more. Since there is a limit to your ability to match exactly the colors that you see with only five colors on your palette, it becomes essential to think in terms of light against dark and warm against cool. If you make the values and color temperatures work right, your actual color choice is of secondary importance. However, the reverse is not true: The painting won't work, no matter how closely you've matched the colors on the painting to what you see, if the value and temperature contrasts aren't right.

I'm going to add a little variety to my palette, too. In this painting, I have attempted to show that you can retain color harmony and a strong play of light against dark and cool against warm using five colors. The light, warm roof of the barn contrasts the cool, dark colors of the background forest. The warm foreground is overpainted with cool shadows; darker and warmer weeds are, in turn, painted over the cool shadows. Throughout the entire painting I worked cool against warm and dark against light.

For this painting, I used French ultramarine blue, cerulean blue, raw sienna, burnt umber, and brown madder alizarin for variety. I began at the top with a mixture of the two blues, then went to cerulean blue only, and finished with a pale wash of raw sienna. While the paper was still damp, I painted in the dark forest using the French ultramarine blue and burnt umber. I painted the first color on the foreground—a cool, grayed raw sienna—while the forest area was drying. The roof of the barn was painted with a mixture of burnt umber and brown madder alizarin after the background trees had dried. The warm foreground grasses were painted with brown madder alizarin and burnt umber.

Applying the Limited Palette

The paintings you'll find on this and the following pages show what can be achieved using only four to six colors at a time. They demonstrate just a few of the palettes I have used in my paintings, so let these be a jumping-off point for your own work with a limited palette. Add to or subtract from these colors and make up your own color schemes from the color guides that you have created. Have fun painting a bunch of 4x6 watercolor roughs for practice.

Don't stop with just these small paintings, however. Painting smart is not only learning by doing, but also learning from what you have already done. Save your practice paintings and study them. Decide what you like or don't like about them; think about what you might do differently the next time. Take the ones you feel are gems and see what colors you like and how they work together. Then take those colors and try them out on a larger painting. Building on what you've already learned will help take away that old bugaboo of not knowing what colors to use.

A Warm Snow Scene. (*Alone in the Snow*, 9x14). I used a palette of burnt sienna, burnt umber, cerulean blue, and Payne's gray to create a completely different mood simply by warming up many of my colors. Here I've painted my clouds with Payne's gray and made them warm by adding burnt umber. I used cerulean blue and burnt sienna to paint the snow. The large foreground tree is Payne's gray, burnt umber, and Hooker's green dark. (*Collection of Laura K. Hollenbeck*)

A Cold Winter Snow Scene.
Compare this scene with the one you saw on page 55. I used a cool palette for this painting: raw sienna, Payne's gray, French ultramarine blue, cerulean blue, and Hooker's green dark. In the earlier painting I used burnt umber and Payne's gray for warm gray clouds. To get cool gray clouds here, I've used French ultramarine blue with the Payne's gray. The background trees and the pine tree were done with Hooker's green dark, Payne's gray, and raw sienna. I repeated the same colors in the fence but added more raw sienna to warm up the mixture.

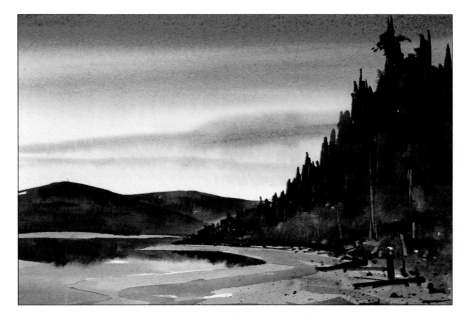

A Sunset Scene. I wanted a warm palette for this sunset, so I chose raw sienna, cadmium orange, and burnt sienna. For dark, cool contrast notes, I added cerulean blue and Hooker's green dark. Over a pale wash of raw sienna, I painted the sky with a mixture of burnt sienna, cadmium orange, and a little cerulean blue, beginning at the top. The distant mountains were painted with cadmium orange, burnt sienna, and Hooker's green dark. I used the same mixture for the closer trees but made it darker in value and warmer, since they're nearer to the viewer.

A Fog Scene. Here I used raw sienna, Payne's gray, cerulean blue, Hooker's green dark, burnt sienna, and cadmium yellow pale. Using six colors for this painting helped me gain a greater range of grays, blues, greens, and browns. The painting is rather somber but ethereal, so I've let cool colors predominate with only gentle warm notes. The colors are still closely enough related to preserve color harmony throughout the painting. I let my colors gradually warm as I moved from the distant headland to the foreground rocks.

A Coastal Scene. (*Pacific Coast*, 9x14). With my palette of raw sienna, Payne's gray, cerulean blue, alizarin crimson, and burnt umber, I'm going to get a lot of warm-cool, dark-light contrasts. The sky was painted using a pale wash of raw sienna, the clouds with Payne's gray for contrast. I painted the distant formations and the beach with raw sienna, Payne's gray, and cerulean blue. The foreground rocks were painted using the same colors as the other rocks, but I warmed up the mixture to make them appear nearer to the viewer. (*Collection of Laura K. Hollenbeck*)

A Sunlit Beach. Here's a warm, happy painting done with a palette of cerulean blue, raw sienna, burnt sienna, and French ultramarine blue. Although I've included plenty of cool and dark notes for contrast, even those are slightly warmed to keep them in harmony with the rest of the painting. For example, I painted the lighthouse with French ultramarine blue and cerulean blue, using raw sienna to warm the shadows slightly.

A Scene with Autumn Colors. For this painting, my palette consisted of Hooker's green dark, cadmium red, burnt sienna, raw sienna, and cerluean blue. The trees were painted next with various mixtures of burnt sienna, Hooker's green dark, raw sienna, and cadmium red. The water was done with the colors used for the sky; I used the same colors as the trees for their reflections in the water. The darker reflections were added with deeper values of cerulean blue and raw sienna.

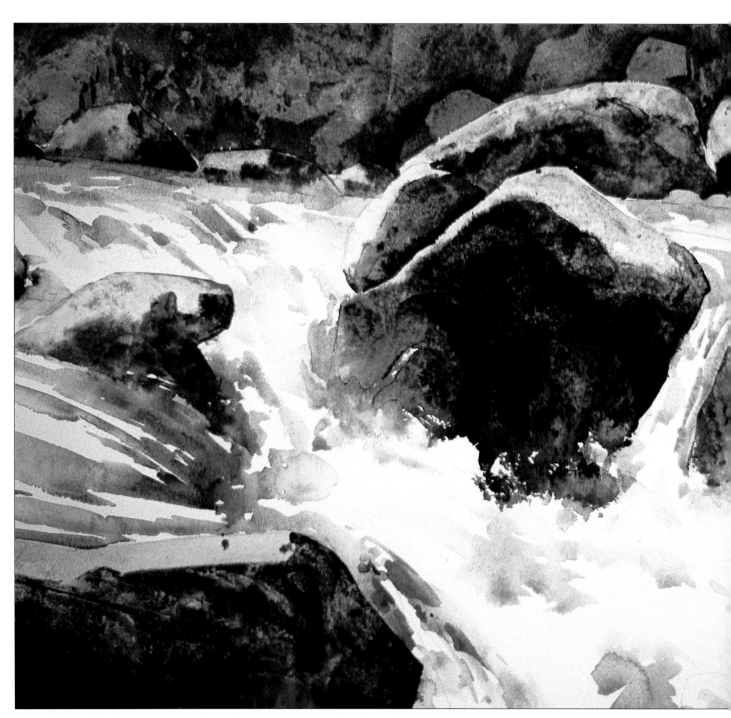

Mountain Rapids (13x20).

CHAPTER FIVE

Practice Makes Perfect

I know watercolorists who won't attempt a painting that contains an element they can't paint well. Please don't fall into that trap! Sometimes we give up on a challenging project because we think we can't do something, when in fact we're just not tackling the problem with the right attitude. We fear that, because we don't learn how to paint a subject right off, we lack the talent to master it and eventually give up on it completely. Painting well is more than a matter of innate ability; it's also a matter of learning skills. Do you remember the first time you tried to roller skate or ride a bike? I'll bet you didn't give up when it went badly, because you didn't think you had to be born with a talent for roller skating. You have to view your efforts to paint in the same way.

Concentrate on painting smart, which means being willing to practice your painting till you get it right. Work on the elements that give you trouble, not just on the elements that you enjoy painting. If you hang in there, you'll find that you can not only lick these problems, but you'll eventually look back and say, "Gee, that wasn't so tough after all." You'll finally reach the point where you don't even have to think about your brush or colors; they will just seem to be an extension of you. You'll feel confident that you can paint anything. And that's a goal worth working toward.

If you are having a problem painting certain elements of a watercolor, don't despair. By thinking smart and practicing on your particular problem areas, you can master these elements. I can recall having difficulty some years ago painting water and reflections. So I decided to concentrate on these elements for at least a year. Now, I didn't spend one whole year painting nothing but water scenes—that would be too boring! But I made an effort to choose as many subjects as possible that would let me practice painting water and reflections.

Although the more we work at our craft the more we grow as artists, it's still possible to benefit from someone else's experiences. In this chapter I'll share with you some of what I have learned over the years. I hope my experiences may help you avoid some of the pitfalls and mistakes that I have made in painting watercolors over the years. The most important thing I've learned, though, is that all you need to improve your painting is the desire to improve combined with an open and inquisitive mind. Begin by really looking at different elements, such as skies and clouds. Get to know them, let them become a part of you. It would be impossible to cover thoroughly all of the elements of a painting, so I'll concentrate on those that seem to have given my students the most trouble over the years.

Skies and Clouds

We're going to discuss four of the many different ways to paint skies and clouds. Although there is no one correct way to do a watercolor, perhaps what I demonstrate here will give you a good start. The most important thing to remember about painting clouds and skies is that they should be done quickly. You will have more of a chance to play around if you're working wet in wet, but you should still put your colors down and get out of it as quickly as possible. The longer you work at it, the greater the chance you will mess it up. Put the brush down and get out—even if you're dissatisfied with what you have done. The color will dry lighter and softer, and you'll probably like it more than you thought you would.

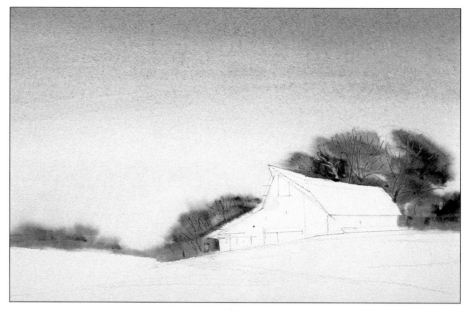

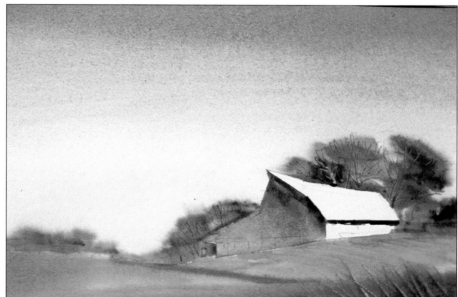

1. This is a typical summer sky with clouds. I use this sky primarily when I don't want my sky to fight the subject matter in the painting. First, I wet the entire upper surface of the paper, being careful to work around the barn. Working wet in wet, I brushed in the colors, using French ultramarine blue touched with a little burnt umber. Moving down, I switched to cerulean blue, and near the horizon I again changed color—this time to raw sienna. While the sky was still wet, I painted the background trees dry on wet.

2. When the paper had dried, I laid in the midtone values of the barn using wet on dry. I then wet the foreground with clear water and brushed in the foreground colors, dry on wet.

3. When the painting had again dried completely, I finished by putting the details on the barn and into the foreground.

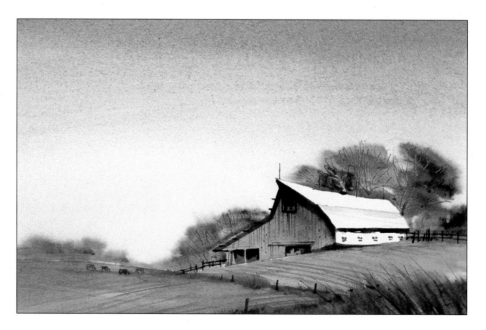

Two Easy Skies

I often paint the sky with a very simple gradated wash, keeping it darker and cooler at the top, lighter and warmer at the horizon, and without clouds. Not only are such skies easy to paint, they're also less likely to fight with your subject matter.

Another easy way to paint a sky is to apply a flat wash of one color to your paper and then, while that's still wet, add another color dry on wet to create cloud formations. Remember here that you have to lay in your clouds and then leave them alone. Don't work back into them. If you feel that you need darker areas in the clouds, wait until the paper is completely dry, then rewet the entire sky area with clear water and paint in your darker values. Rewetting the entire area before you paint back into it will help you avoid introducing hard edges; your painting will remain fresh and clean looking. If you don't scrub around in them, you won't disturb the under-lying colors.

The first step in this painting was wetting the entire surface of the paper. Then I brushed in a light wash of raw sienna, painting wet in wet.

While the paper was still wet, I brushed in the cloud formations dry on wet with Payne's gray, so I would get diffusion of the colors while retaining the shapes of the clouds.

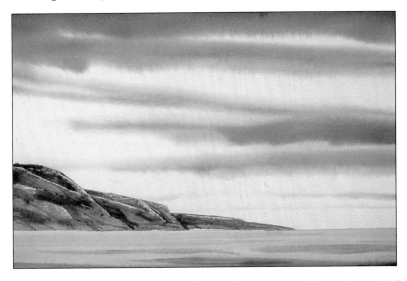

I painted the water next, using a slightly darker value of the colors used for the sky, then the headland. I scratched out the texture of the rock formations with a credit card. After everything had dried, I did some additional painting, including negative painting, to further define the shapes.

Skies, Dry on Wet

Another method I use to paint skies begins with wetting the entire sky area with clean water. Then I use the dry on wet method to work both sky and clouds, which gives you a soft diffusion of colors and shapes but still allows you to retain the shapes you want. This works well for me because I'm not trying to reproduce specific cloud formations but instead to create well-designed shapes that suggest sky and clouds. I don't try to fix passages that I don't particularly like. I just put the brush down and hope that the painting will be more what I want when it's dry. And it usually is.

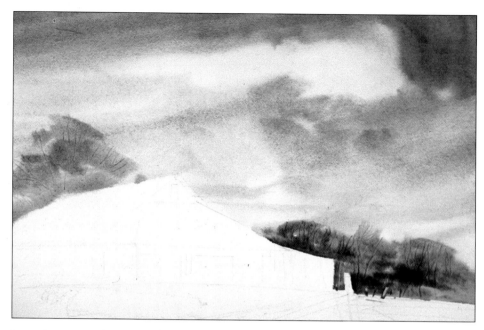

I wet the paper with clear water, working around the barn structure and foreground, and painted in the sky and cloud formations dry on wet. I did this very quickly, in no more than a minute, to get just the right amount of diffusion. While this was still wet, I painted in the background trees dry on wet.

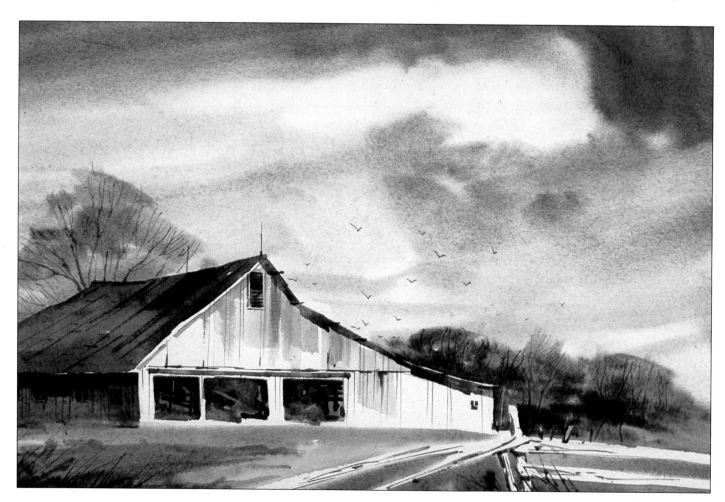

The barn and foreground were painted, and additional trunks and branches were added to the trees. Now you can see why I painted the gradated sky going from cool and dark in the upper right to lighter and warmer in the lower left. This gradation became an aid to draw the eye to the subject matter in that corner of the painting.

Storm Clouds

Stormy skies are probably the most difficult to paint; I must have attempted at least four of these skies before I came up with this one. For stormy skies I wet the sky area thoroughly with clear water, then lay in the colors, working wet in wet. I lift the board, tilting it and allowing the colors to run and take on magical shapes. Sometimes I spray droplets of water into areas or drop in darker colors just for fun. Wet in wet skies don't always turn out, so be prepared for some failures. Remember, though, that failures are how you learn. You're not painting smart when you just throw up your hands and toss an unsatisfactory painting away. Instead, ask yourself:

1. What did I do that I could have done better?
2. What didn't I do that I wish I had done?
3. Did I put the colors on too wet or not wet enough?
4. Did I use the right colors and the right values?

If you get into the habit of analyzing your failed attempts, you'll learn a lot and find you're painting better.

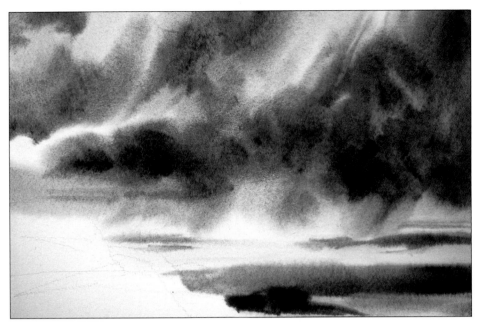

I saturated the entire surface of the paper except for the area where I planned to put some rock formations. While the paper was still quite wet, I flooded in raw sienna, burnt umber, French ultramarine blue, and Payne's gray, letting the colors mix and diffuse together on the paper. I applied a slightly heavier paint, working a bit more dry on wet, for the darker cloud areas. While this was still a little wet, the water was painted rather dry on wet in order to hold the horizon line without creating a hard line.

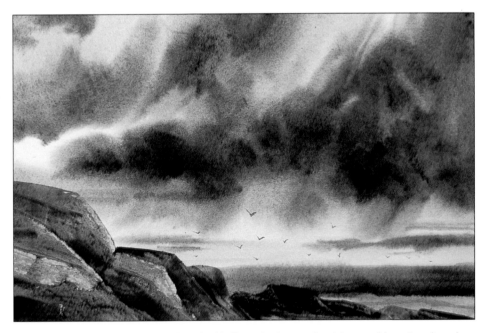

The foreground rocks were painted with French ultramarine blue and burnt umber. I tried to follow the contour of the rock and to achieve the right value for the planes. While the paper was still wet, I used a razor blade to scrape the texture in the rocks. I also did some negative painting to help define certain areas of the rocks, then added lines with a rigger to represent cracks in the rocks. I darkened the water a bit, added a few gulls, and the painting was finished.

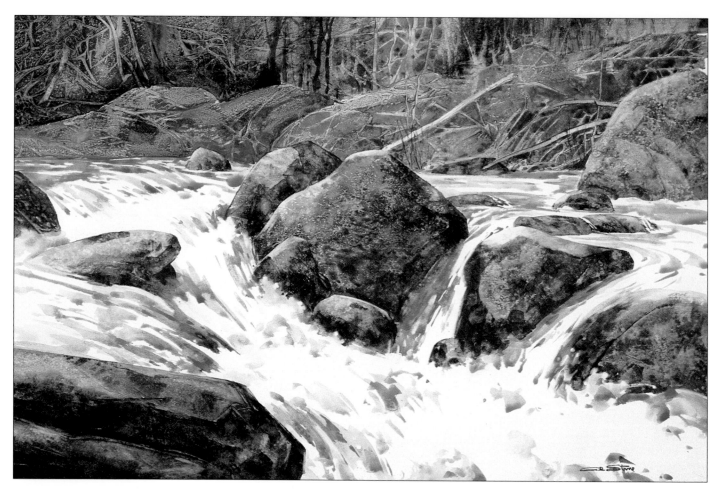

Painting Water

There are three basic types of water—quiet water (almost motionless because it hasn't been disturbed), water with some motion (disturbed by some force acting against it, such as a boat moving through it), and rough water (greatly disturbed, a sea blown by a storm, crashing against the shore). Remember that the water will pick up reflections of anything else that may be on or near it.

I have been a boater for many years and truly love to be on or around the water at daybreak. I have vivid memories of the sun coming over the horizon, the water often undisturbed by either wind or boats. I remember early morning fishing trips when the mists rose off the water and only jumping fish or passing ducks disturbed the smooth surface. Can you tell it's also one of my favorite times and subjects to capture?

Rapid Succession (21x29). Unlike the demonstrations I've done so far in this book, I painted the water first, then the background. While the background was still wet, I sprayed droplets of water on the area and blotted lightly with a tissue, which is the only way to achieve all those lovely textures. The rocks were then painted, one by one, using the same spraying and blotting technique. I finished with some negative painting to bring out detail in the background. *(Collection of Mr. & Mrs. Dana Burwell)*

Water in Motion

To paint water in motion I do a gradated wash for the sky, from darker and cooler colors at the top to lighter and warmer ones at the horizon. Sometimes I'll put in some clouds, as I did in this demonstration. I painted the water after I'd finished the sky, putting the lightest and warmest colors at the horizon and gradating the wash down to darker and cooler ones at the bottom. I added reflections of anything in the distance that I wanted diffused and also painted in the darker color of the sky and some wave action while the paper was still wet. To create this wave action, the brush strokes must indicate that something has disturbed the surface of the water. I used a clean, thirsty brush to remove some color. I generally do this at the top part of the water, which helps break up the area and keeps it from becoming boring.

When painting water in motion, the reflections are quite sharp but, unlike in quiet water, they're broken up. Where there is movement of water, the sky will also be reflected, so those areas will be lighter. Where an object is reflected in that same area, its reflection will be darker.

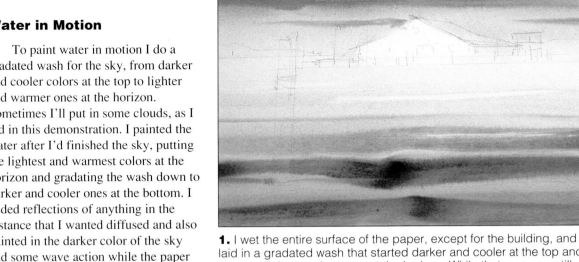

1. I wet the entire surface of the paper, except for the building, and laid in a gradated wash that started darker and cooler at the top and became lighter and warmer at the horizon. While that area was still wet I brushed in, dry on wet, darker value of the same colors to indicate the cloud formations. Next I painted the water in a mirror image of the sky using the same sky and cloud colors. While the water area was still wet, I brushed in slightly oblique streaks of darker value to indicate disturbed water, working mostly dry on wet. Before the area dried, I also lifted some lighter streaks with a thirsty brush.

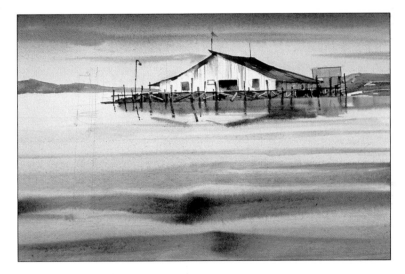

2. I painted in the distant hills, the fishing shack, and docks. Again I rewet the water area below the docks and then painted in the reflections, some a bit sharper than in the quiet water scene.

3. Finally I added the old post in the water along with its reflections. Notice how the rippling water gives the reflections very distinctive S-curves. You can also see how much sharper the reflections close to you are than those seen in the distance. I added a darker value to the top of some of the waves in the foreground and washed that down with clear water.

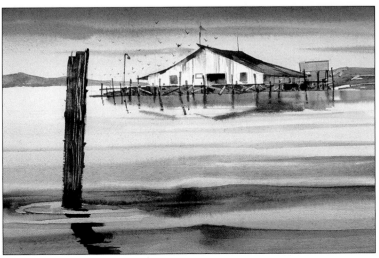

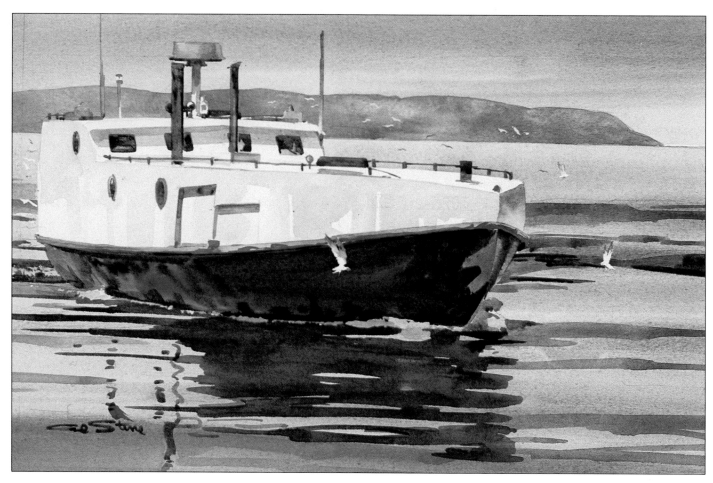

In addition to the demonstration, I've included a painting of a fishing boat in motion. This type of boat, used in Door County, Wisconsin, has a powerful diesel engine and a steel hull that can break through up to eleven inches of ice for winter fishing.

The painting is a good example of water that has been gently disturbed by the boat as it turns to head into its dock. You'll notice how the water in the distance has been kept very simple and flat with only the boat's movement to disturb it. You can also see that the stern waves in the distance have some soft edges to indicate they are dissipating. The reflections of the boat are sharp and broken to indicate the motion of the water.

Breaking Waves

Waves, whether in the open sea, breaking over rocks or shore, or rolling against a headland, are things of beauty. This is the most difficult of all types of water to paint and takes much thought and practice.

I painted this demonstration of waves while visiting my friend, Phil Austin (a fine watercolorist), near Gills Rock in Door County, Wisconsin. I wet the area around the foam with clean water, spraying some of the edges with a spray bottle so I'd get a different texture from that of the water. Spraying leaves little pin holes of light that suggest foam and give some rougher texture to contrast the edges softened by the water. This technique is a bit harder to control but well worth the effort. I try to capture some of the color of the rocks as it is diffused by the water, which keeps them from looking as though they were pasted on the paper and offers a nice color variation from the rocks that are clear of water.

Full Catch (9x13). Here's a typical fishing boat from Door County, Wisconsin. After the sky had dried, I painted in the land formations in grayed colors to keep them in the distance. When the paper had dried completely I painted the boat with all of its details and the reflections on the water, which you will notice get sharper as they come toward you. I picked up the colors reflecting from the boat, even the red separating the top of the hull from the bottom, but they are grayed down a bit. Before I started the painting, I had masked out the gull with a liquid masking agent, which I removed after the painting had dried. I had only to add detail to the gull and the painting was finished. (*Collection of Mrs. Alyse Hallengren*)

Remember to have the foam flying in the same direction as the wave and the wind to help add action to the painting. If the wave and the wind actions are going in opposite directions (which can happen), the foam will go in the same direction as the wind. I don't use much color in the shadows of the foam, but keep it a grayed blue instead (using French ultramarine blue and a little burnt umber). The shadows are painted in the direction that the foam is flying, and some edges are softened while other edges are left a little rough.

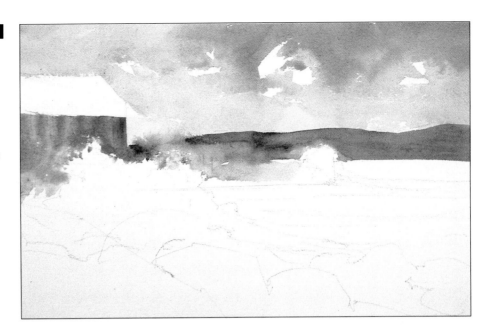

1. I began this painting by painting the sky directly, wet on dry. I wet the paper around the breaking water with a brush and clear water and used a spray bottle to spray droplets of water into some of these edges so that I could get different textures to the edges of the flying spray. When the colors merge with the edges of the wave where the paper has been brushed, I get soft edges; and where they merge with the sprayed areas I get a rougher texture. The distant hills were painted next, followed by the fishing shack, where the edges were handled in the same manner.

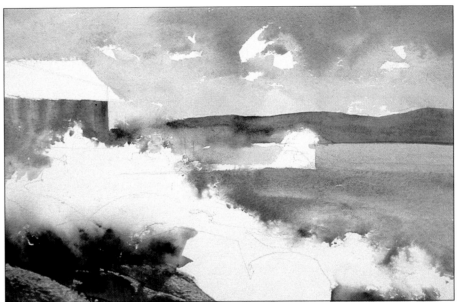

2. I tackled the water next, softening the edges of the flying sea spray in the same manner as in the previous step. The area beneath the wave was also handled in the same manner. I painted the colors of the rocks up into the soft and textured clear water, which allowed the colors of the rocks to diffuse up into the breaking water, giving me different edge textures.

3. Next, I painted the rocks ouside the breaking water. While this area was still wet, I scraped texture into the rocks with a razor blade. I also used a razor blade to scrape out a little more white of the flying spray. I painted the shadows in the breaking water using a grayed blue, softening some of the edges while leaving others a little rougher. I did a little more work on the water by adding a few darker values.

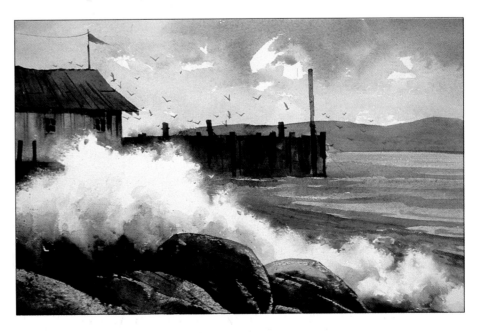

Rocks and Rushing Water

I don't believe there is a more thrilling or beautiful sight than a rushing mountain stream with water swirling and boiling down over rocks and fallen trees. It's terribly exhilarating to stand in or near a stream like that! Every time I find a new mountain stream or revisit a familiar one, I just can't wait to paint it.

The stream in this demonstration is in the Cascade Canyon of the Tetons in Jackson, Wyoming. Created by melting snows, these rapids flow from the top of the mountains. The canyon is completely hidden by forests and the mountains themselves.

When I paint rapidly flowing water, I put three or four separate puddles of color on my palette. As I paint I pick up these colors on the brush, one at a time, letting them mix on the paper and not on the palette. One of my favorite ways to give rocks texture is by spraying and lifting: I apply very heavy color to the paper, let the colors set for a minute or so, and then spray droplets of water back into it. When the time is right, I lay a tissue over the area, press or otherwise mark through it if I want, and then lift.

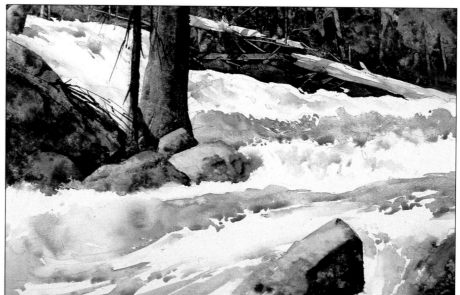

1. Here I began by painting the water first, wet on dry. I just made puddles of color on my palette and let them mix on the paper. I also tried to keep the brush strokes moving in the same direction as the churn and flow of the water.

2. The colors of the rocks were painted on with fairly heavy pigment, then sprayed with droplets of water, and lightly blotted with a tissue. I painted the background next, texturing that the same way as the rocks.

3. In this close-up of the rocks, you can clearly see the marvelous coloring and texture that are made possible by painting the colors on somewhat heavily, spraying droplets of water from a spray bottle, and lightly blotting with a tissue.

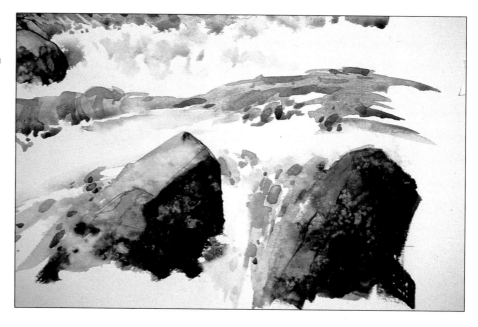

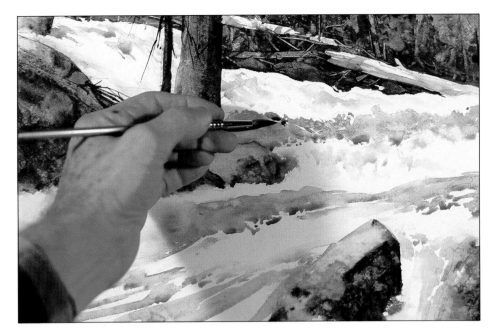

Here I added more detail in the water, dapples of shadow that play across the rushing water, and deepened the values in the shadow areas.

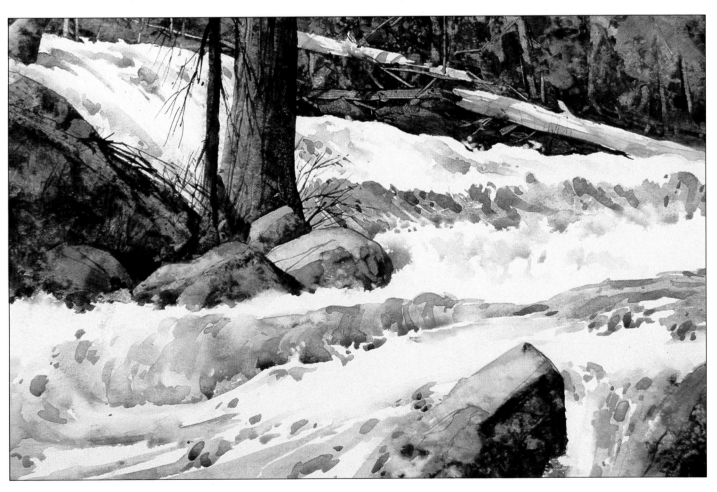

Down Cascade Canyon (11x14). I feel it is far better to keep a subject like this from getting overworked, so as you can see, I handled the water very simply. Some weeds and twigs were added to finish the painting.

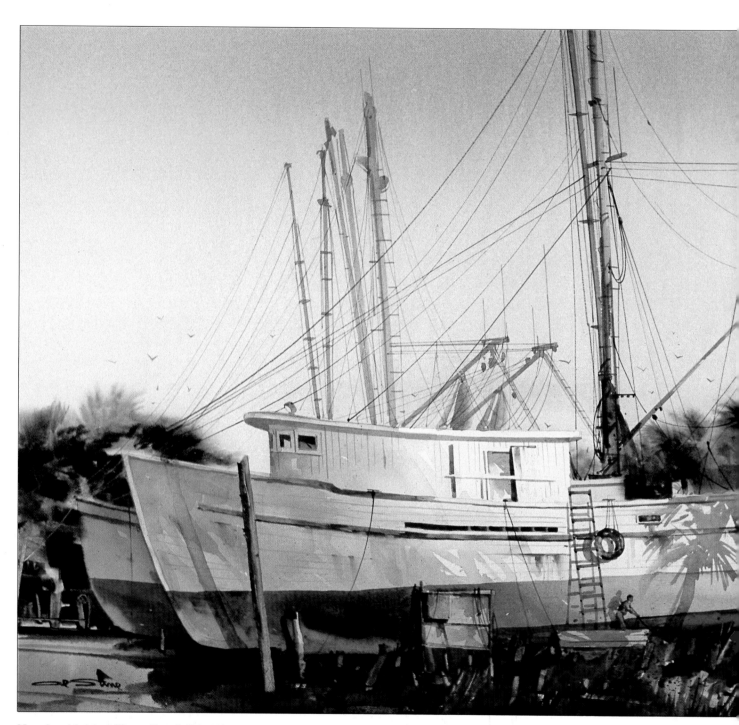

Morning Light at Shem Creek (20x28).

CHAPTER SIX

Design Smart

You have to design a painting before you can paint it. But don't let the word "design" scare you. Design basically means arranging shapes on paper in a pleasing manner. It means thinking about your options, deciding what you want to do, then doing it. Designing a painting doesn't make your work less spontaneous or free. But you won't be dependent on "getting lucky" to make a good painting.

There's no great mystery to good design. We're not really talking about something foreign to you as you live with these principles every day, although you might not realize it. For example, if a house dominates a landscape, we plant trees and shrubs around it for balance (one principle of design). When we plant things in our yards we try to pick a variety of different kinds of trees and

flowers, not all the same thing—that's repetition with variation (combining two principles of design). When we worry about the overall effect of our landscaping, how the whole thing comes together, we're thinking about unity (still another design principle). See, design is that simple and ordinary.

We work with eight basic principles of design: unity, balance, repetition, alternation, variation, dominance, contrast, and gradation. I'll discuss each principle and offer you some thumbnail examples to illustrate what I'm talking about. Students seldom like to do thumbnails, because they don't know how to use them to improve their paintings. It's tough to critique your own work like this, but I think you'll find that the results are worthwhile if you stick with it.

The Eight Principles of Design

So let's look at these principles of design and how you can use them to make better paintings—before you've put any color on the paper at all.

Unity

Unity is the principle of order; the painting must be one unit—to which nothing else could be added or from which nothing could be taken away. Think about our house and landscape example; it would spoil the unity of the scene if you put a bright red doghouse in the middle of your front yard. Unity implies a whole, not a collection of elements. If any element such as line, value, or texture occurs in any one area of the painting, then it should be repeated somewhere else in the painting. The repeated element works best if it is at an oblique angle from the first element because this placement is more interesting, but a horizontal relationship also works. A vertical repeat—that is, one placed directly above—should never be used because it often destroys the illusion of space in a picture.

In sketch A we have a painting that is not unified even though there is repetition, because the repetition is out of balance. Elements should never be vertically stacked over each other.

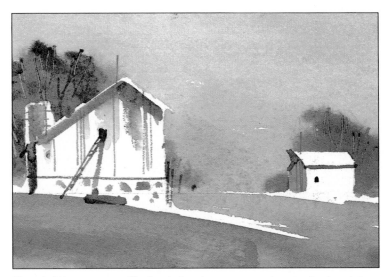

Sketch B is a more unified painting because we have a horizontal repeat in the design. This is a slight improvement over sketch A, but it still could be better.

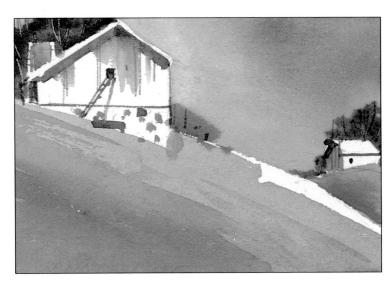

In sketch C we have exactly the same elements as in sketches A and B, but we have a more unified painting because of the oblique repeat.

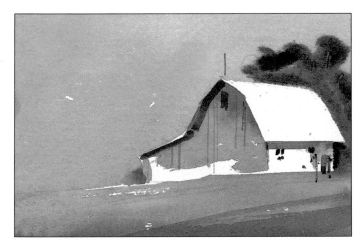

Sketch A: This painting is out of balance because there's nothing set against the large barn at the far right. All of the space to the left cries out for something to be placed there.

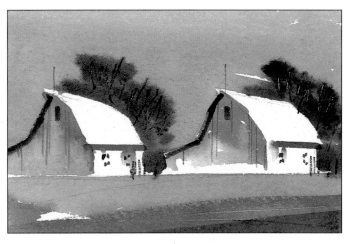

Sketch C: Here we have a case of two masses that balance quite nicely. This is called formal balance, but it is very boring because we do not have any variation of size, shape, color, or texture.

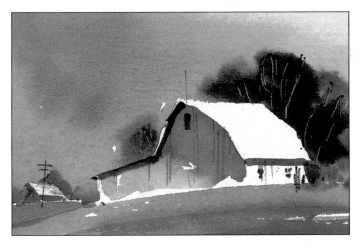

Sketch B: The barn has been moved slightly to the left, closer to the center of the painting, which by itself would improve the balance a little but not enough. Adding the mass of trees at the left side of the rectangle makes it all work.

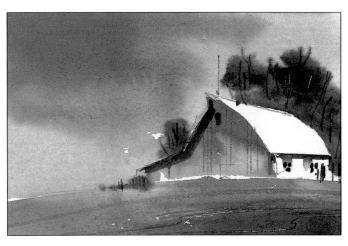

Sketch D: Here we have pretty much the same scene as in sketch A, but how much nicer it is to have it balanced by the gradation of the sky (darker in the upper left to lighter near the barn). The foreground is also gradated to counterbalance the sky (darker at the right and lighter as it moves to the left).

Balance

Although balance applies to all of the elements of design, such as size and value, it is more applicable to shapes (a balance of masses). If we place most of our large or dark shapes on one side of the painting, it will look out of balance. You don't need to make both sides of your painting mirror images of each other to create balance. You can put many small shapes on one side balanced by a few large shapes on the other. You can have light, large shapes balance small, dark shapes. Another alternative is using a gradated wash as shown here in sketch D. The dark gradated wash in the upper left balances the shapes in the lower right. Without it, the painting would be lopsided.

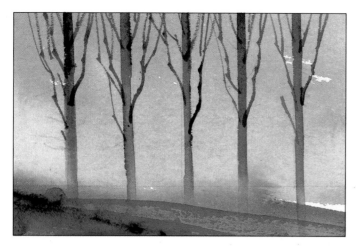

Sketch A: Here we have a row of trees, demonstrating repetition. Although there's a little alternation in the limbs coming off the trunks, it's still very boring.

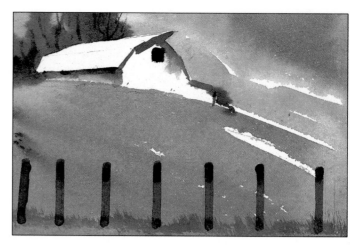

Sketch C: This happens to many students who lack knowledge of design. They will do a fairly nice painting and then mess it up by putting in fence posts at regularly spaced intervals just as they were placed by the farmer. This is repetition without variation.

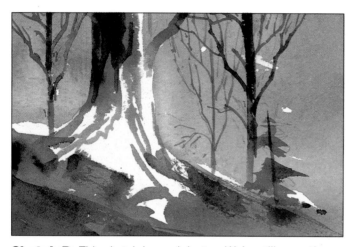

Sketch B: This sketch is much better. We're still repeating trees, but now we've added variation to the little bit of alternation—and that really breaks up the monotony. There is now variation in the size and type of the trees.

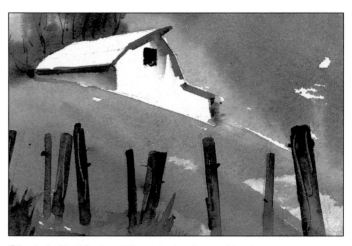

Sketch D: What a difference between this sketch and sketch C! We still have the repetition of the fence posts, but they are now painted with variation of size, value, and direction. Notice also the variation of space between them. I hope you agree that this is much more interesting than sketch C.

Repetition, Alternation, and Variation

Repetition is a passage that is done over and over again, such as the pickets in a picket fence. We can repeat any of the elements of design: textures, values, colors, shapes, sizes, lines, and directions. Repetition of the exact same subject in a painting, such as a row of identical trees, can become very boring and should be guarded against at all costs. When you combine repetition with alternation or variation, however, the results are much more interesting.

Alternation means to do by turns, one after the other, such as leaves along a stem. All of the elements of design—color, line, value, shapes, directions, textures, and sizes—can be used in alternating patterns.

Variation is changing the size, shape, or color of a subject you're repeating. If you were doing a painting with several boats, for example, you wouldn't want to make all the boats look exactly alike, because that would be boring to look at (much less to paint). I remember attending the old Chicago Academy

of Fine Arts, where we had no air conditioning. One summer the instructor for our class in layout and lettering had a monotonous voice that, combined with the heat, could put you to sleep in minutes. How much nicer it would have been had he raised his voice once in a while to offer a little variation. Remember—repetition without variation is to be avoided.

Variation of the space between objects is also important. The intervals between objects and the shapes of those intervals are as important as the objects themselves to producing interesting paintings.

Dominance

I believe that dominance is the most important of all the principles of design. Without dominance there can be no unity. Dominance resolves conflict or contrast and gains unity. This means that, although there are two types of lines (curved and straight) and three types of shapes (curved, angular, and rectangular), only one should stand out among the others. Unless you have something in your painting that is dominant, your painting will lack unity—you have a painting that does not tell a story. When there is no lead character and no main action, there is no story; and after all, we are story tellers. A good story depicts one character involved in one main plot. Without a dominant subject, you can apply all the other principles and elements of design correctly, and the painting won't work as a unit.

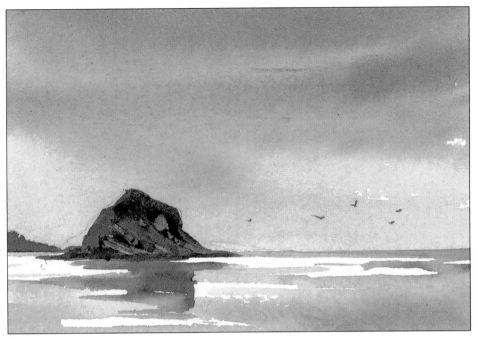

In this first sketch you can see that the painting lacks authority, because the most dominant part of the painting is the sky.

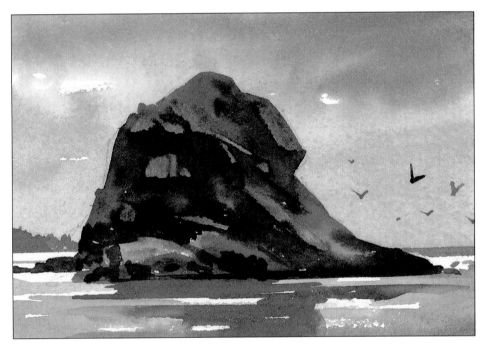

In this sketch you see the effect of placing the subject matter in center stage with the spotlight on it, dominating the scene. It's far more dramatic than the first one. Both the change in the mass (or size) of the rock and the change in the light and dark value patterns work to give the subject dominance. Striving for a dominant mass in your paintings is a worthwhile goal.

Contrast

Contrast (sometimes called conflict) sets a painting in motion and creates interest. We can have contrast in line (curved or straight), in value (light or dark), in shape (round, angular, or rectangular), and in size (large or small). Contrast is the spice that is essential to all art forms. Contrast could be a horizontal line with a vertical for contrast, a soft texture against a rough one, or a cool color against a warm one. You can achieve a very strong contrast or a muted one depending on what you are trying to say. You have to be careful, though; while a little contrast is interesting, too much is disturbing. Sugar and cinnamon are contrasting elements, but if you don't get the proportions right the result won't be worth eating. You'll probably find yourself working with contrast the most when you're working on values—light against dark or dark against light.

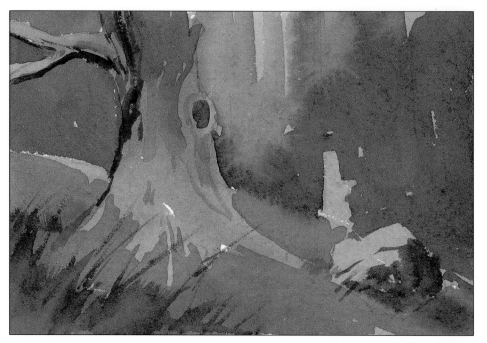

You can see the effect of a lack of contrast—the whole painting falls flat; it has no zing. There is no contrast of value, color, texture, or shape.

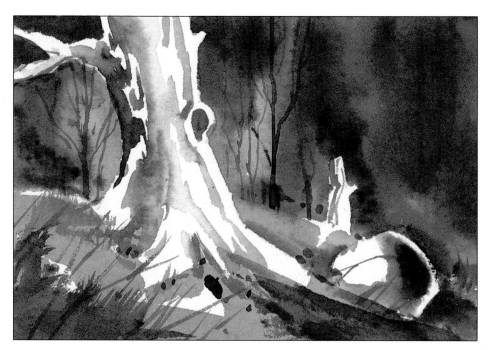

Here you can see the striking contrast in values and the contrast of soft textures in the background versus the rough textures in the foreground.

Gradation

Gradation is the gradual change from one thing to another. You can change from a warm to a cool color, from dark to light in value, from rough texture to smooth, from a vertical to horizontal direction, or from large to small in size. Gradation indicates movement and enlivens paintings. Although you can apply gradation to all seven design elements, for all practical purposes I find I tend to use it with value and color the most, especially for skies. Gradation does apply to other subjects as well. For instance, when painting a barn wall you could start it cooler and darker at the top, going to lighter and warmer at the bottom where it picks up warm reflections from the ground.

I've discovered that many students have difficulty painting foregrounds, but using gradation will make foregrounds much easier for you. Paint foregrounds with gradated washes starting lighter and cooler in the distance and getting darker and warmer in the foreground, also gradating it from right to left or left to right, depending on how you need to balance the painting. After this initial wash the only other thing you'll need to do is to indicate some darker values for weeds and ground clutter. I use gradation in even the smallest passages of a painting, for example, in a small window pane. I try gradating the color of the pane from dark at the top to lighter at the bottom while changing the color as the wash gradates. This holds the viewer's interest and keeps the painting from becoming boring.

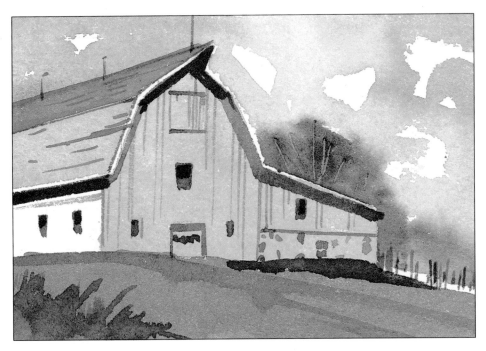

You can see there was no gradation used in any of the washes, leaving the painting very flat and with no movement at all.

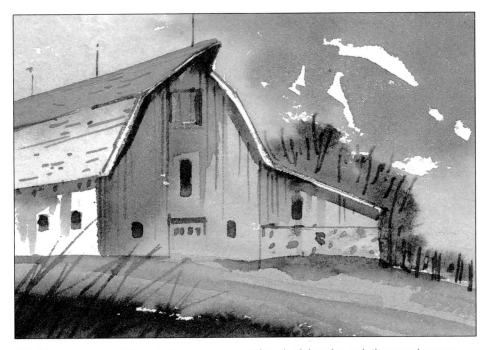

All of the washes in this painting area are gradated, giving the painting much more interest, movement, and life. The gradated sky seems to be moving, doing something. The foreground also has more movement. Try gradation in all of your washes; I think you'll be very pleased with the results.

The Seven Elements of Design

Now that we have covered the eight principles of design we come to the seven elements of design. That's not a lot to remember, just fifteen words, but without the knowledge those words represent you might falter for years, only occasionally stumbling onto a successful painting (one that is well designed). And, when you did succeed, you might not be able to repeat your success because you didn't know what went right.

As with the principles of design, there is nothing foreign about the elements of design—you use them every day and work with them in your paintings whether you know it or not. These seven elements are: size, shape, direction, color, texture, line, and value. Using them effectively to design your painting is just a matter of putting them together with the eight principles of design.

Size

There are shapes of different sizes in relation to one another. We have to think of the principles of design and make our shapes different sizes (variation), choosing one to be dominant (dominance).

Shape

A shape can be in one of three forms—curved, rectangular, or angular. You may have any or all of these in any one painting. But—back to the principles of design—only one should dominate. You also need to remember that whenever you paint a positive shape you create a negative space, which has to be well thought out in terms of design also.

Direction

Always try to plan into any painting a dominant direction, whether it's vertical, horizontal, or oblique. This plan can be implemented with the shapes of our subject (a cathedral would be a good example of vertical dominance). A painting of the southwest with the mostly horizontal lines of the landscape is a good example of horizontal dominance. An industrial scene with derricks and material handlers would fill the bill very nicely for oblique directional dominance.

Color

We certainly have a multitude of hues to choose from, but we need to apply the principles of design and plan for a dominance of either a warm or cool color. The result is color harmony that unifies the painting. In fact, color harmony is a good example of the principles of design at work. One color is dominant, but it is contrasted with its complement. To add variety, the colors between the dominant hue and its complement are added in small quantities for balance.

Texture

We have three types of texture to work with—soft, hard, and rough. I try to incorporate all three into every painting I do (variation), but I let only one dominate.

Line

There are only two kinds of line that you can use in a painting, curved and straight. But the design principle of dominance still applies; you can vary the lines in shape, size, and direction, but only one should dominate.

Value

Value is probably the most important of all elements, because the painting doesn't have a chance to succeed without it. We generally only work in three broad values (light, midtone, and dark), but the one that holds the painting together—and should be dominant—is the midtone. Midtones should dominate about one half of the painting and the lights and darks the other half, although either the dark or the light should dominate in their half. Think of it as a stage play where most of the stage is in shadow (midtones), with the spotlight on the actor (light tones), and the costumes are the dark tones.

I have attempted to pinpoint some of the elements of design in an actual painting by labeling them with callouts. In the painting, I tried for hard, soft, and rough edges, used both curved and straight lines, and tried to change the direction of the line. Most of the painting is not in the midtone range, but I felt that the subject matter called for a darker mood.

You don't have to worry about breaking any rules; they are not carved in stone but are there to guide you in making decisions. As long as you understand and use them wisely, your paintings will come much easier and will have life to them. Remember—think smart, paint smart.

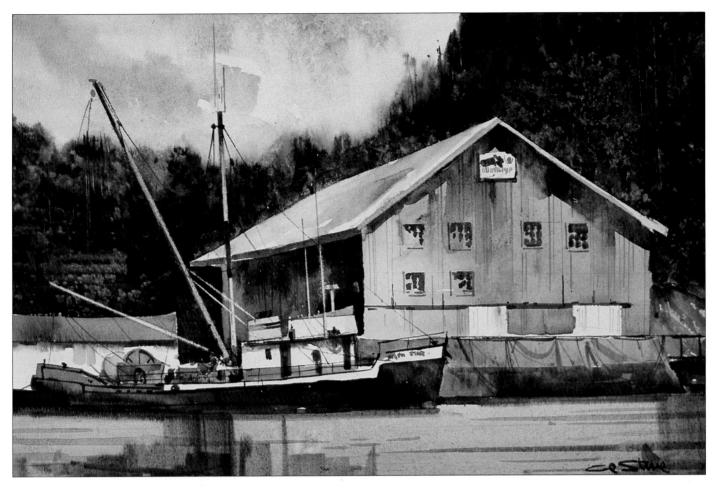

Reflections at Quathiaski Cove (10x14). (*Collection of Mr. & Mrs. Robert Skelton*)

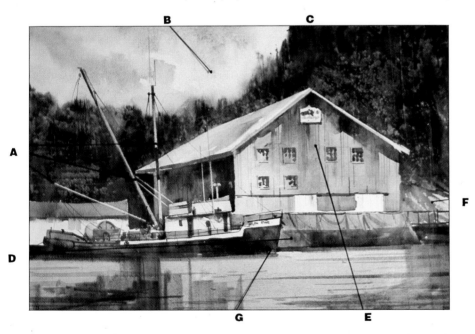

A. Straight lines—vertical and oblique.
B. Soft texture in the sky and on the tops of the trees.
C. Hard edges and dark value against a light value. The trees form a curved line.
D. A rough texture.

E. The building is dominant in size and rectangular in shape.
F. Warm color against cool color.
G. A light value against the dark value of the ship's hull for separation. The dominant direction of the painting is horizontal.

Elements and Principles

The principles of design are not hard and fast rules, but they should be well understood before you try departing from them. Use your knowledge of the principles and elements of design to give you that creative edge. When you do your thumbnails, keep all of the principles and elements of design in mind. Design your shapes; plan what will have dominance; decide whether the colors will be predominantly warm or cool.

Please don't forget that each principle of design can be applied to all of the seven elements. For instance, the principle of balance can be applied to each of the seven elements of design: line, size, shape, direction, color, value, and texture. If you can use this concept, I believe you will have taken a giant step forward in planning, in creating your thumbnails, and in critiquing them. The two concepts that you will probably use most are the contrast of values and gradation of values and color. These two concepts will give your watercolors that singing quality, and they will also supply some movement. I hope that you will read and digest this chapter and the one that follows it very thoroughly, because they'll help you create good sketches and thumbnails on which to base your finished paintings. When someone looks at your painting and says, "My, isn't that lovely?" you'll know that it was well designed. You will have applied a thoughtful, creative process to your art using the design principles and elements.

If you can't critique your own work, you won't grow creatively as an artist. You'll keep making the same old mistakes over and over again, never knowing why. When you can critique you also acquire the ability to see other artists' work and understand your reactions to it.

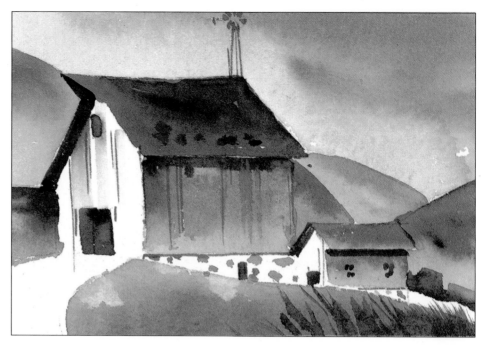

A tangent is two lines or planes that touch at one point. A bad tangent point can weaken a drawing or a painting by destroying the feeling of depth and distracting the eye from the center of interest. As you can see, this is full of bad tangent points. The roof of the barn is at a tangent with the hill, the smaller hills come to a tangent with the other corner of the barn roof and wall and so on. It is so bad that you can probably pick out more instances where the tangent rule has been broken. (It reminds me of those puzzles, "How many things can you find wrong in this picture?")

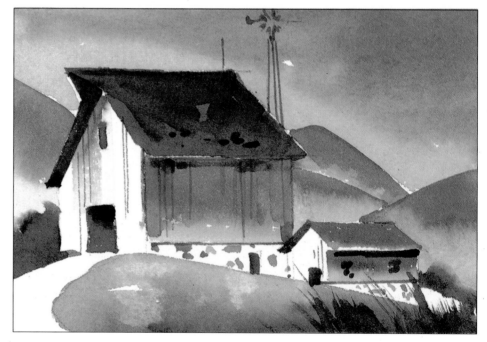

I have tried to do the same scene without the bad tangent points. The painting now begins to have depth and is visually more interesting.

Paint Your Watercolor in Bed

Have you ever had a thought, a great idea, while lying in bed, and wished you had a recorder to capture those thoughts so they would still be fresh the next morning? Frequently, while I'm lying in bed, I'll go through the painting process for something I'm working on, or plan to work on, especially if I have already penciled it on paper. I go through the process of selecting my palette, think about where I'm going to save whites, where my value patterns should go, and what area will be painted first. In fact, I run through this exact procedure (though not always in bed) every time I do a painting—before I ever touch a brush to paper. It only takes a few minutes to work through the entire painting sequence. For example, I ask myself if I will do the sky area wet in wet or use the wet on dry method, or whether I will paint from light to dark or jump right in and establish the darkest value first. Only after having spent this time mentally walking through the painting process from start to finish do I pick up a brush and begin.

I have been in many workshops where fine watercolorists are doing demonstrations; they lay out their colors and all of the equipment that will be needed, then step back and take a few minutes to plan how the painting will be done. If professionals take the time to do this, shouldn't you? This is what we're talking about in this book— thinking smart and painting smart. It's so much better than just jumping right in and putting something down that you then wished you hadn't. This thinking time solves many of your problems and calms your nerves. It helps get rid of that panicky feeling and makes you feel more in control. Your time spent in this thinking process is never wasted so think smart to paint smart.

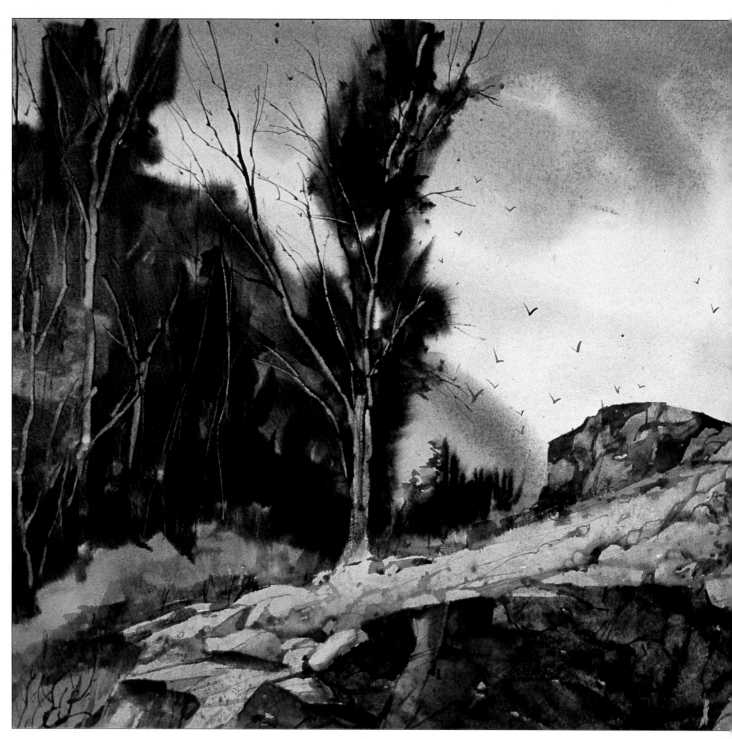

On the Lazy L & B (13x19). The rugged rock formations set against the softer sky and trees seemed to make an attractive subject for a painting. Whenever I see rock formations like this I feel compelled to paint them.

Plan for Success

Do thumbnails. Do thumbnails. Do thumbnails. Doing thumbnail sketches is the smartest habit you can develop. And I stress this to my students over and over. However, though I ask them to do several thumbnails of the subject they have chosen to paint, lo and behold, I invariably discover that some have done only one thumbnail before proceeding to pencil it onto their paper and start painting. Well, I don't have to tell you that they are often the students who are the least satisfied with their final results. I can understand their reasons, as I have been guilty myself.

During the years I spent in a large art studio in Chicago, I would often skip the thumbnails to beat deadlines (taking the easy way out) and hope that fancy painting would save the illustration. Well, it obviously doesn't work that way—I was usually forced to tear up my work and start all over, this time doing thumbnails, a larger value sketch, and at times even a large color rendering.

Why are thumbnails and other preliminary steps so important? A good painting is the result of a long series of decisions. In a thumbnail, you can make those decisions before you have committed paint to paper. You can try out different solutions and test options in just a few minutes, and you never have to live with a bad choice. Thumbnails give you a chance to make the smart choice.

I know what a temptation it is to start slapping paint on the paper, hoping for the best. Doing several thumbnails seems such a boring waste of time when you're eager to start what you think will be an exciting painting. But consider this: If you create a good design, a good drawing, and have a well-planned pattern for your values, even bad technique can't completely ruin your painting. On the other hand, if you have a bad design—or worse, no design at all—a bad drawing, and a poorly planned value pattern, even the best technique won't save it.

Eliminating the preliminary steps is a shortcut to failure; in watercolor, failing to plan is planning to fail.

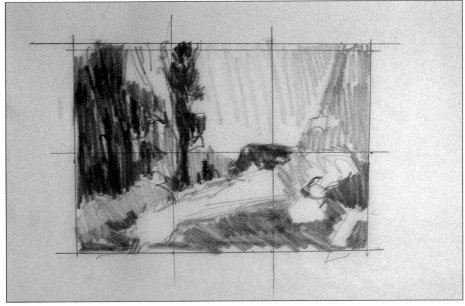

This is the larger (5x6) value sketch that I made for *On the Lazy L & B*. All I attempted to do in this sketch was establish large masses and value patterns.

Paint a Translation, Not a Literal Description

Whether you are working from a slide, a photograph, or have the actual landscape before you, your goal is to paint a good painting, not an exact copy of your subject matter. You must make a translation of what you see, based on a smart application of the rules of design. It is easy enough to mindlessly copy your source material without reflecting on what it is you are trying to say in the painting. I think one of the worst things a viewer can say about a painting is that it looks "just like a photograph." Doing thumbnails is the best way to free yourself from mere copying.

Strive to capture the feeling of a subject in your painting, eliminating everything that doesn't contribute to that end. A tree standing in front of the barn you want to paint doesn't necessarily belong in your painting just because it's there. If it ruins the design of your painting, move it or leave it out. If you want to emphasize the barn, go ahead and make it larger than it appears in your photograph. You are telling a story to share with your viewer a special experience. Therefore, simplify, simplify, simplify, keeping only those details that will make your story clear and the experience more vivid. Here is your opportunity to move things around, change shapes and sizes, establish a dominant value pattern, and plan your color relationships—in your thumbnails, not when you're actually painting.

When I'm doing thumbnails, the creative juices really begin to flow. Idea after idea comes to mind, but it's getting the ideas down on paper that makes them jell. I trap the good ideas on paper. After trying out various ideas in a series of thumbnails, I do a larger value sketch of the thumbnail I feel is the most promising. Occasionally, I also do a small color rendering to decide on the best palette to establish the mood.

For this demonstration I've selected a photograph of an old midwestern barn. There is something compelling

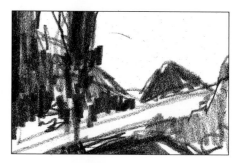

about barns; they're like people to me, each one different and with a unique character of its own. My wife Liz and I often get in the car and drive, hitting all the back roads and taking photographs of whatever seems appealing. The following demonstration of the barn illustrates how easy it is to find good subjects without traveling far from home. This photo was taken within twenty miles of our former home in the Midwest. Now that we've moved to South Carolina we have many new vistas to explore.

Studying the photograph I felt that the barn needed more definition of the light planes, but those on the silo looked pretty good. The fence posts in the photograph are repetitive, so I knew I'd have to give some thought to the spacing and sizes in order to get variation in them. After analyzing the photo and mulling over a few ideas, I started doing my series of thumbnails. I selected the third thumbnail you see here for the value sketch, because I liked the dramatic effect of the high horizon line and the white space created by the road, which brings your eye into the subject.

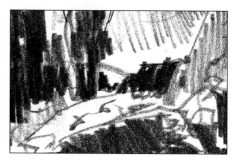

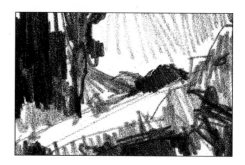

These little thumbnails, about 2x3, are the result of my thinking about what I wanted to say in *On the Lazy L & B.* In the first one, I kept the rock formation below the top of the rectangle. In the second, I didn't show the rocks going up at all. In the third thumbnail, I had the rock mass going up and dominating the right hand side. The second thumbnail was probably the best, but I chose the third one instead—probably because this one gave me a chance to have fun with the large rock formation.

In this first thumbnail, I decided to make the barn a very dominant part of the scene. I made an effort to keep the subject matter a different measure from each of the four edges, in accordance with the principle of variation. In the second sketch, I opted for a low horizon line with the sky gradating from dark in the upper left to lighter near the barn. I planned the road as a white area to give a nice lead into the subject. I tried a high horizon line in the third thumbnail, again with the road as a lead into the subject.

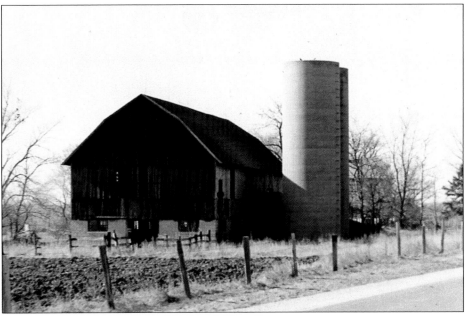

I chose this photograph of an old barn and silo as the basis for my painting. As we go through the demonstration, please pay close attention to how the work evolves and changes as I do the thumbnails, the larger value sketch, and finally the painting itself.

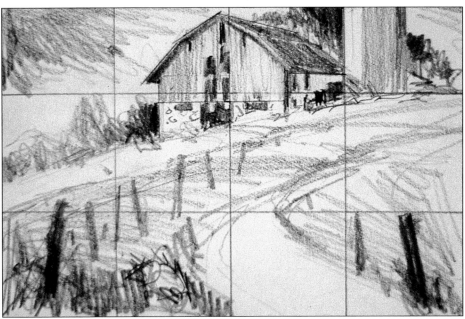

In this enlarged value sketch (5x7), I tried to recapture the flavor of the thumbnail while defining the drawing a little more and establishing my value patterns. This didn't mean I would follow the value sketch exactly; I still might have changed the values as the painting progressed. I also didn't worry about colors at this point, as the painting could be done with one, two, or ten colors. Here I was only concerned about large masses and values. When I was satisfied with it, I ruled the sketch off in grids and transferred it to the paper.

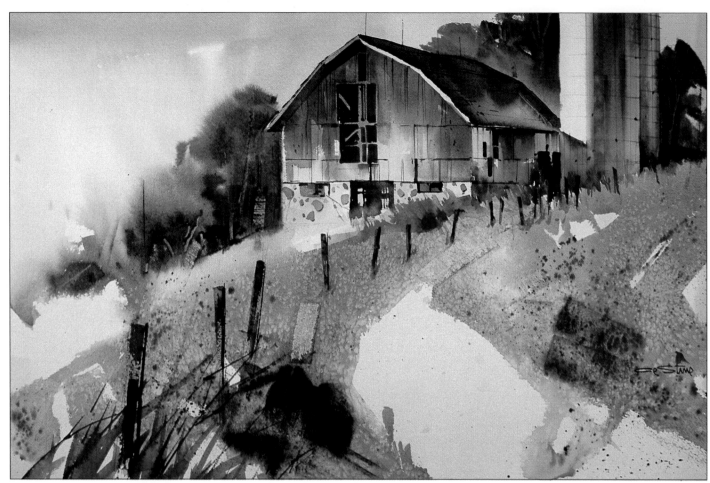

The Center of Interest

A center of interest should be established in every painting. You should have something of interest to serve as a focal point—it is a place where the eye can rest before and after exploring the rest of the painting. Remember going to a three-ring circus? You didn't know where to look with so much going on, but when they put the spotlight on the performer, they created a center of interest. Your eyes quit wandering all over and settled on a focal point. That's what you want in your paintings.

It's important to keep in mind that a figure always automatically becomes the center of interest in a painting, whether you want it to or not. For instance, let's say you want to do a painting in which a fishing boat will be the center of interest. If you then add a figure outside that area, you'll have destroyed the center of interest and the unity of that painting. The viewer won't know where to look for the focal point

Fond Remembrances (13x19). As it turned out, I basically stuck to the value sketch, although I did depart from it in places. I started the painting by wetting most of the paper, leaving some areas dry, and laying in a cool wash of blue so I would have a cool underpainting. I planned to lay warmer colors over it to finish the painting. Then I eliminated the fence posts to the right, since I felt they carried too much importance and would distract from the main subject matter. I didn't want to say "road," so I left that area fairly white to lead the viewer's eye into the subject matter.

of the painting; his or her gaze will bounce back and forth between the boat and the figure.

You can locate your center of interest almost anywhere on the paper as long as its not the same distance from any of the four edges of the paper. There are no hard and fast rules on establishing the center of interest. (How can you have any hard rules in creative process?) You can get fantastic results by breaking the rules, but you must have some guidelines to follow before you go off to do your own thing.

Artists have many different ways of finding the center of interest. I use a method I learned in art school, and I'll illustrate it here. Divide your paper into quarters, then draw diagonal lines in those quarters. Wherever the lines cross you have a good place to start your subject matter. You don't have to limit your subject matter to this area; you can build out from there. I don't actually draw these lines on my paper now—I just visualize where my center of interest will be. You might want to draw the lines in lightly when you start making your little sketches, however, until you become accustomed to the procedure.

There are a few more things to watch out for when selecting the center of interest. You already know from the preceding discussion that you should never locate the subject matter right in the center of the rectangle. The same is true of the horizon line: Never place it in the middle of the paper; use either a high or low horizon line.

After you decide what your painting is going to say (and it certainly should be something to grab the viewer's attention), your center of interest should shout "Hey, look at me!" Don't try to say too many things in that area, however, or you'll confuse the viewer. The supporting elements in the painting should never over-power your main subject. You want paths and pointers that lead the eye to the center of interest and paths that lead the eye around the rest of the painting, but these must always lead the viewer back to the main event. I try to put the most detail (and the strongest value contrasts) in the center of interest and less in the supporting elements.

This diagram shows how to arrive at the center of interest. The paper is divided into quarters; then each quarter is crossed diagonally by lines drawn from each corner. The points where these lines intersect are a good place for the center of interest, because they are optical points on which the eye naturally focuses.

This diagram shows the center of interest for the painting shown below.

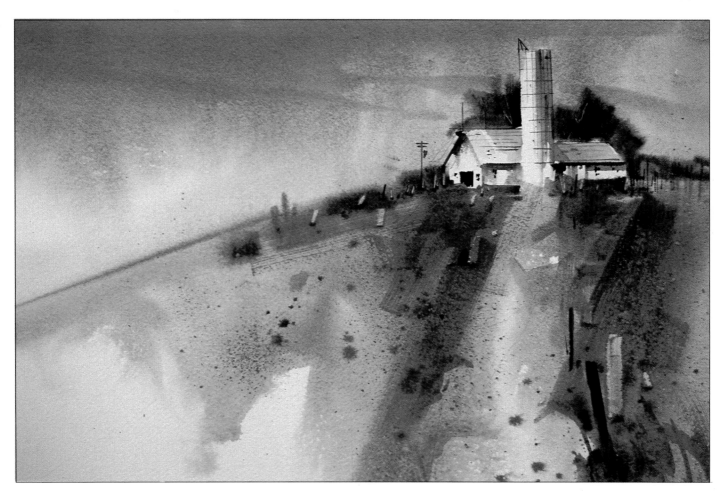

I placed this painting's center of interest in the upper right quadrant of the paper. As you can see, the rest of the painting was built out from there.

This diagram shows how the center of interest was developed for the painting at right.

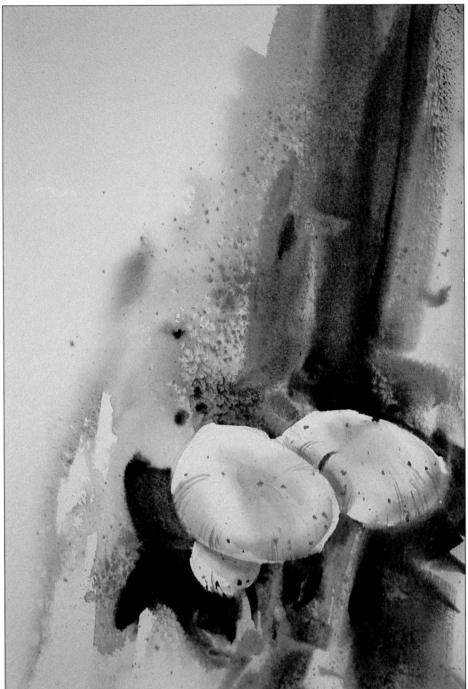

Untitled (14x9). This painting's center of interest was placed in the lower right quadrant of the paper. The rest of the painting was developed from that point, while keeping it subordinate to the subject matter. By the way, the idea for this painting came from something right out of my woods. (*Collection of Mr. & Mrs. John L. Hughes*)

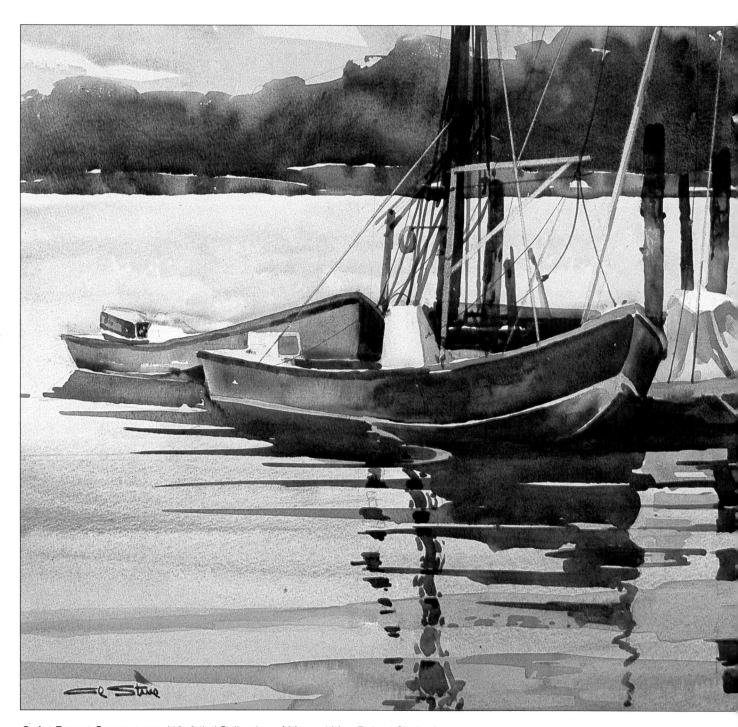

Quiet Day at Georgetown (18x24). (*Collection of Mr. and Mrs. Robert Skelton*)

CHAPTER EIGHT

A Good Beginning

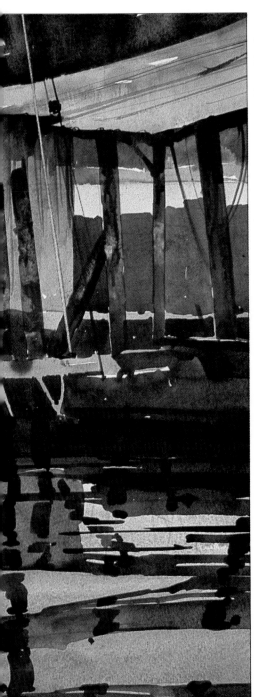

The key to success in the starting process is more smart thinking as you paint. Let's say you've done the preliminary thumbnails, making decisions about the composition of your painting. You've decided what goes in and, equally important, what stays out.

Following the rules of design, you've made sure you have a center of interest to act as a focal point for the viewer's eye. You've thought about dominance and harmony and variation. Then you've done a larger value sketch based on your choice of the best thumbnail. This value study has helped you place your lights and darks effectively. Now you just need to transfer the drawing to the watercolor paper, and you're ready to begin.

Don't forget that the thinking process has to continue after you have started to paint. For example, if you begin with a midtone wash you have to think about what comes next, because the darker dry on wet washes are painted before the first wash has dried. Luckily, you already have a good idea where they are going to go from the value sketch.

Now let's see how you can do some more smart thinking. Choosing the right way to start each painting is an important part of painting smart. Please don't fall into the trap of always starting your paintings the same way just because you're comfortable with it.

I believe that having clearly defined goals is a powerful incentive for better painting. These goals should be set high; you might not achieve all of them, but you will reach a higher plane than if you had not aimed high. One of my own goals is to learn one new technique each year that really improves my painting. Not tricks and gimmicks, but a technique that makes all of my paintings better.

However, learning new techniques cannot be an end in itself. I remember a story Fran Larson, a fine watercolorist from New Mexico, told me. There were these two folk singers and one said to the other, "When you sing the same song I sing, it sounds so much better and so much truer." The other replied, "When you sing the song, you get in front of it, and when I sing it, the song gets in front of me." So it is with painting techniques. When we work in watercolor, the concept has to get in front of technique. Why you paint and what you want to say to others are more important than the technique you use to do it.

The First Step

One of my favorite methods of getting started is to lay a midtone value over most of the paper except for the places I want to keep white. One advantage to working with midtones is that it helps overcome our fear of the fresh blank paper. We all feel it when that pure white sheet is staring at us, almost challenging us; a feeling of uncertainty sets in as we ask ourselves, "What do I do first?" Well, when we know our first step will be applying the midtones, we have a ready answer to that question. And since we have a value sketch showing us where we plan to save our whites, we know where those midtones should go. That fear of the blank paper soon disappears.

Although the lights and darks in a painting make it sparkle, the midtones hold it together. Midtone values give unity to the painting's design and make the lights and darks work. Since I already have the whites located on my value sketch, it acts as a road map as I paint. (See, our smart thinking done in the planning stage is helping us already.) While this midtone value is still wet, I work in the darker midtone values, using a dry on wet method. (If the first wash does dry, wait until the paper is completely dry, rewet the area you wish to paint with clear water, and then paint into it.) At this point I usually paint in background trees and the foreground; they will dry with lovely soft edges. I can then go back to add darker details and calligraphy.

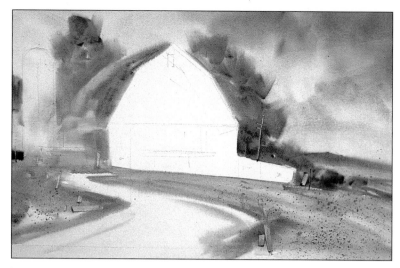

I started this painting by wetting the paper with clear water except for those areas that I wanted to leave white, the barn and the road leading to it. While the paper was still wet, I painted in the sky wet in wet. The trees around the barn were painted dry on wet as were the foreground and the shadow side of the barn.

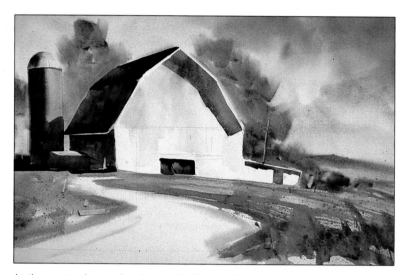

In the second step, I painted all of the midtone and dark values.

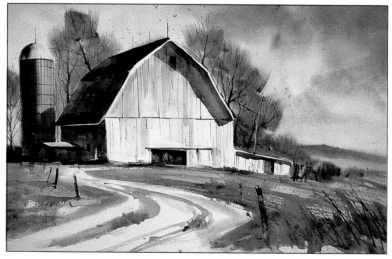

In the final step, I painted in the details on the barn and silo. I indicated the trunks and branches of the trees with a rigger. In order to develop the foreground and add a greater feeling of depth, I painted in the tracks in the road and some weeds in the lower right.

Another way to get started is to lay in a big sky area first. Laying in a large area of sky will also relieve the tension created by all that white paper. Use a large flat brush and paint it in. Don't worry about trying to paint specific cloud formations; just lay in something that says sky and clouds. Do it quickly and don't work back into it or try to change it. Put it down and let it go. If you don't like what you have, don't try to fix it. Chances are good that it will look better after it is dry.

A third way to start is to begin with the darks. Although most of my paintings are painted from light to dark, at times I put in my darkest dark first and key the rest of the painting to that. In general, I like to get my final value with the first wash, rather than build it up with successive layers of color. One of the problems I have found among students who are working from light to dark is that they do the painting layer by layer with weak washes that slowly build up to the value they had intended. This not only tends to muddy up the color, but when they try to add the really dark values, the values are already so dark that they can't get a good, strong contrast. The result: a muddy, lifeless painting. Layering is a timid approach and invites muddiness, so I recommend that you avoid it.

Remember that watercolor dries about 20 percent lighter than how it looks when wet. That means the values should look even darker than what you want when you first paint them. If you make a bold, dark wash the first time, you won't have to build up values by layering. To get those rich darks, you need plenty of fresh, soft paint in the wells of your palette. Not allowing yourself enough paint or trying to use dried paint forces you to scrub around for enough color to get the job done. This wears out the brushes and rein-forces the timid approach. So don't hesitate to squeeze out plenty of fresh paint from the tube. If there is a deposit of dry paint on the palette from your previous painting session, wet it with the sprayer about an hour before you begin painting to soften it up.

To start this painting, I wet the entire painting with clear water. I floated in a gradated wash for the sky while the paper was still wet. While this wash was still wet, I painted the pine boughs dry on wet because I wanted the boughs to diffuse a bit but still retain their shape. While the paper was still wet, I immediately went on to paint the sand dunes and weeds.

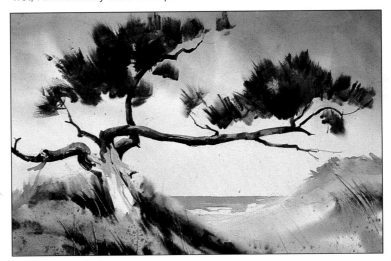

When the paper had dried completely, I painted in the large mass of the tree. Then I painted the sea in the background. I painted the top of the dune on the right a bit darker so it would contrast with sky better.

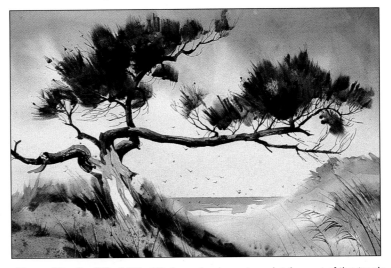

Shaped by the Wind (13x19). I used a rigger to paint the rest of the tree's lacy branches. A few more details were added to the trees to enhance the lacy effect. I also added more weeds. (*Collection of Mr. & Mrs. Robert W. Klatt*)

I started this painting a bit differently. Instead of washing in my midtones, I first wet the surface of the paper with clear water, again leaving dry the areas I wanted to be white. While this first wash was still wet, I flooded in a wash of cool blue over the same wet areas. This got me started by covering with color the areas I will work in wet in wet.

While the cool blue wash was still wet, I painted in the sky, the background trees, and the foreground. I continued to add detail while these areas remained wet. To add interesting texture, I scraped in the branches in the background trees and spattered, stamped, and scraped in the foreground.

At this point I decided the background trees to the right weren't dark enough to separate them from the building. When the paper had dried completely, I rewet the area and painted in a slightly darker value in the trees. I needed to rewet an area large enough to avoid getting a hard edge where the color stops diffusing. In this instance, I rewet the area beyond the trees and not just the trees themselves. Next, I painted the barn and the other structures. I used salt on the face of the barn for texture.

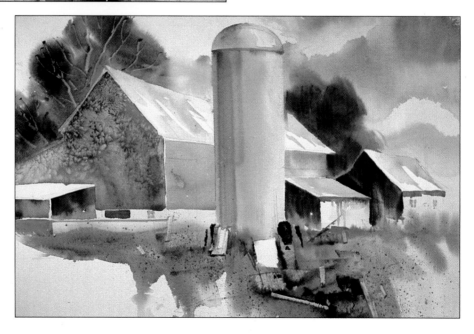

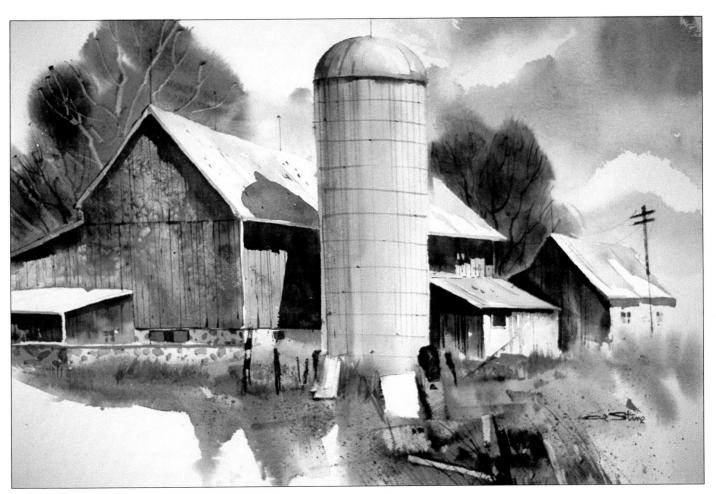

October Morn (13x19). When everything had dried again, I added the details to the silo and buildings. The telephone pole was stamped on with a piece of matboard, and a little calligraphy indicated the trunks and branches of the trees. I also added some more weeds.

I started this painting by wetting the entire surface of the paper with clear water, leaving only the barn dry. Then I painted the sky wet in wet using gradated washes so it was darker at the top right and lighter and warmer near the barn and the horizon. All of the foreground shapes were painted dry on wet. I wanted to have a soft, diffused quality here so the details I painted later would contrast nicely.

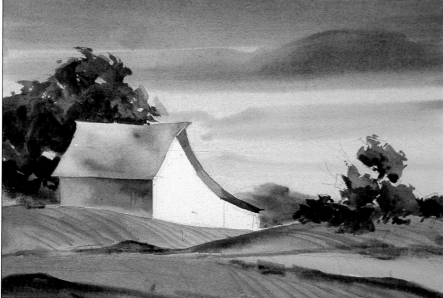

I painted the barn when the paper had dried completely. The trees were painted with a wet on dry method instead of wet in wet. This is a departure from the technique I used to paint the trees in other paintings in this chapter. As you can see, we get an entirely different effect.

The darks of the barn were painted in the final step. I also painted in the trunks and tree branches and added details to the foreground. I made some of the edges of the ground a bit harder for clarity and added the rows of plantings. I softened some of the edges here with clear water. Finally, I stamped in the fence posts with matboard.

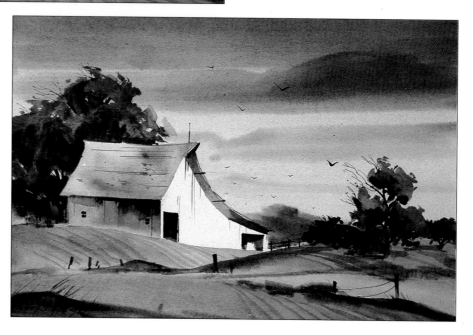

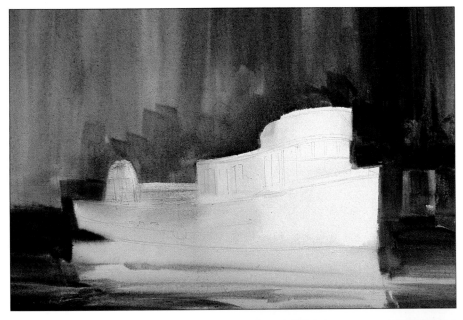

This painting was done on 112-pound Crescent rough watercolor board. I started with the wet on dry method, using vertical strokes to paint in the background around the boat and horizontal strokes for the water.

In this stage, I added a few more darks and let it dry. I then masked off the masts and some rigging with white artists' tape and lifted the color by scrubbing with a clean, damp sponge.

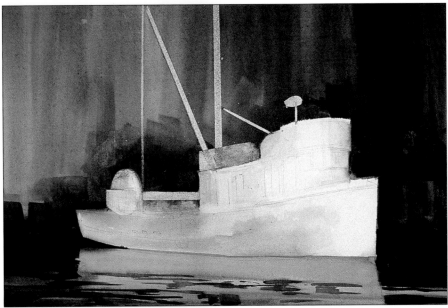

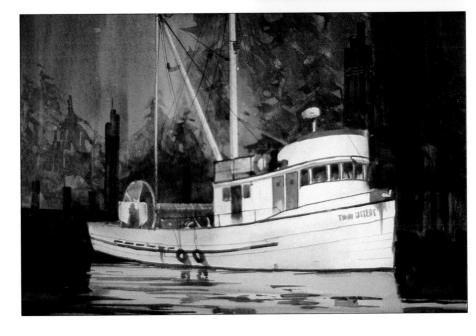

Twin Sisters (13x19). I painted the details of the boat at this point. I also defined the dock a bit more and added some large ballards in the background. As the last step, I painted some trees in the far background. (*Collection of Dorothy DeVaughn Dent*)

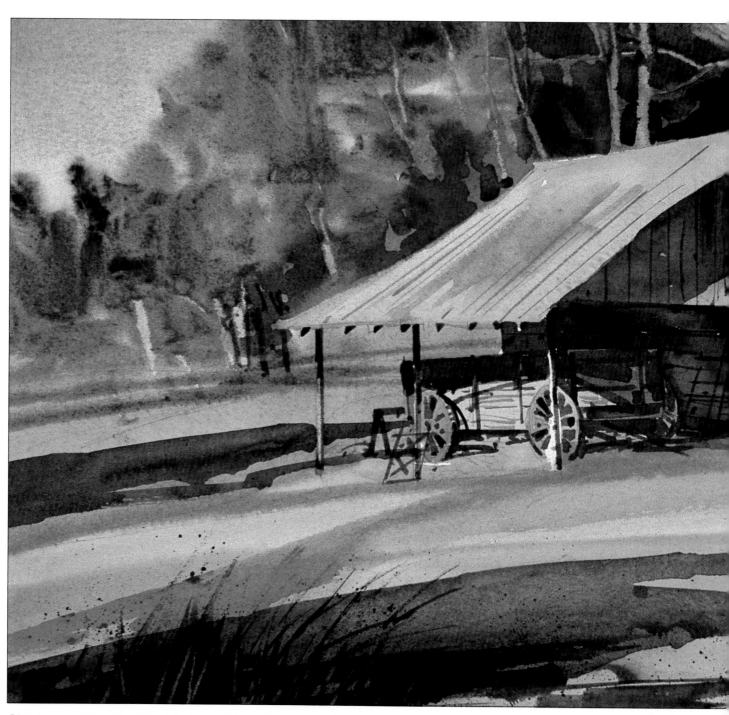

Shadows of the Past (9x14). Once while driving through Tennessee, we decided to stop at the Museum of the Appalachians. The quality and number of restored log buildings, including a blacksmith shop, broom factory, and grinding mill, were quite a surprise. I especially like this painting because of the seasonal colors. A nice, warm glow was captured in this painting. (*Collection of Mr. & Mrs. Kenneth Klatt*)

CHAPTER NINE

A Great Ending

In the last chapter we concentrated on starting a watercolor, laying in the large areas and midtone values. This put our framework into place. We now move to the finishing stage of painting—the addition of darks, detail, and the placement of textures. This is the part of a watercolor that makes it sing and sparkle, which gives it life. I have noticed that some of my students do a very nice job of laying in the midtone values or the framework of the painting but then overwork the painting in the final stages. They put color over color, working back into areas where the color is still wet. These mistakes make a painting scratchy-looking and muddy.

Some of the paintings in the following demonstrations will be developed in a light to dark fashion, others will be finished by painting the negative space around the subject. We'll look at ways to save a painting after it has gone sour—it can sometimes be done, by scrubbing out areas that have gone wrong and repainting, for example. It's a question of when to call it quits.

It may be my background in illustration, but I personally don't have a tendency to overwork a painting. If you feel that you just have to change a value, don't work back into that area until it is completely dry. To illustrate my message about overworking, I did a demonstration painting and took a photograph of it at the point at which I'd normally quit. Then I continued to paint and overworked it. I hope you can see the difference, as this was a difficult job for me; it goes against my grain to overwork a painting like this.

I have noticed that it does take a lesson or two with my students before they get the message—at which time their painting improves immediately. If you have developed the habit of overworking your paintings, it may help you to imagine that little man some artists joke about who stands behind you, ready to hit you over the head and say, "Enough!"

One of our great watercolorists, John Pike, kept a large sign in his studio classroom that read "K.I.S.S."—his reminder to "Keep It Simple, Stupid." If you need a big sign hanging in the room where you work to keep you on track, by all means put it there.

Painting from Start to Finish

Let's take a look at two paintings from start to finish. Although you'll observe all the stages from the beginning, I'll concentrate on what I did to give each painting just the right finishing touches. Painting smart requires building your painting purposefully, not just letting things happen and trusting entirely to luck to have them turn out well. When you become adept at painting smart, you will know when your painting is finished—when it doesn't need one stroke more or one stroke less.

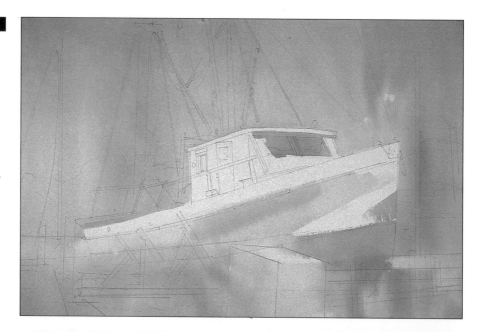

1. Initially I wet the entire paper with clear water except for a few areas of the boat. While the paper was still wet, I laid in a wash of cool blue. I used a cool underwash because the final colors of the painting would be warm, and I wanted to develop the play of warm against cool.

2. In the second step, I used a mixture of French ultramarine blue, burnt sienna, and a color called "Opera" made by Holbein (a new color for me). I painted in all the midtones with mixtures of these three colors and used a spray bottle filled with clean water to soften some of these edges, letting them run in places. "Opera" is a beautiful color but I'm not sure how permanent it is, because it was only recently introduced. It seems to give good results when mixed with other colors but isn't permanent when used alone.

3. Labor of Love (16x24). The finishing touches included the addition of all of the details on the boat, cradle, masts, and rigging. I also lifted some areas to reclaim whites. Look at the two posts to the right. This alternation of value adds interest to an area that could be very ordinary.

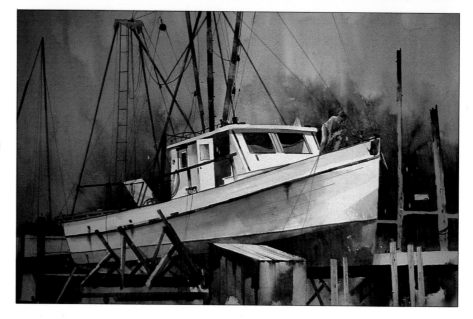

I began painting this red barn by wetting the sky area as I worked around the barn structure. While the sky was still wet, I painted the trees dry into wet, then scraped in the trunks and branches with the end of a brush handle before the trees dried.

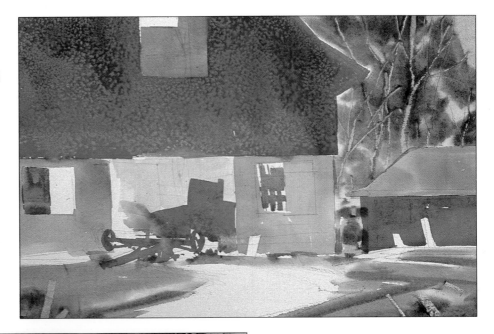

As a final step, I painted the local colors of objects showing through the windows and the other barn openings as well as the hay in the loft. Some darks were added under the barn and shed roofs to indicate shadows created by the overhead light.

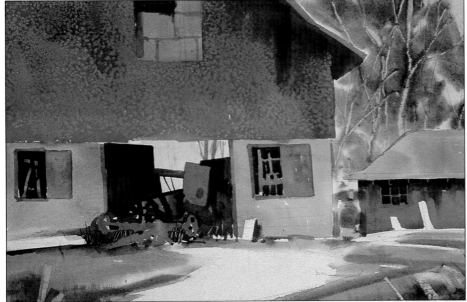

Is a Barn Red? (9x14). For the finishing touches, I painted in the indications of the boards on the wall of the barn and shed and added more detail using negative painting in the window openings and main door of the barn. I didn't want to conjure anything specific in this detailing, but rather to suggest that something was in there. Some stones and cracks were indicated along the concrete wall, and I added a few weeds and tracks to the foreground. I used a scrap of matboard to stamp in the posts in a dark value.

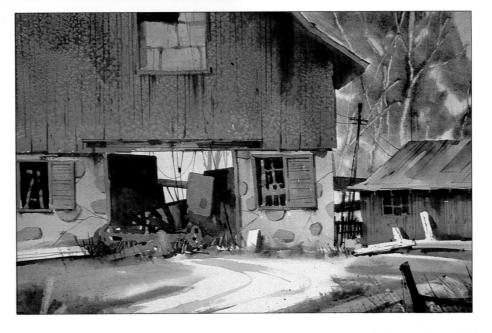

Knowing When to Quit

I've often looked at paintings being done by my students, or even by professionals at demonstrations, and wanted to say, "Enough already, quit!" Knowing when to quit is one of those things you have to learn for yourself. The most important thing in finishing a watercolor is to make sure that the values are right. If you don't have the right value contrast to spotlight your subject matter, the painting will fall flat. This is the most important thing to consider when you do step back from your painting. You can easily appreciate the importance of strong value patterns when you look at paintings in shows. I'll bet that the ones that catch your eye are the ones with good value patterns. A watercolor may be well drawn, well designed, and have great subject matter, but it won't succeed without a good value pattern. So think while you're finishing your painting and make sure it's all as good as it can be.

I keep an old mat at my drawing table, which I place around the painting when I'm nearing the final stages. This immediately eliminates those messy edges around the painting and helps me decide whether I am finished. After eliminating the messy edges I may decide that I need to work on a certain area a bit more. There is nothing like using a mat on a painting to bring those areas into focus.

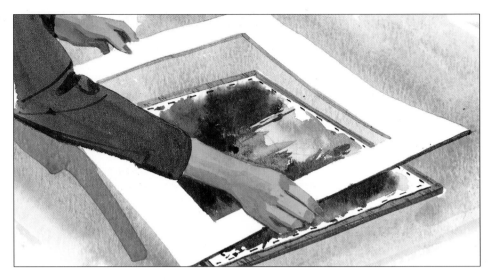

Keeping an old mat handy to place over your painting when you're nearing the finishing steps eliminates the messy edges and helps you to judge if it needs more work or if it's finished.

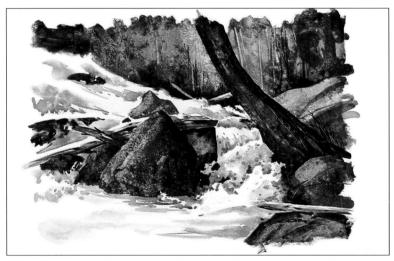

Notice how messy the edges are in this painting of a rock and river scene. This has a tendency to distract you, making it hard to know when the painting is finished.

Cascade Canyon (9x14). Now here's the same painting with a mat. When I put the mat over the painting, I could see that the painting was indeed finished. It also showed me where to put my signature; I have, on occasion, signed a painting without using a mat as a guide and signed too close to the edge of the mat or even under the mat.

Overworking a Painting

As you can see from the demonstration here, overworking paintings causes sorry-looking watercolors. The timid approach we discussed in an earlier chapter is usually to blame. Putting in first washes that are too light in value and going back over them before they have completely dried in order to build to the desired value are common causes of mud. When you go back over a color that hasn't completely dried, you disturb the underlying color, which then blends with the color you are attempting to lay over it. Mix individual puddles of color on your palette and place them on your paper, allowing the colors to blend on the paper rather than on the palette. Keep in mind that the colors will dry about 20 percent lighter and mix your values accordingly. Lay in your colors and don't work back into them; they will remain fresh and crisp. Even if you're not satisfied with what you've painted, don't work back into it.

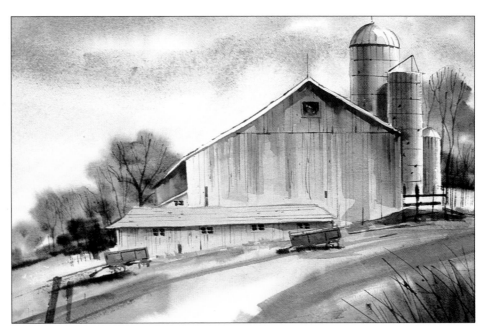

In this painting I laid in the sky wet into wet and, before it dried, painted in the trees dry on wet. The final steps were to paint the local color of the barn and silos, then the foreground. Using an old mat to frame the painting, I decided that it was finished.

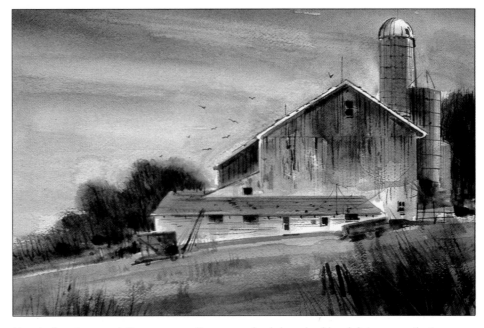

Here's the same painting, now really overworked. I worked back into areas that weren't dry and created all the fuzzies, then worked back into the sky while the previous washes were still wet. In fact, I tried to do all the wrong things I could think of to demonstrate my point. To avoid overworking, stop, look at your painting, and keep it simple.

Sponging Off— Saving a Painting Gone Wrong

There will be times when you'll become so dissatisfied with a watercolor that you'll be sure you'll have to discard it if you can't do something to save it. Sometimes you can take the painting to the sink and sponge off parts or even all of it.

When you sponge off a painting you must remember to wait for the paper to dry completely before you start to repaint it. If you don't, you will create fuzzy edges and blossoms, which you certainly don't want.

Sponging colors off any surface will leave a faint tint on that surface. Sedimentary colors, such as French ultramarine blue, and earth colors, such as burnt sienna, sponge off quite easily, but staining colors, such as Winsor or Thalo blue, will be more difficult to remove. How well the colors sponge off depends on the surface you're using. The colors will sponge off a smooth surface, such as the Kidd Finish Strathmore Board or the 112- or 114-pound Crescent Watercolor board, very nicely. If you're working on Arches cold-pressed or rough, though, you may not do as well, but you'll still be able to scrub off enough to repaint the areas and save the painting.

Try sponging off a painting you had planned to discard anyway, and see for yourself how it works. You can also mask off and repaint a small passage that is not working. Watercolor paper is a lot tougher than you might think and will stand up to a real beating. Just be sure you use a clean sponge and keep rinsing the color out of it throughout the entire scrubbing process.

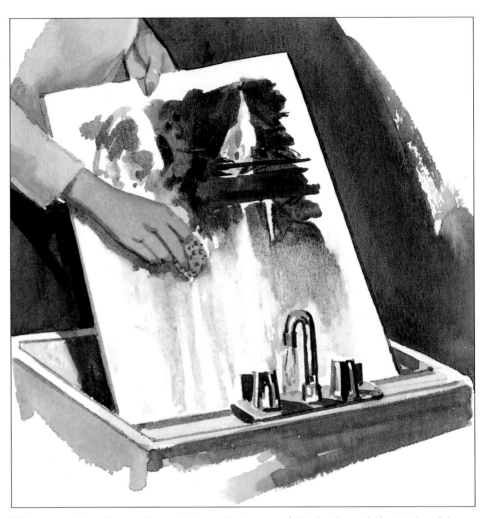

When sponging off an entire painting or just areas of it, take the painting to the sink and use a small natural sponge to scrub it. Keep rinsing the sponge under the tap to keep it clean. The sponge must be kept free of color or a muddy tint will remain on your paper.

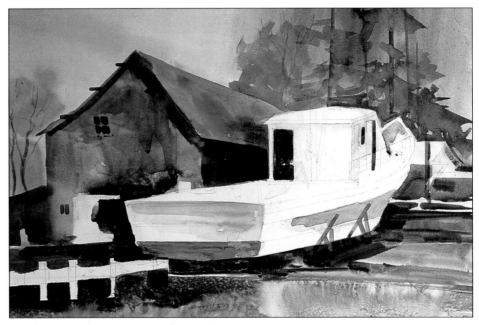

I painted this boat, laid up in dry dock for repairs, on Strathmore Kidd Finish board. But the painting was just not working at this stage, and I felt that any more work on it would be a waste of time. The trees and building seemed to distract from the center of interest, so I decided to take the board to the sink and sponge this area off.

At the sink I sprayed the painting with clear water and used a small sponge to scrub off the unwanted top area. Because I was working on a smooth surface, the colors came off quite easily. In fact, I repainted the upper area, still didn't like it, and scrubbed it off a second time.

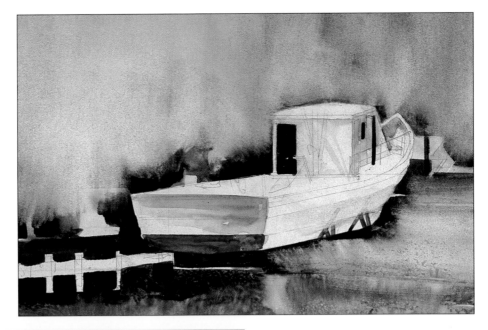

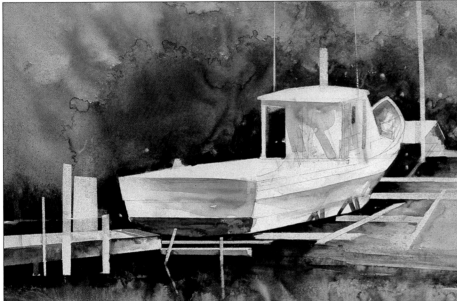

I repainted the upper area for the third time, with the board tilted away from me, and worked around the boat. Then I sprayed this area—especially the outer edges—using a spray bottle and let the runs develop wonderful, diffused edges. I lifted the color in several areas by masking them off with white artists' tape and scrubbing with a small, damp sponge.

Prodigal Son (13x19). In this final step, all of the details were painted on the boat. Masts and rigging were painted in, and a few more darks were added in places. The painting was finished. (*Collection of Mr. & Mrs. Kim Klatt*)

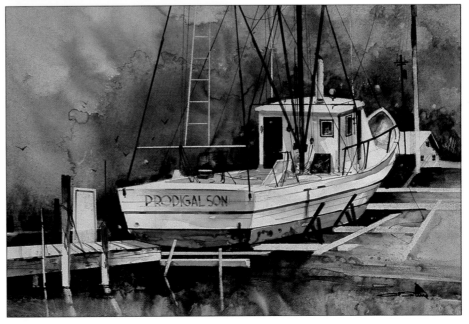

Reclaiming Whites

Frequently, you'll lose whites that you had planned to save or feel you need to reclaim more whites to improve your painting. Sponging off a small area can be risky; there's always the chance you'll change another area you don't want to disturb. When you want to lift color from specific areas or to lift whole areas—such as leaves, masts and rigging on boats, or parts of buildings—as part of the design, you can use artists' tape or stencils.

Let's look at stencils first. I generally use the paper found on disposable palettes to make stencils because it has a waterproof surface and can withstand the scrubbing. Although I prefer this disposable palette paper, you can also use brown wrapping paper, old watercolor paper (which I find somewhat difficult to cut), or any other sturdy paper that will hold up. I cut the stencil into the shape I want to lift and place it on the watercolor paper. If I need a complicated shape, I lay tissue paper on the painting and draw the exact shape to be cut on to it. Then I lay the tissue paper on top of the stencil paper and cut the design with a sharp razor blade or X-Acto knife. Using a clean, damp sponge, I scrub the area within the stencil and immediately blot with a tissue to remove any excess moisture that could creep under the stencil and onto another area.

You can also use white artists' tape to reclaim whites. I keep a roll of it at my drawing board all the time, because I find it especially useful for reclaiming areas—for masts on boats, square areas such as signs and roofs, telephone poles, and so on. Simply mask off the area that needs to be reclaimed with strips of tape on the paper when it's bone dry. Then scrub the area inside the strips with a clean, damp sponge. When I paint a boat scene with a lot of masts and rigging, I find it is generally easier

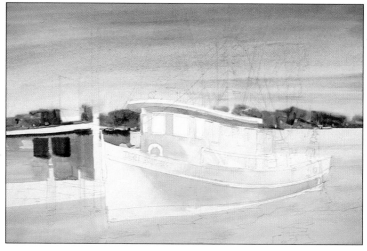

I wet the entire upper surface of the board with clear water and painted the sky wet into wet. While this area was wet, the background trees were added dry on wet. Then I worked the water wet on dry, using the same colors as the sky, painted the dock and fishing shack, and put some local color on the boat.

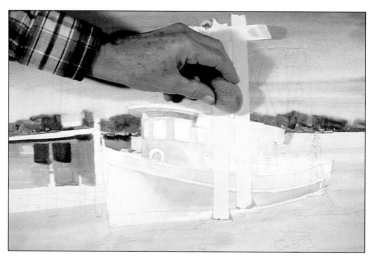

After the board was completely dry, I used white artists' tape to mask off the masts, some rigging, and the sign on the left. I then scrubbed the color out with a clean, damp sponge, blotting with a tissue to keep the moisture from seeping under the tape.

Here you can see how the painting looks when all of the lifting has been done. As long as you are not using a staining color, you can bring the lifted areas back to near white.

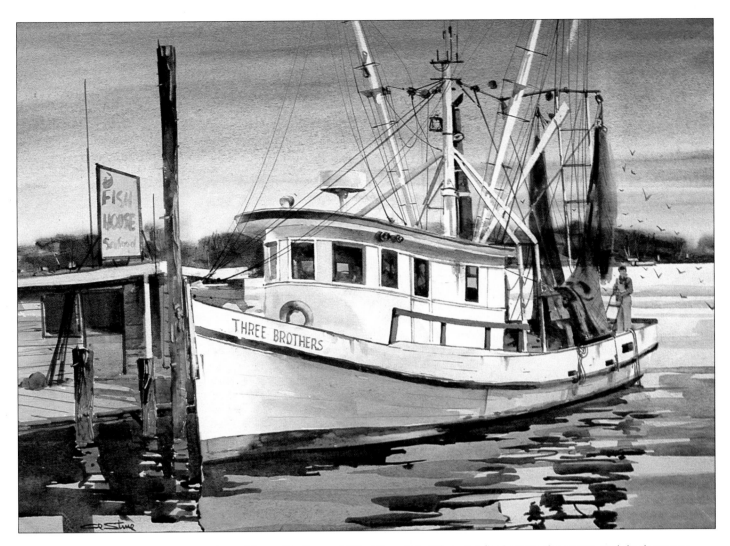

Three Brothers, Little River (14x19). In the final stage, the masts and rigging were painted in to give form and add definition. All of the details on the painting were added at this time, including the nets, dock, and the posts to the left. The last step was to paint the reflections on the water; this kept the boat from looking as though it were floating in the air and added life to the painting. (*Collection of Mr. & Mrs. Forest Suggs*)

to scrub these whites out than to mask them off with a masking fluid or attempt to paint around them. Masking fluid leaves a hard edge and also makes it difficult to paint fine lines. (I've found that putting a light value of a color on the paper before using masking fluid keeps you from getting objectionably stark, white shapes.)

As in sponging off, the success of this kind of lifting depends on the paper or board you're working on. I use the 112-pound Crescent board for most of my marina and boat scenes because the color rides on the surface (unlike Arches paper, where it sinks) and can easily be lifted. Although you'll want to try different types of surfaces, I think you'll be consistently happy with the results you obtain on the Crescent board.

The first step was to paint in the local color of the sea and beach. I painted right over the seagull that I had penciled on the board as I could lift that area back to white later.

After the first washes had dried, I further developed the wave action and picked up some of the sand color showing through the water.

After the board had dried completely, I cut a stencil (or frisket) out of disposable palette paper and placed it over the seagull. With a clean, damp sponge, I scrubbed the color off while constantly blotting with a dry tissue to keep moisture from creeping under the stencil.

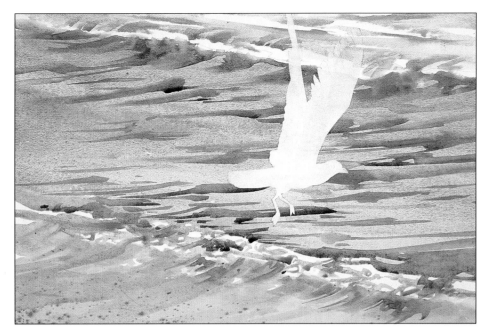

Here you can see how the painting looked after I scrubbed off all the color from the area where the seagull would be painted. This method gives you a rather hard edge but not nearly as hard as I would have gotten with masking fluid. In fact, depending on the way they are scrubbed with the sponge, some of the edges can be a little on the soft side.

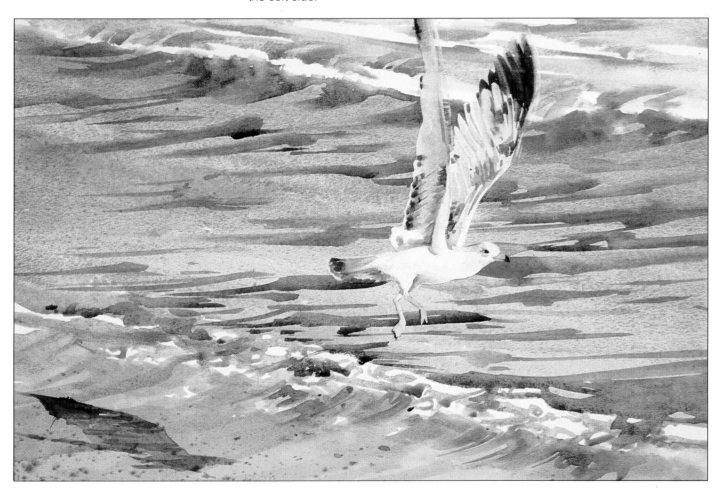

Take Off (14x19). All that remained to be painted in the final stage was the seagull. I tried to diffuse the left wing to indicate a little motion especially at the top of the wing. Then I painted the shadow of the gull, trying to indicate that the shadow was cast on a thin wash of water covering the sand.

Finish with Negative Painting

I can still remember the first time I heard the term "negative painting." It all sounded like a big mystery to me, and I was sure it was something I didn't want to know about anyway. I was wrong; there's no big mystery—in negative painting you are simply painting the space around an object rather than painting the object itself. Negative painting is one of the most exciting ways to paint parts of a watercolor, so don't let the term scare you.

I recently had a student doing only her third watercolor who wanted to do a painting of flowers. I showed her how to lay in an experimental design of color all over the paper. When it had dried, I showed her how to bring out a flower by painting the space around a petal and then washing the outer edges away with clear water. Her eyes lit up—a whole new world had just been opened to her! This is one of the joys of teaching watercolors, to watch the progress of your students.

Negative painting can be used in so many ways. It brings out all of the subject matter but gives a much softer effect, a more diffused look. You paint shapes, not things, and painting the negative spaces around a shape will keep your painting from looking too linear or like a colored line drawing. You have to decide for each area of your painting whether to paint the object itself or the space around it. I think, though, that once you've tried negative painting you'll be as hooked on it as I am, and will constantly find uses for it.

I started this painting without any preliminary drawing, except for a line to indicate the division of space. I laid in the colors, sprayed them with clear water, and blotted with tissue to develop textures for the background.

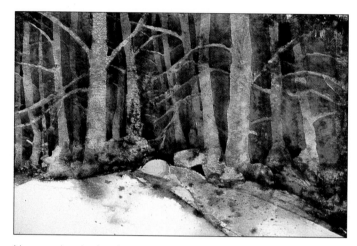

I began developing the trees in the background with negative painting—painting the spaces around the trees. The colors that I achieved in the previous step became the colors of the tree trunks as I darkened the areas between the trunks by painting a color beside a tree and washing the outer edges away. I could then further develop the trees while retaining a soft feeling.

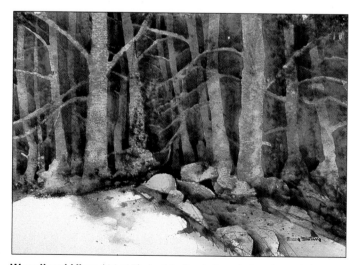

Woodland View (11x15). In this final step, I developed the rocks in the foreground with negative painting. I added some darker values to the trees in the same way.

Negative painting is an effective method for subjects other than flowers. One painting shows a forest where all of the trees in the background have been brought out by painting the spaces around them. I also took two rolls of print film of mushrooms growing on the forest floor because they were so beautiful, and I felt that they would make lovely paintings. I chose the mushroom subject for a demonstration painting because of the complexity of the leaves, twigs, and other matter on the ground, feeling that the best way to paint it would be to paint the negative spaces. This is a good example of finding material for paintings in your own back yard—I only had to walk a little way from my own back door to find these subjects.

First I wet the entire paper with clear water and painted experimental free shapes wet into wet in a light midtone value. I painted around the mushroom, leaving it mostly white.

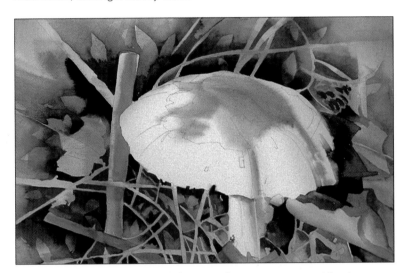

In the second step, I painted the negative spaces around the leaves and twigs.

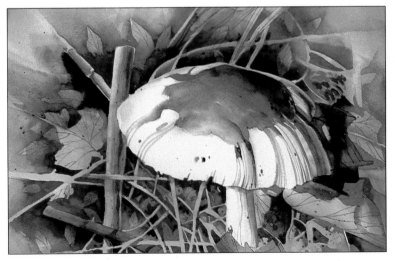

Forest Floor (9x14). To finish the painting I added details on the mushroom and some detail to the leaves and twigs lying about it. Most of the painting had already been finished with the negative painting, leaving very little to be done at the end. (*Collection of Mr. & Mrs. Herbert Barten*)

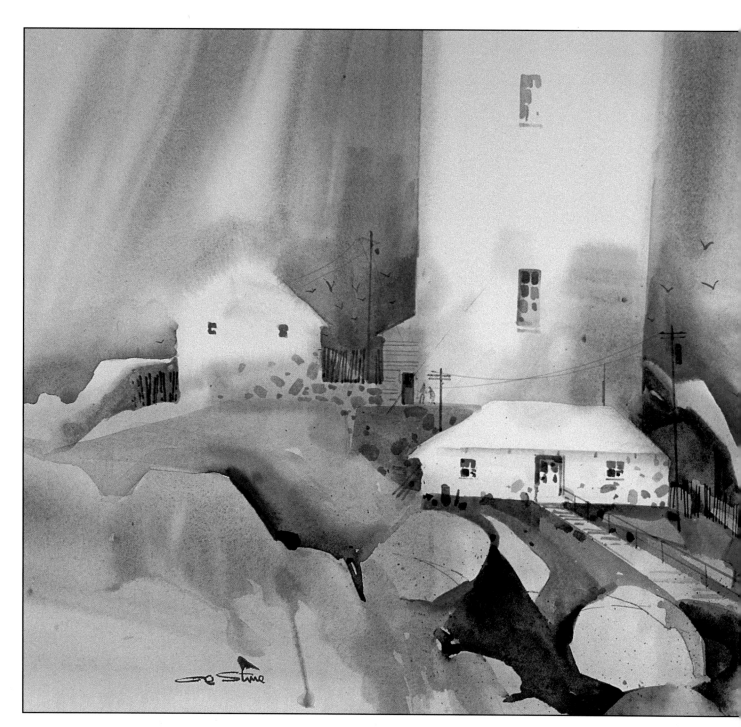

Fantasy Shore (13x19).

CHAPTER TEN

Playing Around

Do you ever get bored with your watercolors? Have you reached a dead end in your search for subject matter and composition? Then here is one solution to your problems. Break away—get loose—have some fun and play around.

Even if you are relatively new to watercolor you may find yourself doing the same things over and over. This is particularly true if you tend to stick close to the safe and familiar. An artist thrives on challenges. Without them, painting becomes routine. No matter how experienced you are, you need to change the way you think and work to make new discoveries and to extend your artistic horizons. I think the best and most refreshing way to do that is to play around, trying new things, breaking away from the usual and having fun.

To me, playing around is an important part of my artistic life. It replenishes my creativity and keeps me from getting too serious about my art. After all, one of the reasons I love watercolor is that it is fun. I shudder to think of the time when watercolor wouldn't be fun for me. Time spent playing around is never wasted; instead, it is a wellspring of new ideas.

The key to productive playing around is your attitude—you have to be receptive, maintaining an open mind so you will recognize new things. Be willing to accept your "mistakes" and even to make them a part of your experimental process. Sometimes mistakes are the most creative things I do in the studio, but to make the

most of them I must analyze them and look for new possibilities and opportunities.

Playing around is easy too, especially when you limit the palette to only four or five colors for each painting. Try to use colors that you've worked with and know well so you can get the most out of them while concentrating on new ways to compose your pictures, or to create new textures, and so on.

Generally I begin my watercolors as thumbnail sketches, expand them to larger value sketches, and then paint in a more traditional fashion. These are the procedures we've worked on in this book up to this point. In this chapter, however, we're going to depart from the traditional and just have fun.

One departure from the traditional will be our use of abstract patterns. There is probably no word more misused and misunderstood by artists than "abstract." For many, it is a code word for whatever kind of art the user doesn't like, particularly that kind of modern art that isn't a representation of identifiable objects. For others, "abstract" means the opposite of "realistic." Realistic art looks more or less like a photographic image; abstract art is more stylized. For our purposes, I am going to define abstract as any pattern of color or shapes that does not form an identifiable picture of a real object. The rules of design work for all pictures, whether they are realistic, abstract, stylized, or whatever you want to call them.

An Experimental Composition

In this exercise you're not looking for subject matter, such as barns or trees, but for satisfying compositions. Using two *L*s made from stiff paper, such as a file card, form a frame to lay over a photo from an old magazine you don't mind cutting up. Move the frame over the picture until you find an abstract composition that pleases you. You're looking for shapes with unusual character and balanced light and dark arrangements rather than recognizable pictures of things. You can turn the image in any direction—horizontal, vertical, diagonal, or upside down.

These little compositions should be cut out and pasted down on file cards to use as basic plans for future abstract underpaintings.

Make a small frame for finding abstract patterns in magazine photos and use them as the basis for abstract underpaintings.

Some of the small abstract patterns I have found.

Here I chose an experimental composition and penciled in the large shapes on my stretched paper.

I thoroughly wet the paper and painted the space relationships present in my small composition. I used middle light values, working wet in wet and planning where to save my lights. I worked quickly to finish the underpainting of French ultramarine, Winsor blue, and cobalt violet before the paper began to dry.

I decided that my subject would be flowers. After the paper was completely dry, I started developing the shapes of the flowers with negative painting, working around an edge, then washing the color out with clear water. I added some darker values at the base of the flowers and a little color excitement in the flowers with cobalt violet and brown madder alizarin.

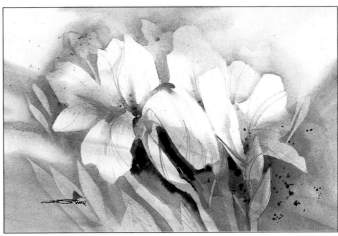

Iris (9x14). When the paper had again dried completely, I developed some leaves with negative painting. I also cut friskets and did some lifting of leaves by scrubbing them out with a small, damp sponge. I also added some calligraphy on the leaves.

From Experimental Composition to Underpainting

An underpainting is exactly that, a well-organized layer of color just beneath the subject matter. It will give color harmony in the finished painting and help hold the painting together with good composition. Choose colors for the underpainting that will be right for the mood you want for your painting.

The underpainting should never fight with the subject matter, so a few issues must be considered at the outset. It is best to employ a wet in wet technique in this first stage, using only light to midtone values. This is also the time to establish a color mood, playing warm against cool but letting one be dominant. Keep the underpainting simple; the painting will become more complex when the subject matter is developed using sharper edges in the second stage of the painting.

From Abstract Shapes to Reality

Abstract composition can be used for underpainting almost any watercolor, even if you are doing a realistic painting. Laying on those first abstract shapes in a daring, nothing-to-lose manner will help you loosen up even if you plan to tighten up on your subject matter. You can see in the finished painting of the steer's skull that the cool blue underpainting shows through in places to add a nice color bounce. Remember: warm-on-cool, cool-on-warm. Be daring in brushing in those first abstract experimental shapes and remember to plan for your whites. Don't get too dark on your lighter midtones and midtones and do it quickly. Put it down and get out.

When I do a watercolor that started with a well-planned and organized abstract composition as an underpainting, I find I usually wind up with a successful painting. The shapes and colors of the underpainting seem to hold the painting together with a unity of color and composition. In this series, watch how I develop an abstract composition for the underpainting. Then try a series of your own.

You'll choose your subject matter, perhaps a barn as I've done here, but don't let the subject matter influence you too much. You want to establish shapes, color, and value balance, and plan where your whites will go.

I roughly penciled in the skull of a steer, then used Winsor blue to brush in experimental shapes, reserving my whites where they would be most needed.

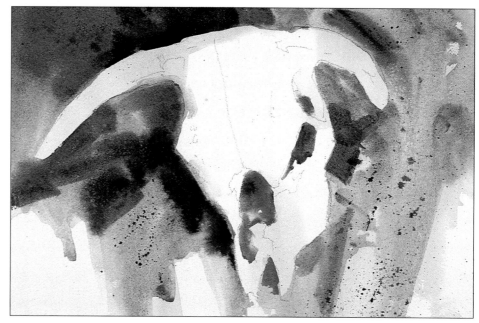

On the thoroughly dried paper I brushed in more experimental shapes, starting at the right with burnt sienna and gradating to the left with darker value, adding burnt umber and French ultramarine. I added some spatter with a toothbrush.

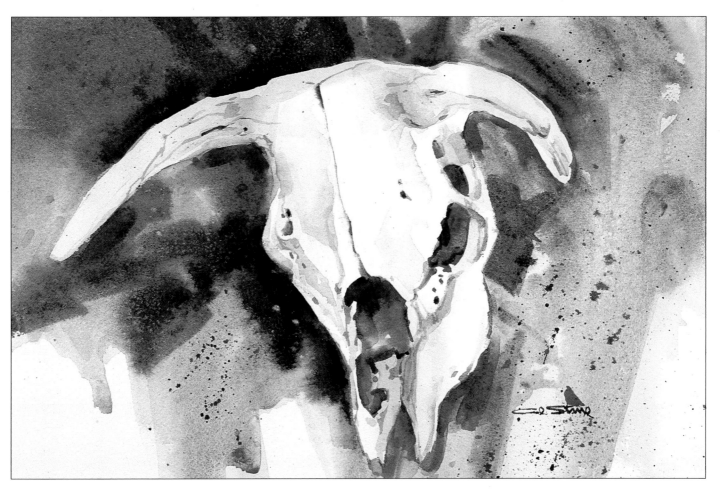

Only a Memory (9x14). The final steps included placing a few more dark values around the skull to help bring it out. Then I painted the skull itself, keeping it very simple, adding just enough detail to show the various planes and to indicate cracks and holes.

I thoroughly wet a stretched sheet of 140-pound Arches cold-pressed paper except for the areas where my plan required I save whites. I brushed in the colors of my experimental composition with a mixture of French ultramarine blue and Winsor green. Since the subject would be developed in warm colors, I used cool colors for the underpainting. When the underpainting was completed, I allowed the paper to dry completely.

I thoroughly wet the paper again except for the areas where whites were to be saved. I washed in the sky with burnt sienna. Using midtones and dark midtones that were a mixture of burnt sienna and French ultramarine blue, I painted the background trees, barn openings, and some shadowed areas. I also did some scraping with my brush handle in the foreground and added a little spatter for texture. You can see that the warm against cool underpainting really starts to make the painting sing.

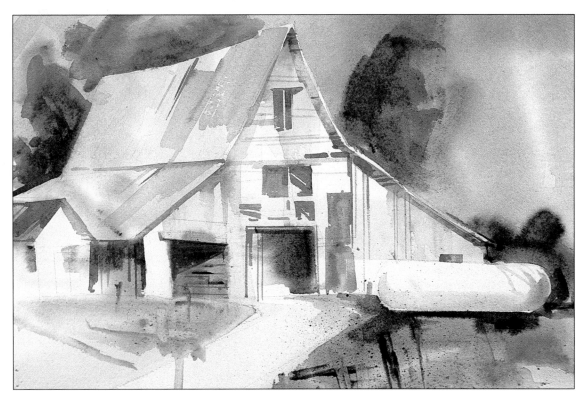

I indicated some shadows on the propane tank to give it roundness. I also put a few broad strokes on the barn roof and indicated some of the detail on the barn but saved the really dark values for last.

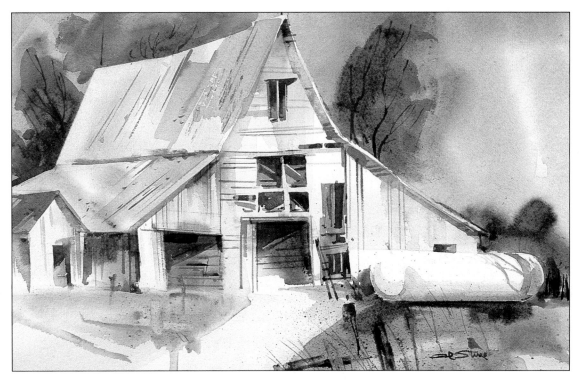

Indiana Moods (9x14). I added details to the barn and propane tank. Rather than try to portray them realistically, I added calligraphy to the trees with the use of a rigger and designed the branches to flow with the shapes of the trees. I think you will agree that the shapes say trees without my overworking them. I have also placed some weeds in the foreground with a rigger for additional depth in the painting. (*Collection of Mr. & Mrs. Robert Brenner*)

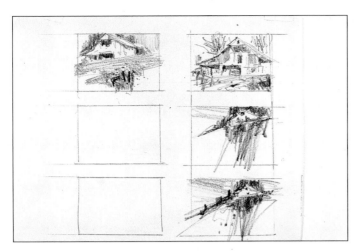

For this demonstration, I again used 140-pound Arches cold-pressed paper. I started by doing several thumbnails, selected the one that worked best for me (the one on the upper right), and did an enlarged pencil value sketch.

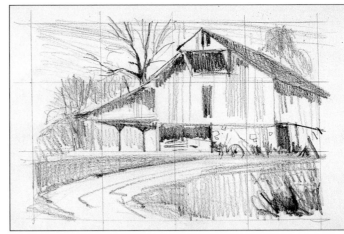

I squared off the enlarged sketch with grid lines and duplicated the grid, only proportionately larger, on my watercolor paper. I then transferred the drawing onto the paper very lightly so as not to mar the surface with too many pencil lines.

From Traditional to Experimental

Very competent painters get caught in the trap of always painting one type of subject in a particular style because it sells well. Painting in this way not only becomes very boring, but it also stifles creativity and stunts artistic growth. I hope this three-part demonstration will kindle some new ideas and fire your imagination. In the first demonstration you'll observe a rather traditional approach; the second is a little more experimental, and the third even more so.

In the last demonstration of the barn I worked on 112-pound Crescent Rough Watercolor board. Although Crescent describes this board as rough, it has a much smoother surface than that of the Arches cold-pressed paper. This board will give you entirely different effects when you are working wet in wet or dry on wet. You can lift colors easily because the paint lies more on the surface rather than being absorbed. The one drawback to this board is the care required when working one color over another; it is quite easy to disturb the underlying color. A plus in favor of using the board is that it does not require stretching.

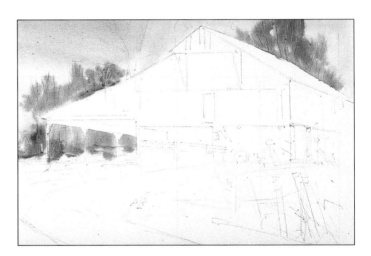

I thoroughly wet the paper, working around the barn area, with clear water. Into this I flooded French ultramarine blue with a little burnt umber. Working down I added cerulean blue and, still further down, a little raw sienna at the bottom. While the paper was still damp, I added the trees and foliage in the background.

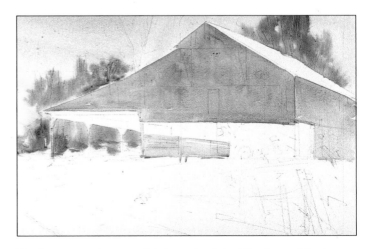

I let the paper dry completely and painted the face of the barn, moving from cool at the left to warm and darker on the right where it meets the lighter plane (along the roof line).

First I painted the local color of the concrete wall. Next, the foreground, gradating from cool at the left to warm and darker in the lower right. I added some scraping with the brush handle for texture and also did some spattering with a toothbrush for additional texture.

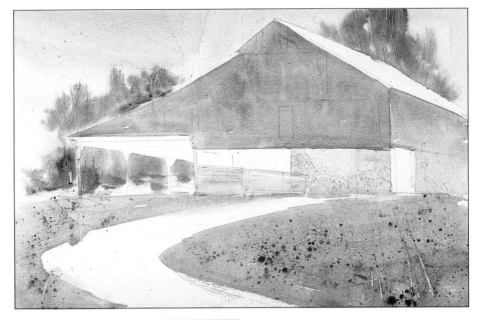

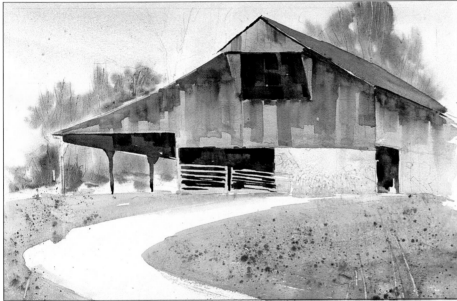

After the painting had dried completely, I added more detail on the barn. I completed the fence with negative painting.

Long In Use (13x19). I added more detail to the barn and put cracks on the concrete wall with a rigger. For balance, I added a tree to the left of the barn. Then I painted some weeds and grass along the road and at the base of the barn and indicated ruts in the road. After the painting dried completely, I erased my pencil lines.

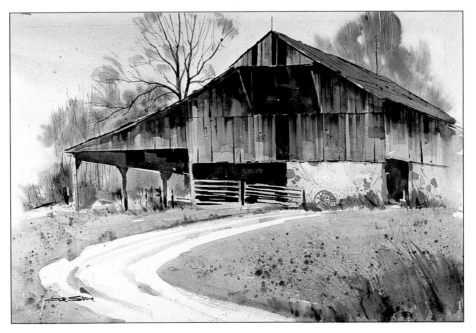

This pencil value sketch is an enlarged version of the thumbnail that was on the upper left in the original set at the beginning of this series of demonstrations (see page 120). This enlarged version served as my road map for the entire painting. Capturing the feeling and mood of the sketch in the finished painting made the additional work worthwhile.

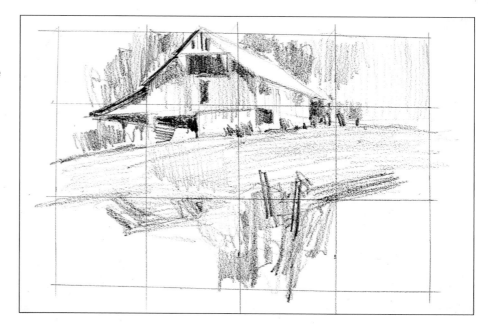

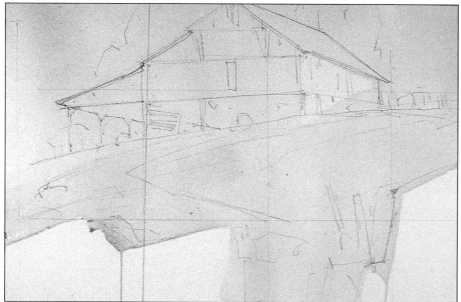

I changed my water, cleaned my palette, and was then ready to have fun with this painting. Using a very light value of Winsor blue (you can make your own substitute for this color by mixing French ultramarine blue and Winsor green), I brushed it on very juicy and wet over the entire surface except at the bottom where I wanted to create a soft shape fading into the white of the paper.

After the paper dried completely, I rewet the entire area except for the barn. On my palette I made three separate puddles of cobalt violet, raw sienna, and burnt sienna. I picked up these colors and let them blend and diffuse on the paper. I then worked in the darker tree area and foreground using the same colors with much richer pigment. I applied some color with a bristle oil painting brush where I did not want as much diffusion. While the areas were still damp, I used a brush handle to scrape and indicate trees and the posts in the foreground. I spattered some darker color with a toothbrush into the foreground.

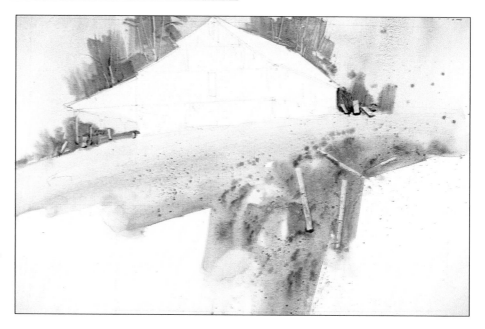

In painting the barn, I started with cooler colors at the top and warmed it up as I went down toward where the face of the barn should pick up the warm reflections of the earth. You can see some of the cool color of the underpainting where the warm color has been brushed over it. This gives that lovely contrast of cool against warm that we should constantly strive for. I then added some color to the right side of the barn and a rather cool and light value to the roof.

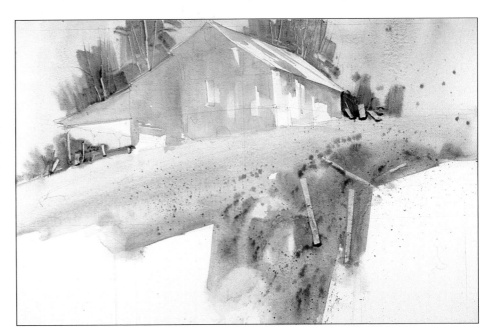

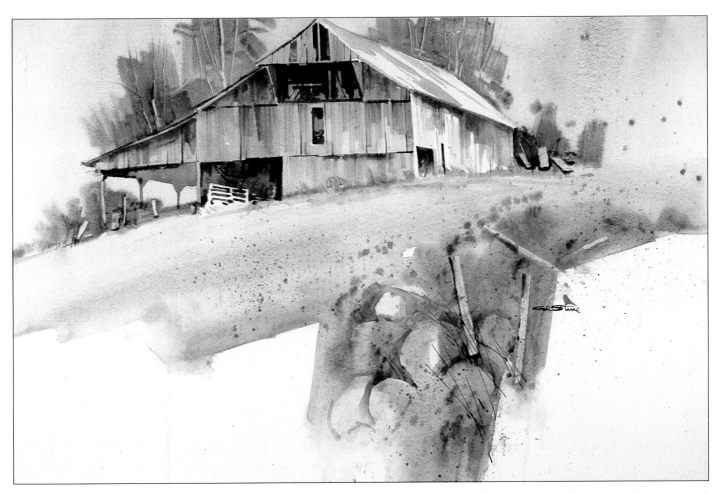

In Our Hearts (13x19). After the painting dried completely, I painted in the darker areas of the barn. You should be able to see into these shadow areas as if you could walk into them. Then I put in the darker areas under the barn roof and washed some of the color down with clear water. I then indicated boards on the barn—some crooked, some missing. I did some negative painting in the foreground to indicate rocks and added some weeds with a rigger for more texture. I then added weeds and grasses at the base of the barn. I did this by brushing on clear water and then painting and scratching the weeds into the color with the end of a brush. (*Collection of Mr. & Mrs. Daniel J. Buchanan*)

I have done a pencil value sketch, again an enlargement of a thumbnail (lower right) you saw in the original set at the beginning of this series of demonstrations on page 120.

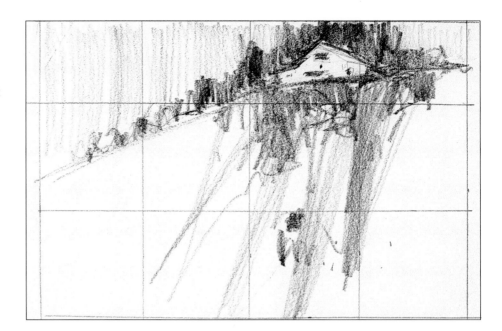

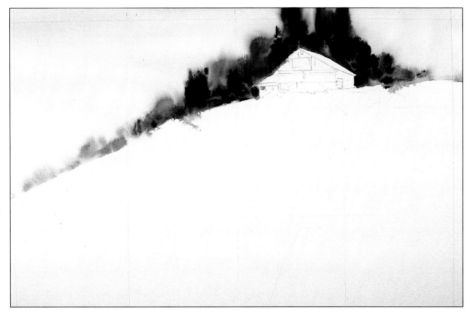

I flooded the upper area with clear water working around the barn where I wanted to preserve my whites. Wet in wet I flooded in Winsor blue at the top and, going down, added cerulean blue and, just above the horizon, raw sienna. While this was still wet I used a bristle oil brush to apply the paint quite quickly. I brushed the colors around the barn, letting the colors mix and diffuse on the board. As I worked away from the barn I let the colors, French ultramarine blue, burnt sienna, and raw sienna, get much lighter in value.

With the background finished, I flooded in clear water continuing down in a soft-edged shape toward the bottom. Where the clear water merged with the background the colors bled, leaving the soft edges I wanted. I also used a spray bottle to spray clear water into some of the edges in order to get a different texture along them. Using my two blues, I brushed in large areas, letting the color run randomly down into the already very wet areas. While still wet, I started painting the darker values using French ultramarine blue, Van Dyke brown, burnt sienna, and brown madder alizarin. In some areas where I did not want much dispersion, I used the bristle oil brush again. I spattered with a toothbrush and loaded a round brush with color to tap larger droplets.

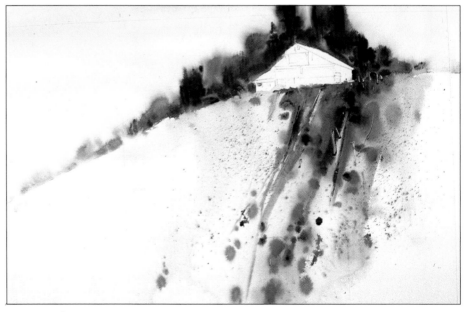

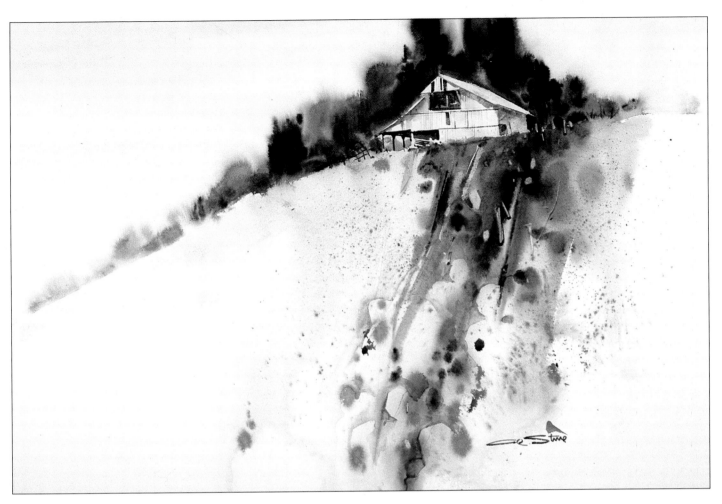

Cool Morning (13x19). When the painting dried completely, I went into the foreground doing some negative painting to indicate boulders. I also lifted out some areas using a small bristle brush to wet and scrub and clean tissue to lift the color. I added detail to the barn keeping it light in value.

Experimenting for Fun

I encourage you to play with all the techniques I have shown you in this chapter. Take what you can use and discard the rest. There is no one correct way to do a watercolor, so experiment and enjoy yourself. The one question I always ask my students is, "What is the worst thing that can happen if you mess up your painting?" The answer is, of course, you turn it over and start again.

Rather than tackling those frightening full- or half-sheet paintings, try doing quarter sheets. Do many quarter sheets. Don't forget that this is experimental painting and you're supposed to have fun. You can readily adapt what you've learned from each painting you do for use in your other paintings.

Fantasy (13x19). I began this painting by saturating the entire sheet of 140-pound Arches cold-pressed with clear water. Then I brushed in my light midtones and midtone values in abstract shapes using a 2-inch Simmons Sky Flow brush. The light area suggested a tree trunk and root patterns, so after letting the paper dry, I started developing subject matter with negative painting. A stencil was also cut and some lifting done.

Blooming (13x19). The surface of the paper was thoroughly saturated, then cobalt violet, French ultramarine blue, and Winsor green were brushed in a pattern of interesting shapes. I decided to go a little darker to the right so I could use plastic wrap in that area. The plastic wrap was placed to the right, and the paper was left to dry. The bright color in the flower was achieved by wetting the paper, dropping in the color at the base, then using a drinking straw to blow the paint around to create some of the shape at the outer edge.

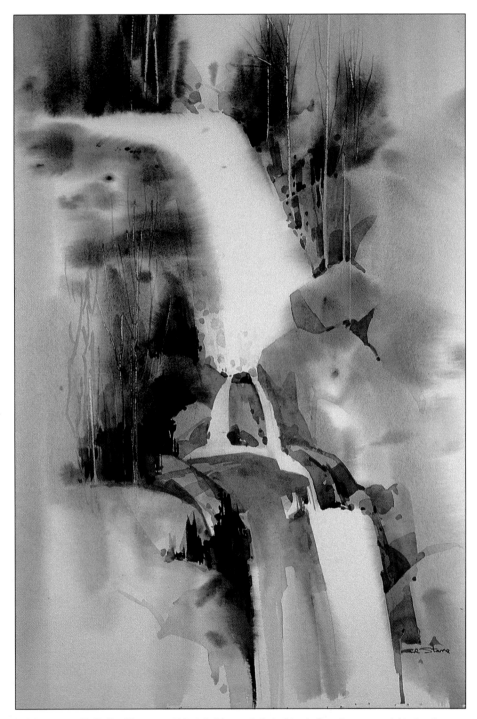

Whitewater Falls in Abstract (20x11). These falls in North Carolina are said to be the highest east of the Mississippi. I began this painting by wetting the entire surface of the paper and then brushed in my experimental shapes with cool colors. The trees and rocks were brushed on in warmer colors while the paper was still wet. As the paper dried a little more, I scraped out the trees with my brush handle. When the painting had dried completely, the detail was added by negative painting. (*Collection of Mr. & Mrs. James Patterson*)

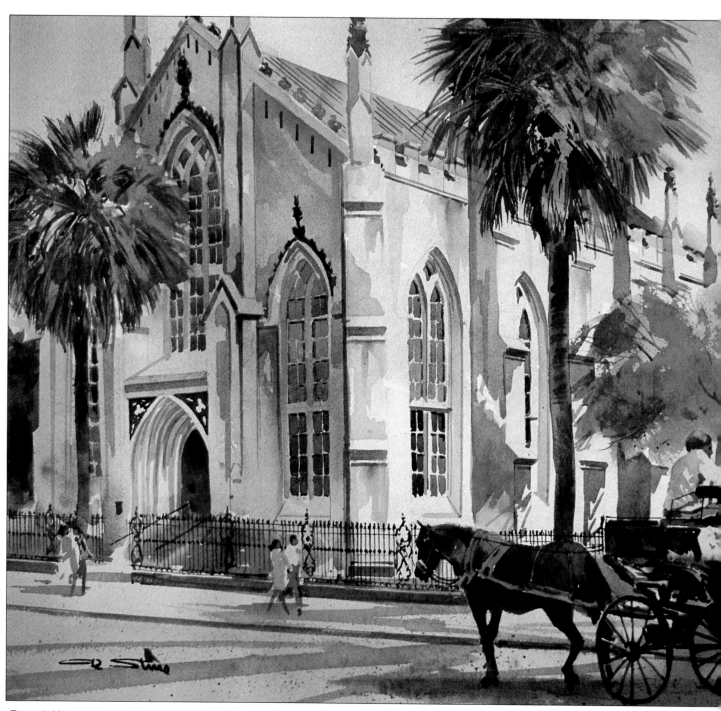

French Huguenot Church II (14x21).

CHAPTER ELEVEN

Painting Smart: Demonstrations

In this chapter I will take you step by step through the entire process of painting. Although we have examined many of the fascinating phases of painting separately in previous chapters, now we will see how they all fit together.

I want to remind you again that the best way for you to paint is YOUR way, not my way or any other artist's way. Some techniques that will work well for one artist won't work for another. That is why I have tried to explain the "why"—the reasoning—behind painting smart as well as the "how"—the mechanics. If you come to understand the reasons for doing something, you can decide on your own if my advice or anyone else's will help you reach your goal.

There are always new things to learn with watercolor. Every book I read, every workshop I attend, every class that I conduct myself teaches me something new. When I go to a workshop, I watch what the instructor does and see how I could adapt his approach and technique to my way of working. I often find myself saying, "I never thought of that! That's another way to do it." Sometimes I incorporate what I saw into the way I work; other times I recognize that the approach just isn't for me and file it away in my memory. I have on occasion remembered a technique I saw demonstrated that I personally don't use but shared it with a student I think will be able to use it.

Finally, I think it is good to remember that often the simplest way is the best. Some of the greatest watercolors were produced using two brushes and five colors and two or three of the most basic techniques.

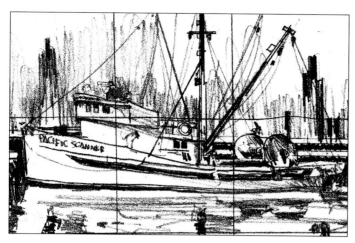

I did this 5 1/2 x 8 1/2 value sketch to use as a guide throughout the entire painting process.

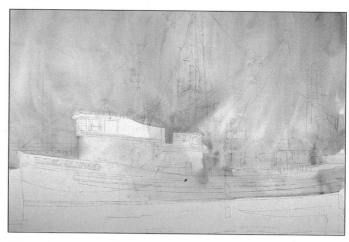

I tilted the bottom of the board up away from me, at an angle of approximately 10 degrees, so that the colors would run down up into the background and away from the boat. I then painted wet on dry, working around the boat. While these colors were still wet, I sprayed them with droplets of water from a spray bottle to get a soft, diffused effect.

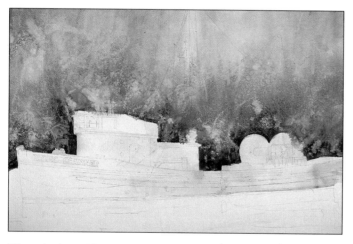

When the board had dried, I repeated the same process using darker values of the same colors. While that was still wet, I sprayed droplets of water on the colors and lightly blotted with tissue for a rougher texture to play against the first soft, diffused washes.

Next I painted the local colors on the boat. I knew from my value sketch that I wanted to leave the bow of the boat in light. I then painted in the local colors of the water, picking up the colors used on the boat but graying them down a bit.

Using a Value Sketch

In this demonstration based on my painting, *Pacific Scanner*, we'll look at how your value sketch serves as your road map throughout the painting process. You'll see how this type of advance planning not only helped me decide where to put the values in this painting but also guided me in correcting values as I worked.

A few years ago I gave a five-day workshop in Campbell River on Vancouver Island. The area was so beautiful we decided to stay after the workshop to see and photograph the countryside. I believe that it was also one of the most rewarding trips in terms of gathering subject material for painting that I have ever taken; every vista was a masterpiece.

It was a wonderful trip and one we look forward to repeating.

You can see that I have done quite a bit of color lifting. Again, the value sketch helped me determine where I wanted to remove color. I used white artists' tape to mask off the areas to be lifted, then used a clean, damp sponge to scrub out these areas, and blotted with a tissue to remove any excess moisture that might creep under the tape. I cleaned up some of the edges of the boat, masts, and rigging. I also lifted color for the ballards in the background and planned to paint back into these areas later.

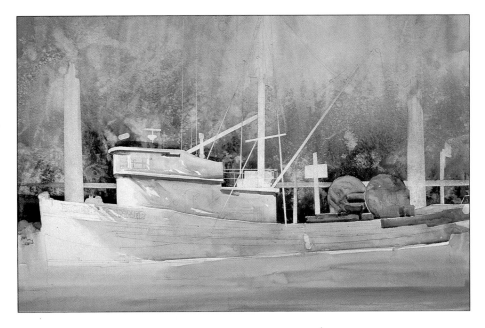

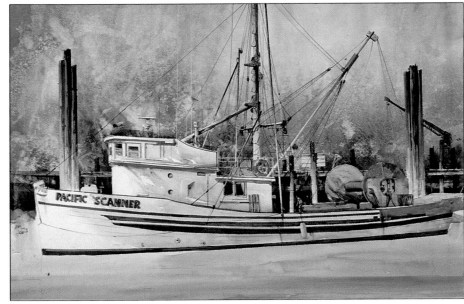

Details on the boat, masts, rigging, docks, and the ballards in the background were added here. I decided that a few human figures would lend more interest to the painting, so I scrubbed out two areas and added them, too. I added all of the detail in this step, because you must first know where the reflections on the water are coming from before you can paint them.

Pacific Scanner (22x32). I painted in the reflections on the water but wasn't entirely satisfied, so I sprayed and scrubbed some of them out. When the board had dried, I again painted the reflections, keeping those on the right a bit more diffused and grayed down than those on the left. The sharper reflections on the left would help my focal point, which is also the area of my lightest light and my darkest dark. After adding a few seagulls and trying a mat on it, I decided the painting was complete.

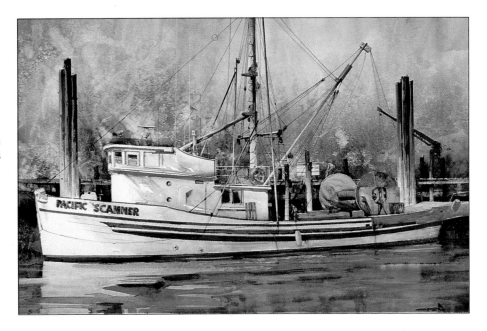

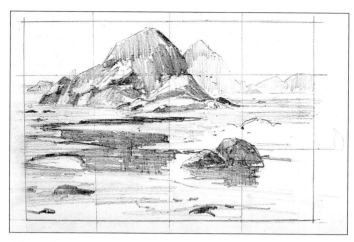

After doing several thumbnails, I picked the one that I felt worked best and made this larger value sketch. I then ruled off this sketch in squares to transfer the drawing to my paper.

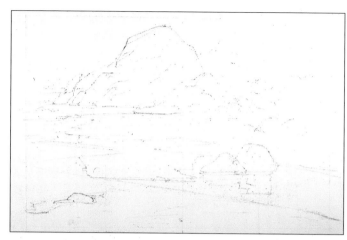

My next step was to lightly rule off my paper in squares and transfer the drawing to the paper.

The Limited Palette

While in Seattle we read about an Indian village called La Push on the Olympic Peninsula. We decided to visit a place called the Second Beach that lay just beyond the village.

We were fortunate to arrive at low tide to see the glorious tide pools and streamlets up and down the three-mile beach, reflecting the huge monoliths guarding the shore. It was a beautiful sight, screaming to the watercolorist, "Paint me!"

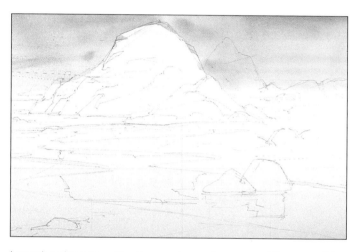

I wet the sky area with clear water, going around the monolith but including the background rock structures, down to the horizon line. Working from the top I used French ultramarine blue with a little added burnt umber, adding a little Hooker's green dark at the horizon line.

When the sky area had dried, I began painting the distant rock formations. To paint the monolith I mixed three separate puddles of color—one each of French ultramarine blue, Hooker's green dark, and burnt umber—keeping the pigment fairly heavy. While the colors were still wet, I used a razor blade to scrape into them to help create the planes and formation of the rock masses. I also added a little salt for more texture. You will notice that the Hooker's green dark stained the paper, and where the other colors are scraped off you get a lovely, soft effect from the underlying green.

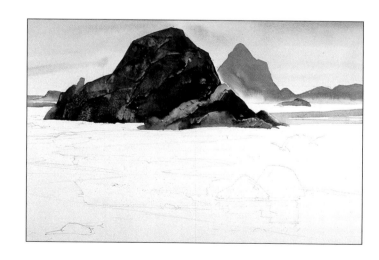

This painting is an excellent example of getting the most from a limited palette. I used only four colors: French ultramarine blue, Hooker's green dark, burnt umber, and raw umber. This selection gave me a wide range of colors and grays while helping to preserve color harmony throughout the picture.

1. I painted in the water of the tide pools and streamlets with juicy, wet, horizontal strokes using the same colors I used for the sky.

2. Using raw umber, French ultramarine blue, and a little burnt umber, I began working at the water line where the sand would be wet. Where the sand would be drier, I used warmer and lighter values of the same colors. Using the same colors I used for the monolith, but warming them up with more burnt umber so they would move forward into the painting, I added the foreground rocks. Graying down the same colors, I painted the reflections of the rocks, softening the edges a bit with clear water.

3. Returning to the sand I darkened some of the edges, especially near the water where they would be wet, darker, and cooler. You can see that I have attempted to achieve hard, soft, and rough edges for variation.

When everything had dried, I very carefully painted the reflections of the large monolith into the tide pool. While still damp, I added some darker areas within this to gain even more of a reflective quality and add life and variation to the area. I added a small rock in the left foreground for balance and softened a few of its edges into the sand so it would look as though it was buried there. I also delineated the edges of the tide pool with darker values.

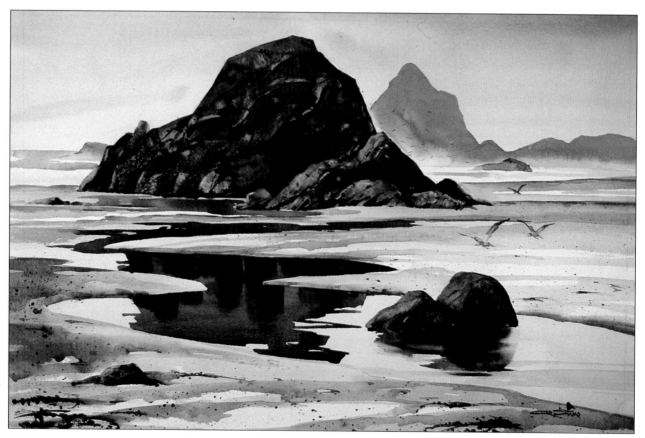

Low Tide at La Push (13x19). I added texture to the beach by spattering with a toothbrush and tapping a brush full of color for larger spatters. I then painted the seagulls and the seaweed lying on the beach. Going back to the monolith, I added detail mainly with negative painting but also by lifting out areas by scrubbing with a small bristle brush and blotting with a tissue. I was particularly pleased with the range of colors I achieved with the limited palette while at the same time keeping a unified and harmonious color scheme. (*Collection of Mr. & Mrs. C. Richard Hallengren*)

Color Harmonies:
Warm Against Cool

This demonstration painting shows one of Charleston's lovely, old churches, almost all of which are steeped in history. It would be almost impossible to take the photographs for this painting in the summer, because most of the building would be obscured by the foliage of the trees. I would much prefer to paint the delicate laciness of trees in winter than with the full foliage of summer.

At first look, a structure like this doesn't appear to pose problems for the watercolorist, but upon closer examination you find all kinds of nooks, crannies, and detail. The problem is to keep the painting fairly simple and yet have enough detail to tell the story of the building and its architecture. I attempted to do this, but I feel that I have put in too much detail and haven't kept it as loose as I would have liked.

In this demonstration we'll look at the way we can use color harmony to hold a painting together. We'll also look at the importance of color contrasts, in particular, the play of warm against cool. Contrasting color temperature is a good way to achieve clarity as well as eye-satisfying variety in a painting. For instance, in this painting, the cool colors of the church set the building off from the warm sky and also suggest the warmth of the sunlight. Contrasting color temperature, almost in a checkerboard, makes for a very interesting painting.

Using slides I had taken, I penciled this large value sketch to help establish value patterns for my painting.

In this first step I wet the entire paper, except for parts of the building that would be in the lightest light. I then laid in a wash of cool blue (Winsor blue, in this case) because the final colors of the painting would be done in warm colors. This is my first, and best, opportunity to establish the play of cool against warm to get color contrast.

While the first wash of cool blue was still wet, I started brushing in my warmer colors for the sky and foreground. I also did a little work in the area where the carriage would be and, at the lower left, I struck in a few darks to help key my values.

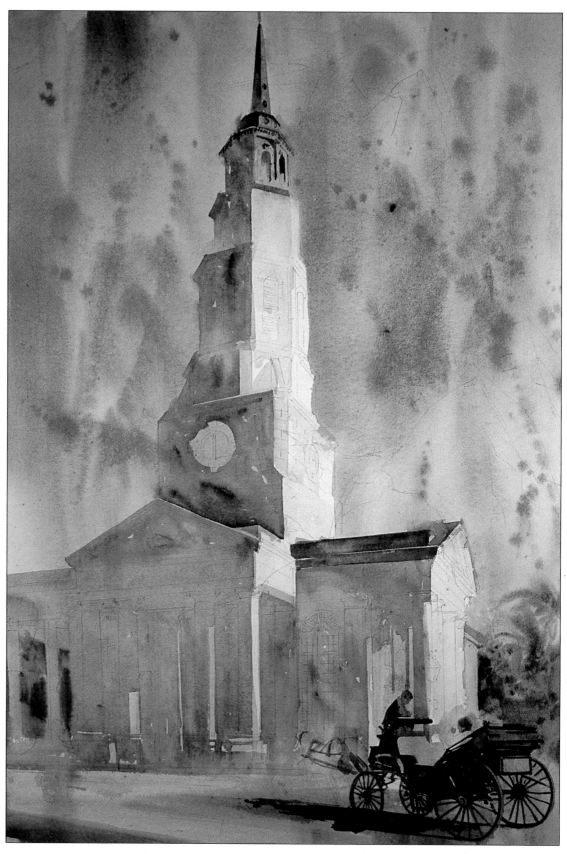

I started painting in the local colors of the church, starting at the top with my warmer colors and working down to somewhat cooler colors. I started painting in the local colors of the church, beginning with the steeple. In general, the colors are cool because they are in shadow. Nevertheless, the colors of the steeple are not as cool as the church building itself. I cooled the colors as I worked down. I also did some work on the carriage to help establish the correct values I wanted there. I didn't bother with the horse at this point.

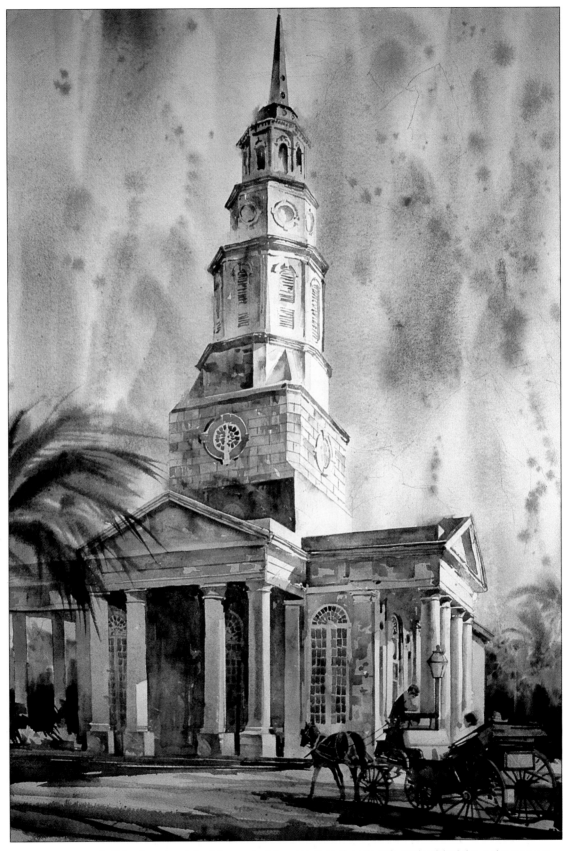

In this step, I painted the rest of the detail on the church and added the palm tree on the left. I finished painting the detail on the carriage and added the horse. Then I painted the final shadows cast on the ground.

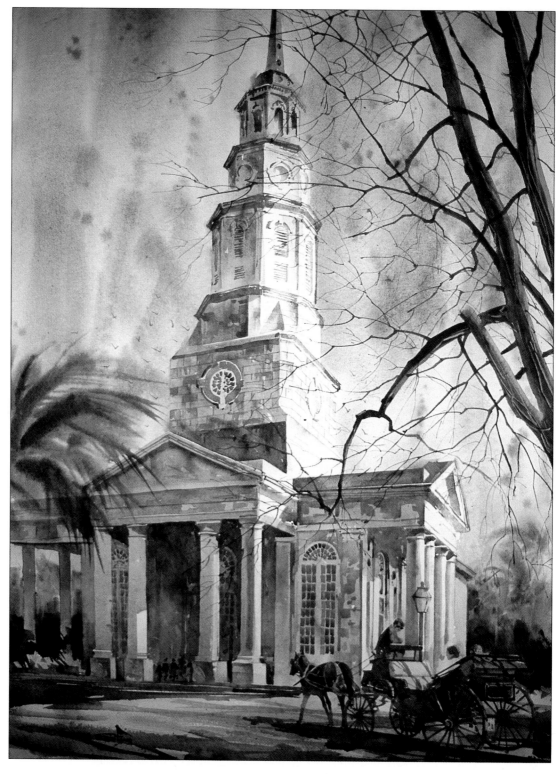

A Carriage Ride to St. Phillips (29x21). In this final step all that I had left to do was to paint in the tree at the right of the painting. I kept the color cooler at the top and warmed it up as I came down the trunk. All of the branches and finer twigs at the ends of those branches were painted with a #4 rigger. This is one place where your strokes must be delicate, but I've seen students paint these in with very stiff, heavy strokes, totally destroying the lacy effect that you see on trees in winter. (*Collection of Mr. & Mrs. Robert W. Klatt*)

Setting the Mood

We spent the morning taking photographs and doing sketches when we were in Charleston, a lovely old southern city full of history and charm. We drove over the bridge to Shem Creek to have lunch and were pleased to find the restaurant had its own docks. We took advantage of this opportunity to go down to photograph the shrimp boats that were moored on the other side of the creek.

I took quite a few shots with my standard 50mm lens, then changed to a zoom lens, taking the same shots again but bringing the subjects up much closer to get as much detail as possible. When boats are moored side by side the masts and rigging become such a maze that it can be very difficult to make heads or tails of what goes on which boat. You need to plan these shots very carefully or you won't be able to use your reference photos when you get ready to paint. Fortunately, the boats at Shem Creek are moored singly along the dock, bow to stern, and I didn't have that problem this time.

We'll look at ways of establishing mood in a painting with this demonstration. The sky that day was soft, with clouds scuttling by, and I felt that this would make a good foil for the white shrimpboat with its protruding masts and rigging. To achieve this feeling I've let cool, grayed down colors dominate and used warm notes for the warm against cool contrast.

After deciding what mood I would like for this scene and doing several thumbnails, I made this pencil drawing to help establish my value patterns and unscramble the complexity of the masts and rigging.

I penciled the drawing on 112-pound Crescent Rough Watercolor board. I chose this surface because I felt it would aid me in establishing the feeling I wanted to achieve. I knew I would get softer edges working wet in wet on this smooth surface, which would help establish a quiet mood, and I could also lift color quite easily if I so desired.

I wet the entire upper surface of the board, working around the boat, then used French ultramarine blue, burnt umber, cerulean blue, and raw sienna for this sky. I wasn't happy with the results. Rather than continue working into it, I simply took it to the sink and washed off the whole area. I repainted the sky using the same colors; though still not entirely happy, I felt it would do, since most of it would be covered up by the masts and rigging of the boat. The sky is key to setting the mood of the painting, but it still shouldn't distract attention from the boat, which would be my center of interest.

I painted in the local colors of the boat, keeping them in the midtone range except for the stern, striping, and the darker area of the hull.

In this step I've painted only the water. I used the same colors I used in the sky, starting lighter at the top and getting darker at the bottom. While this area was still wet, I painted in some darker streaks (dry on wet) to show a little water movement. Notice how I've added warm notes but kept them grayed down to fit with the mood of the painting.

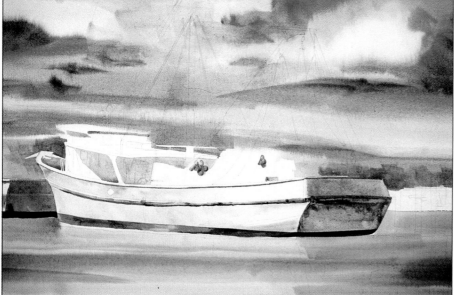

The docks were painted next. Then I painted in the ship's masts and the shrimp nets hanging on the stern.

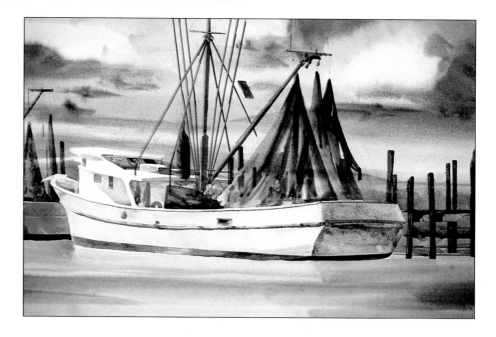

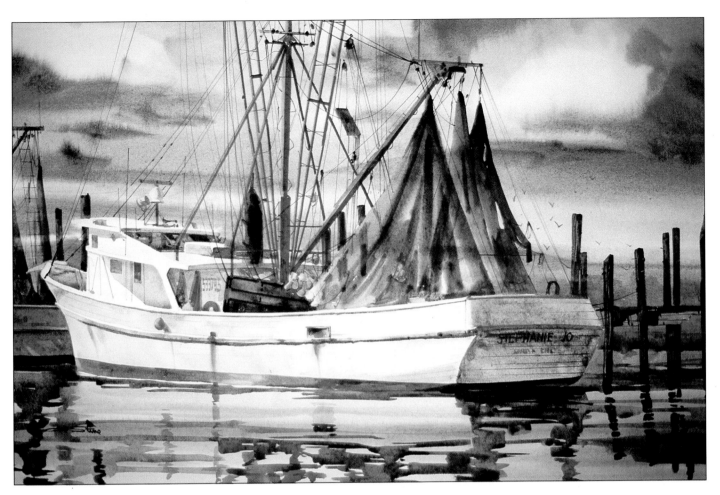

Shrimpboat at Shem Creek (13x23). I finished painting all of the detail on the boat, adding the name of the boat on the stern. The rigging was painted with a #4 rigger, and I added some rust streaks on the hull. The reflections were the last thing I painted. I'd particularly like to point out the effect of the sharper reflections painted over the softer, diffused color achieved by the first washes. Also notice the reflected buoy and rust streaks. Don't be afraid to show these; they are there, and they do reflect in the quiet water. I think that the sharpness of the boat and the reflections stand out quite nicely from the softer, more diffused background. This gives the painting a contrast for interest without spoiling the softer, subdued overall mood of the painting.

Technical Tricks

I was commissioned to do this painting of the Portland Head Lighthouse in Maine by the owners of the painting who were born and raised in this area. Though they are now Florida residents, they return to Maine each summer and wanted a reminder of the sea and lighthouse they love so much.

Rugged coasts and lighthouses are among my favorite subjects to paint. I'm not sure why they've intrigued painters down through the centuries, but maybe the ever-changing sea and sky bring out the love of adventure in us. Perhaps it is a remembrance of the great sailing ships and fishing boats that put to sea from these rugged shores long ago, an experience many of us wish we could have—except, of course, we wouldn't want to be caught in the terrible storms that took so many ships and lives!

In this painting I've used many of the techniques we've discussed throughout the book. Some of them are basic such as gradated washes, working dry on wet, while others are the "fancy stuff" such as masking, lifting, scraping, and spattering. I chose each for the effect it would produce, not to show off what I could do. Study each stage of the painting to see how all these techniques work together to make a unified whole. You should be aware of them at each stage but not in the final painting (if I've done my job right).

As always, I planned my painting by doing thumbnail sketches followed by this larger drawing to establish my divisions of space and value patterns.

I penciled the drawing on 140-pound Arches cold pressed and proceeded to mask out the lighthouse, some buildings, and rocks where the sky and sea meet them. I used a liquid masking fluid because I wanted to be able to paint the sky and sea right over them and still retain my whites.

In doing the sky I wet the entire paper down to the horizon line, going right over the masked areas. I then painted in a gradated wash of French ultramarine blue and burnt umber, keeping it darker at the top and lighter at the horizon. While the sky area was still wet, I painted in the cloud formations working dry on wet and using the same two colors. By painting dry on wet, I was able to hold the shapes I wanted while still getting soft edges.

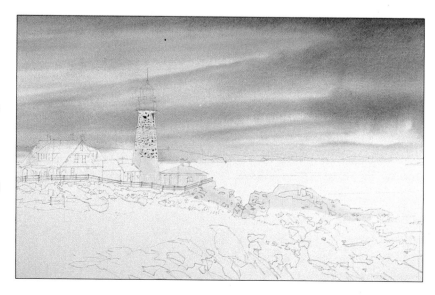

In this step I painted the sea, brushing it in with horizontal strokes and leaving a light area to add variation to it. This lighter area was lifted with a clean, squeezed-out, thirsty brush.

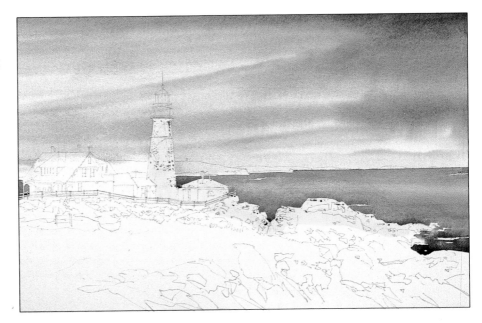

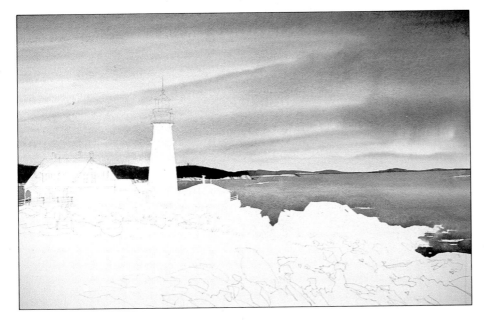

I added the distant land mass using French ultramarine blue with just a little olive green. The nearer land mass in back of the lighthouse was painted next, and here I used olive green, French ultramarine blue, and burnt umber. The cliffs just above the sea were painted with a little raw sienna grayed down a bit with the blue. When the paper had completely dried, I removed the masking.

In the next step, I painted the lighthouse, all of the other structures, and all the detail in these structures. I then painted the local colors of the ground and rocks, trying to paint the planes of the masses with the correct values to help establish the direction of those planes.

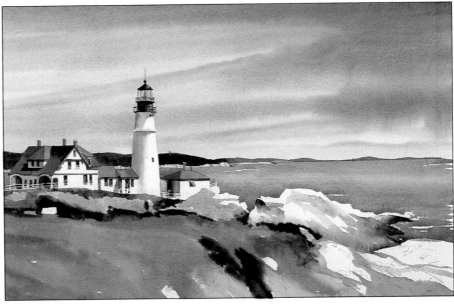

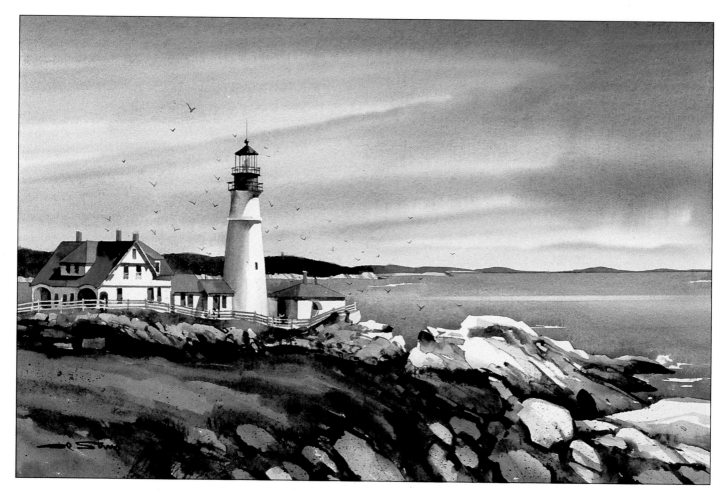

Portland Head Light (13x21). I painted some of the rocks and ground formations directly, but most of this was finished with negative painting. I did a little scraping with a razor blade for texture and to indicate cracks in the rocks. I also added some spatter with a toothbrush for added texture. I did the buildings a little tighter than I would normally paint, but this was a commission and I felt the owners would want very detailed, recognizable buildings. Still, I think the looseness of the sky and foreground works well with the buildings. It seems my clients feel I made the right decisions, as they've told me how pleased they are with the painting. (*Collection of Mr. & Mrs. Gilbert Cox*)

Painting from Start to Finish

While waiting for the ferry that would take us and our car to Seattle from Victoria on Vancouver Island, we did a little exploring along the coast. We came across a lovely place called Gomez Bay, which has a wonderful beach full of driftwood and some remarkable homes high on the bluffs. It just shows that, with a little time and a desire to explore and see new things, you can find all kinds of material for paintings.

I'm going to use this demonstration as a final review of the steps in painting smart from start to finish. You've got to think about what you want to do in your painting every step of the way. Do thumbnails and design your painting carefully. Plan your value pattern and save your whites. Choose the right color scheme and select a suitable limited palette. Select the best techniques to get the effects you want. Then paint to the best of your ability—and know when to quit. Nothing will guarantee a great painting every time, but you improve your chances if you always think smart and paint smart.

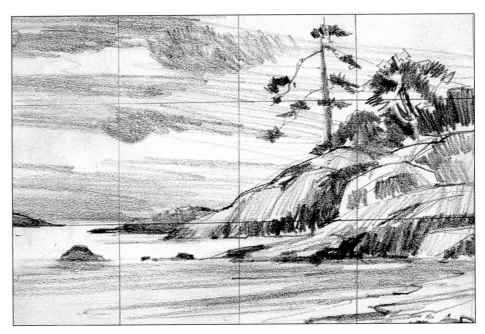

After doing several thumbnails, I drew this larger value sketch, which would be my road map throughout the painting. I then marked it off in grids in order to transfer the drawing to my paper. I chose a palette of five colors: raw sienna, burnt sienna, burnt umber, Payne's gray, and Hooker's green dark. I used the Payne's gray as a blue.

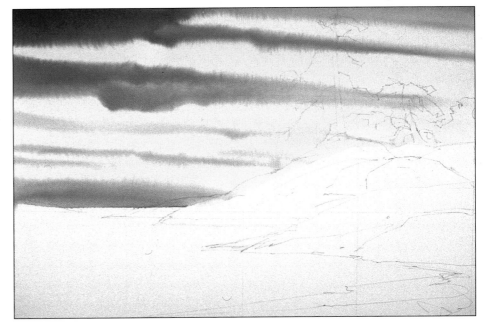

I transferred the drawing to my paper by the grid method and proceeded to wet the upper surface of the paper down to the horizon line, working around the land formation. I didn't have to be too careful around the land area because it would be painted much darker than the sky. I then brushed in a flat wash of raw sienna and, while that was still wet, I brushed in the clouds with Payne's gray using the dry on wet technique. This method helps hold the shapes while leaving a soft edge. I normally would have painted the water next, but in this case I chose to paint the land formations first. I wanted to establish the value pattern to see how dark I would need to make the water to get a good value contrast with the land.

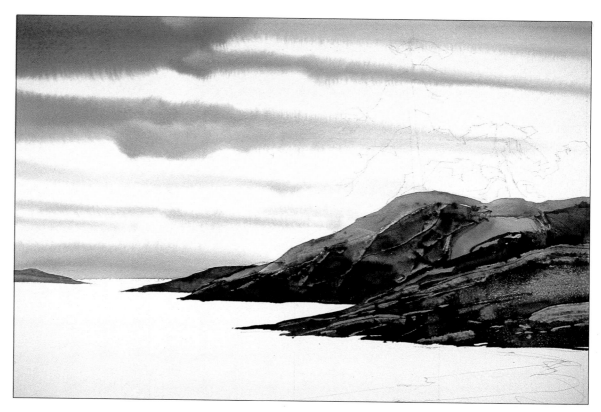

When the sky area was completely dry, I painted in the local colors of the rocky land mass, trying to keep it cooler in the distance and warming it up as it moved toward me. While this was still wet, I scraped into it with a razor blade to achieve the texturing for the rocks and ground. I decided to go ahead and finish the land mass and did so by bringing out all of the detail with negative painting.

The water was painted next, so I laid in a light, gradated wash of raw sienna, making it lighter at the horizon and a bit darker at the beach. While still wet, using the dry on wet technique, I brushed in the action of the little waves near the beach.

I darkened some of the values in the water to better indicate the small waves and also washed in the beach area. I used a toothbrush, spattered a little texture into the sand of the beach, and added a few beach grasses in the right foreground.

Gomez Bay (14x20). To finish I painted in the pine trees and scrub on top of the land mass. Notice that I kept the tallest pine tree cooler and darker at the top, and lighter and warmer at the bottom. I painted the pine scrub to the right and brought out the trunk with negative painting. This is a very simple painting that shows subject matter need not be complicated. I believe the painting works well because of its values; the lights and darks are strongly contrasted. This gives it that singing quality that we have talked about. Notice also the impact of the strong colors of the land mass and tree against the grays of the sky and water. (*Collection of Robert H. Wall, Jr.*)

INDEX

A

Abstract shapes
 defined, 113
 going from, to reality, 116
Alternation, 74
Artist, importance of being among, 8, 13

B

Balance, 73
Blotters, 39
Board, as alternative to paper, 19
Brandt, Rex, 34
Brush handle, scraping with, 42
Brush spattering, 42
Brushes
 care of, 17
 investing in quality, 16-17
 to take on location, 13

C

"California School" of waterpainting, 34
Camera, artist's use of, 5
Center of interest, 3, 86-87
Clouds, 60-63
Cold-pressed paper, defined, 18
Color guides, 50
Color harmony
Demonstration of, 135-138
 in planning stage, 48
Color rendering, 7
Color scheme, defined, 50
Colors
 contrasting, 48
 four ways of applying, 26-29
 palette of, 20-21
Planning for dominance of, 78
 primary, 21
 secondary, 21
 warm against cool, 135-138
See also Palette, limited
Colors, warm and cool
 demonstration of, 135-138
 placement of, on palette, 21
Composition, experimental
 an exercise in, 114
 from traditional to, 120-126
Conflict. See Contrast
Contrast
 of color temperature, 135-138
 defined, 76

D

Darks, as first step, 93
Design
 eight principles of, 71-77
 seven elements of, 78
Detail
 putting in right amount of, 135
 selecting and omitting, 84
Direct method. See Wet on dry
Direction, 78
Dominance, 75
Dry brush, 27
Dry on dry. See Dry brush
Dry on wet, 27-29
 definded, 27
 painting skies, 62

E

Edges
 hard and soft, 28
 messy, 103
Elements of design, 78, 80
Equipment
 basic, 15
 for painting on location, 13
 special, 22
Experimental composition
an exercise in, 114
from traditional to, 120-126

F

Failures, learning from, 11, 63
Figure, as center of interest, 86-87
Film, print vs. slide, 5
Five-color combinations, 54
Flat wash, 30
Foam. See Water in motion
Foregrounds, using gradation in, 77
Four-color combination, 53
 demonstration of, 132-134

G

Glazes, 32-33
Gradated wash, 30-31
Gradation, 77
Grays, mixing, 49
Grid pattern, 7

H

Horizon Line, placement of, 87
Hot-pressed paper, defined, 18

I

Instruction tapes, 8
Interest, center of, 3, 86-87

L

Layering, problems with, 93
Lifting
 with blotter, 39
 spraying and, 44
 with tissue, 38
Lighting, 15
Limited palette, 47
 application of, 55
 color harmony and, 48
 demonstration with, 132-134
 grays on, 49
Line, 78
Liquid frisket, 34

M

Masking off, 106, 131
Midtones, 78
 as first step, 92
Mood, setting, 139-141
Muddy look, how to avoid, 53, 93

N

Natural sponges, 23, 39
Negative painting, 110-111
Neutrals, grays as, 49

P

Paint
 using plenty of, 93
 See also Colors
Painting
 beginning the, 91-97
 on location, 12-13
 negative, 110-111
 overworking a, 99, 102-103
 planning for, 3, 7, 81
 playing around with, 113
 practicing components of, 10
 from start to finish, 100-101, 145-147

Painting techniques, 10
Palette, limited
 advantages of, 47
 application of, 55-58
 demonstration with, 132-134
Palettes, 20
Paper
 methods of stretching, 19
 weight of, 18
Perspective, aerial, to establish distance, 51
Photographs
 planning for, 139
 as source material, 4-6
Practice, importance of, 59
Practice paintings, 10
 saving, 55
Primary colors, 21
Principles of design, 71-77, 80

R

Reflections, in water, 65
Repetition, 74
Rocks, and rushing water, 68-69

S

Salt, texturing with, 22, 43
Scraping out, 22, 41
 with brush handle, 42
Secondary colors, 21
Shape, forms of, 78
Size, of shapes, 78
Sketch
 as map for painting process, 130
 thumbnail, 7, 71
 value, 7, 130

Sketch pad, 4-5
Skies
 and clouds, 60-63
 easy, 61
 laying in, as first step, 93
Spattering
 with brush, 42
 with toothbrush, 22, 41
Special tools, 22
Sponge, natural, 23, 39
Sponging off, 104-105
Spraying, and lifting, 44
Stamping, demonstrated, 35
Stencils, used to reclaim whites, 106
Storm clouds, 63
Stretching paper, 19
Studio, importance of having, 15
Subject matter
 choosing, 4
 interpretation of, 84
Subjects, problematic, 59

T

Technical tricks, 142-144
Techniques
 choosing proper paper for, 18
 examples of, 25
 learning new, 91
 with plastic wrap, 40
Texturing
 with special tools, 22-23
 three types of, 78
Three-color combinations, 53
Thumbnail sketches, 7, 71, 83
Toothbrush, spattering with, 22, 41
Two-color combinations, 52

U

Underpainting, 115
Unity, 72

V

Value, 78
Value sketch
 defined, 7
 as map for painting process, 130
Variation, 74
Variegated wash, 31
Vertical repeat, 72

W

Washes, 30-31
Water, three types of, 64
Water in motion, 65
 breaking waves, 66
 and rocks, 68-69
Watercolor clubs, 8
Watercolor, reading about, 8
Wet in wet
 defined, 26
painting skies and clouds, 60
Wet on dry, 26-27
Whites, reclaiming, 106-109
Wipe outs, 36
Wood, Robert, 34